Close Up
Creative Techniques for Successful Macrophotography

John Brackenbury

RotoVision

A RotoVision Book

Published and distributed by RotoVision SA
Route Suisse 9
CH-1295 Mies
Switzerland

RotoVision SA
Sales, Editorial & Production Office
Sheridan House
112/116A Western Road
Brighton & Hove
BN3 1DD
UK

Tel: +44 (0)1273 72 72 68
Fax: +44 (0)1273 72 72 69
Email: sales@rotovision.com
Web: www.rotovision.com

10 9 8 7 6 5 4 3 2 1

ISBN: 2-88046-782-9

Designed by Richard Wolfströme

Reprographics and printing in Singapore by ProVision Pte. Ltd
Tel: +65 6334 7720
Fax: +65 6334 7721

Close Up
Creative Techniques for Successful Macrophotography

John Brackenbury

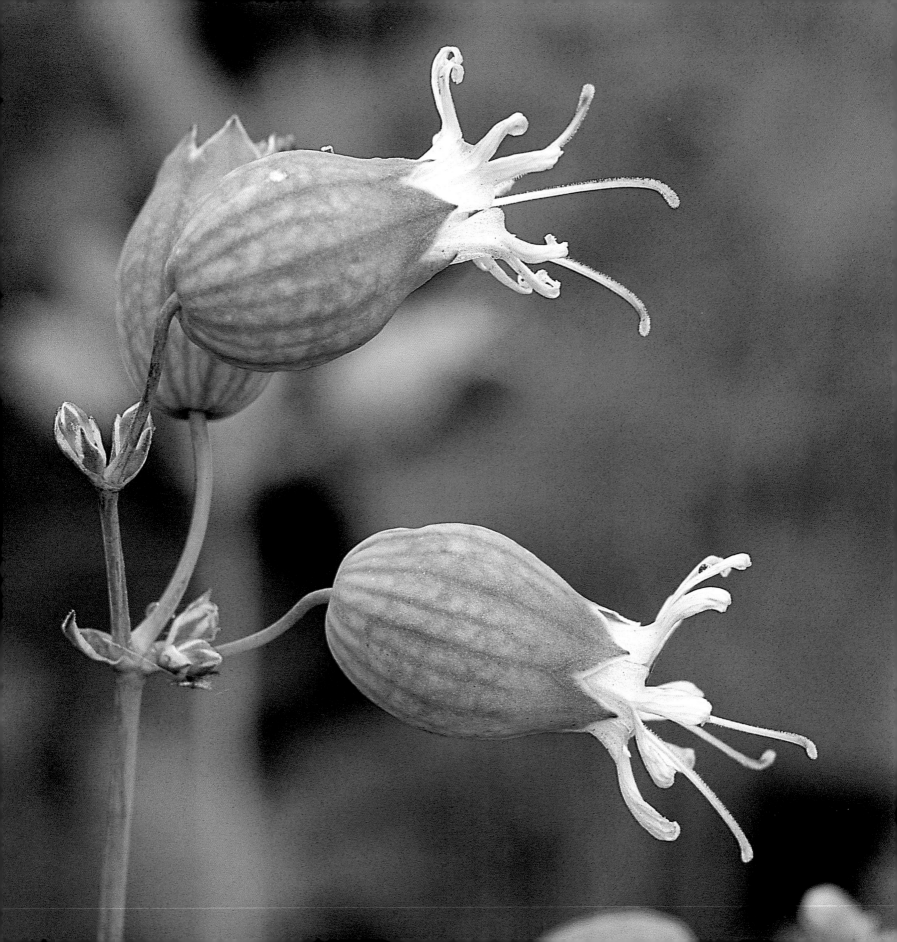

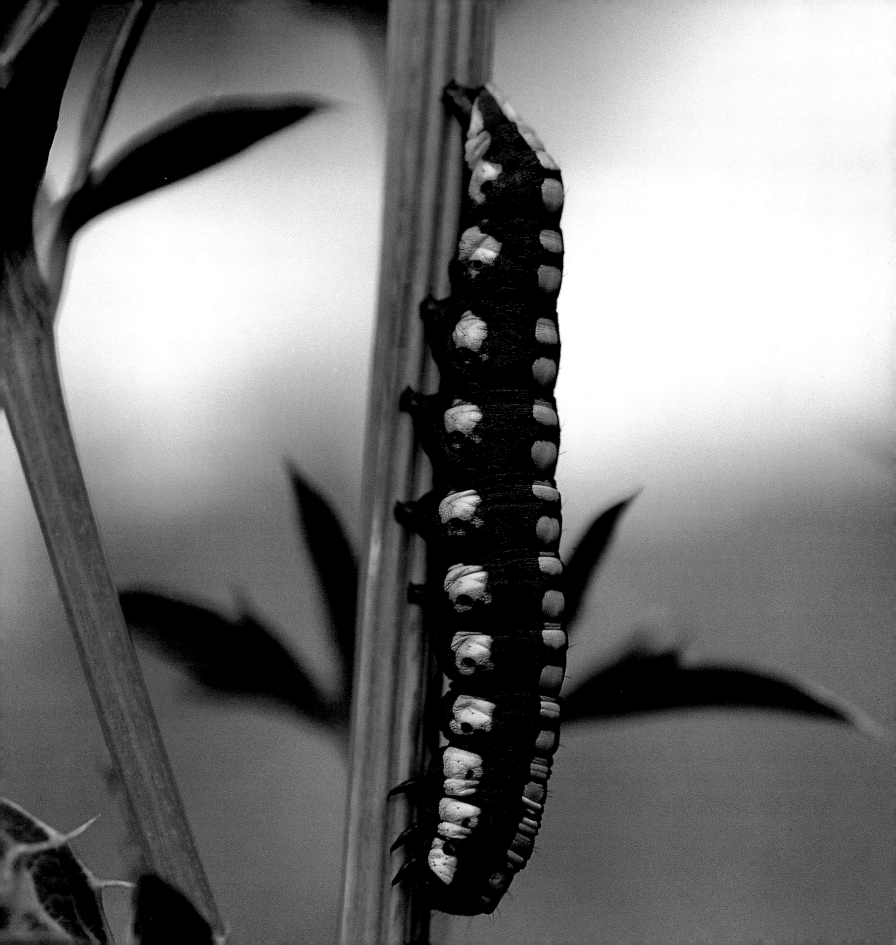

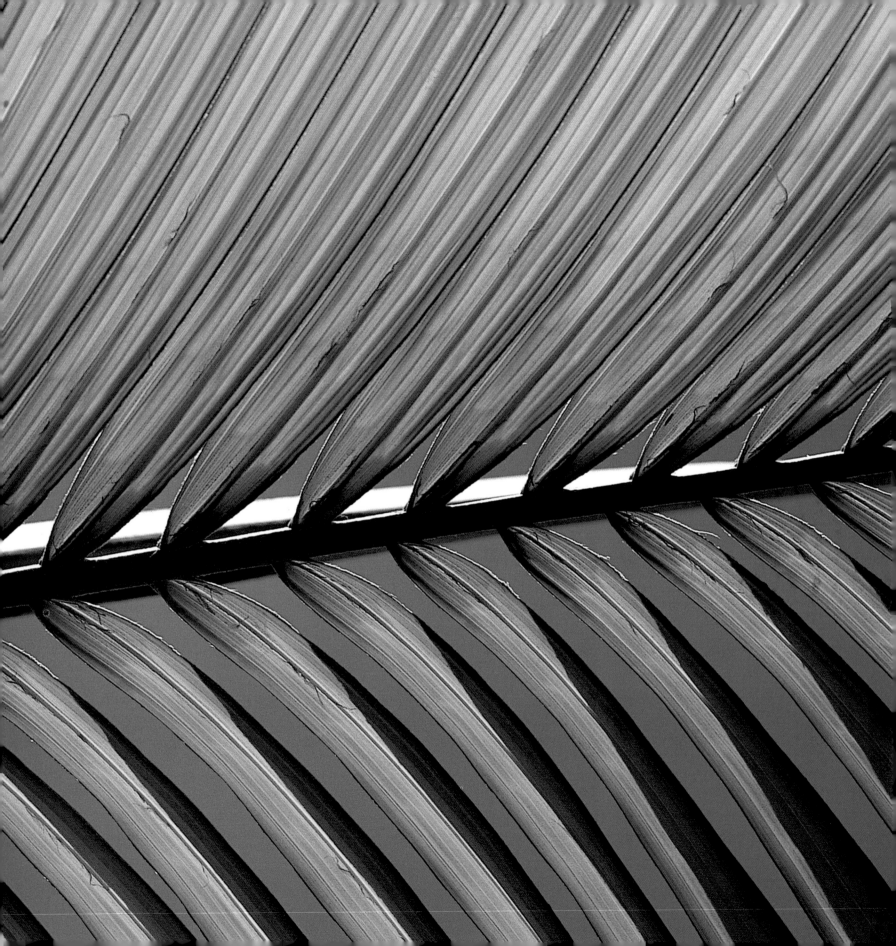

Contents

Left How close is close-up? This photograph of a palm frond is slightly closer than a standard lens would normally be able to capture in focus without the addition of an extension tube. The interest here lies not so much in the individual leaves but the overall pattern of light and shade.

Previous pages (*Left*) Catchfly (*Silene*) photographed in dull lighting, which favored the faithful rendition of its pale color. (*Right*) A Noctuid moth caterpillar. A storm was on the way and, with almost zero light, I managed to shoot at f5.6, 1/60th sec, hand-held.

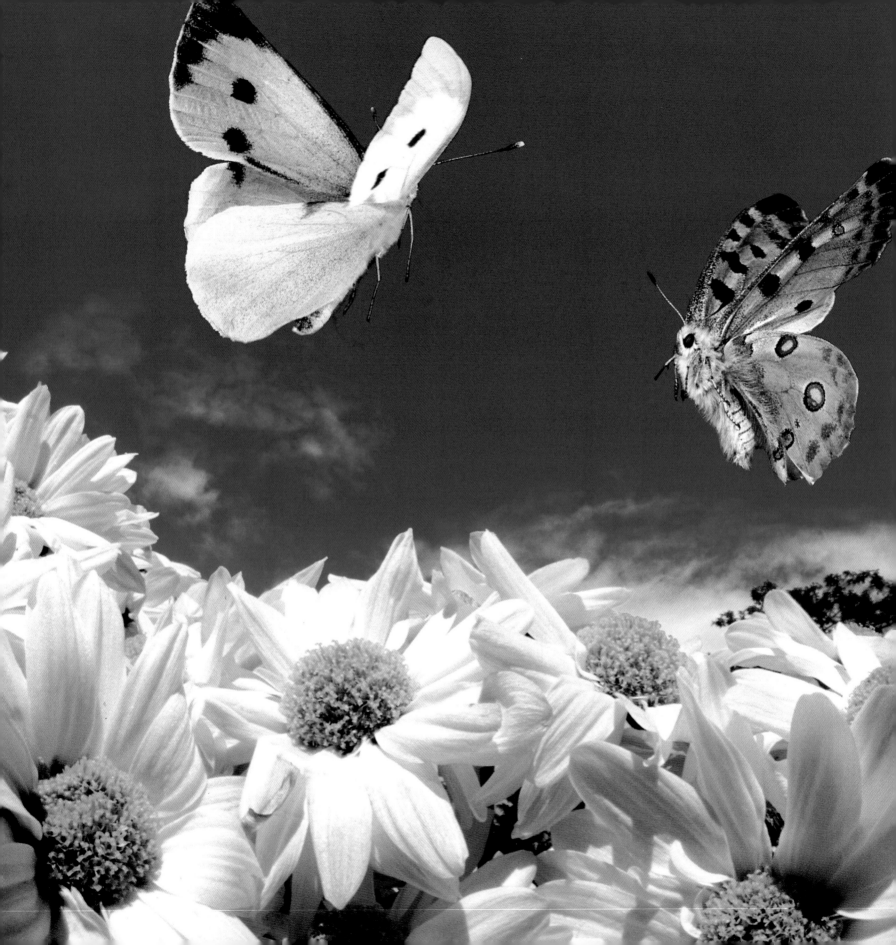

Introduction

Generations of photographers have found inspiration in the imagery of nature. Landscapes, plants, fossils, mammals, birds, fishes, insects, trees, and flowers—all have dedicated specialist photographers. Some bridge the gap between several of these disciplines, thereby achieving a more informed understanding of what it is that makes a good nature image.

Left Large white and Apollo butterflies (*Pieris brassicae* and *Parnassius apollo*).

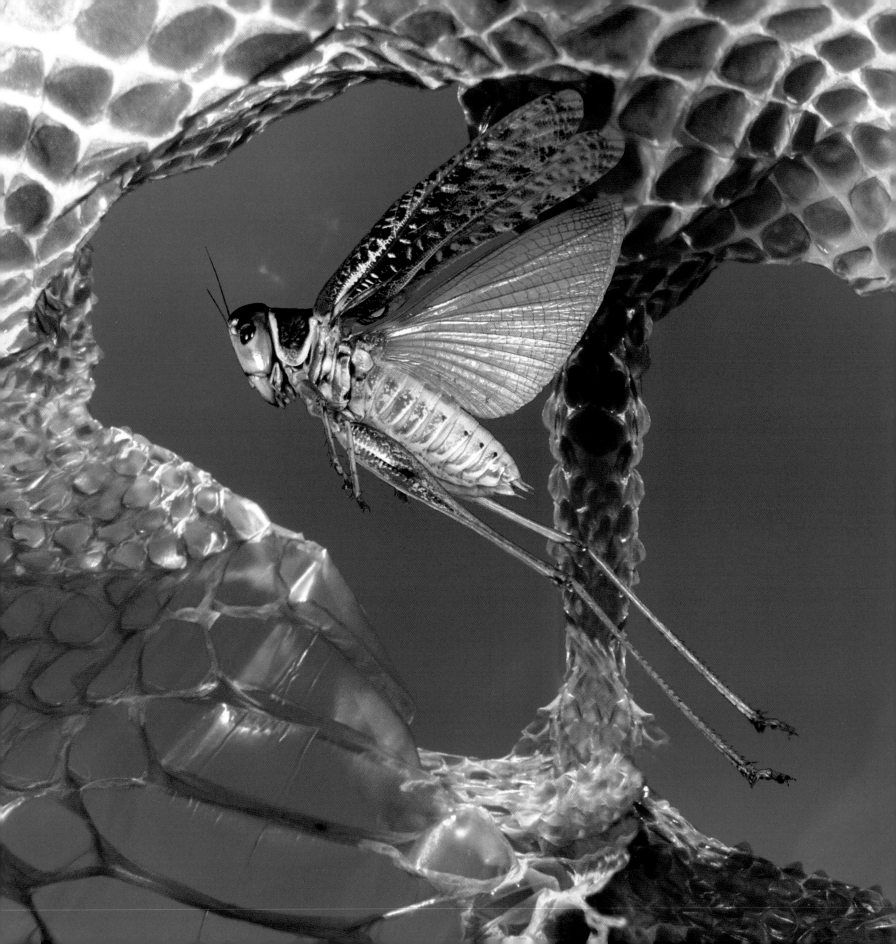

Nature's own eyes

I think that sometimes we regard nature as a kind of master canvas, or perhaps a mosaic of smaller canvases, from which we entice "copies" on to film (or disk). Of course, as a photographer—and one for whom the exercise is about creative satisfaction—one is almost always left with the feeling that one's image is lacking something in comparison to the original, but that is what keeps us striving for better results. Of course, it is misleading to assume that all nature photographers are in pursuit of art. A museum curator, searching through a catalog for a picture of a shell or a tiny bone, would not thank the photographer for any attempts to reinterpret the original; they simply want a record. There are many other applications for close-up photography that have a commercial bias—for use in advertising, engineering, etc.—but the technique, and some of the equipment that is used (excepting, perhaps, the use of artificial lighting in commercial photography) are, for the most part, the same—whatever your reason for exploring the subject.

In terms of hardware, your greatest allies for close-up work are an extension tube and a sturdy tripod. Perhaps obviously, as you take your lens closer and closer to a subject the camera begins to work a bit like a microscope—small things begin to get bigger in the viewfinder—and two things happen. First, because of the reduced light getting into the camera, you need longer exposures. This cannot easily be offset by opening up the lens aperture because of the second factor—depth of field. Depth of field diminishes, and you need increasingly small apertures to offset this. To achieve maximum resolution of detail and color, you need very slow film. A great deal of patience also helps.

Once you've made these considerations, an unexpected world of color, shape, and pattern emerges. The variety changes with every angle of the lens. Close-up photography is like any other kind of photography—it is about observation, and learning to take better nature pictures is about training the eye to see it in a frame. If patience and camera equipment are the vehicles for image-making, then imagination must surely be the fuel that guides them. At first it lurks in the background, overshadowed by one's efforts to get to grips with the methodology, but then it begins to take over, and that is when you start taking better photographs.

My specialist field is plants and insects. Over the years as I have experimented with many different ideas and techniques, and as my experience accumulates, I become more and more creative in my approach. One kind of image in particular tantalized me for a long time. It was of an insect frozen in flight, and seen, not through the eyes of a person, but of another insect flying alongside. Accustomed until then to peering at nature from the outside, I now wanted to see it, or interpret it, from within.

Part of this book is a visual journey to explore just that, to use macrophotography to explore the world from within. Curiously, although I have followed my own unique route into the subject, I now find myself in the company, in spirit at least, with a great many digital photographers who are using technology to attempt to create images which place the viewer at the center of a 360° panorama. I originally described the pictorial efforts revealed in this book as panoramic close-ups or insect-eye views. How ironic—and very pleasing—to find that the so-called immersive image now pursued so eagerly by viewers via the computer turns out to have been out there already for a good few million years, in a pair of nature's own eyes.

Left Bush cricket (*Decticus albifrous*) and snake skin.

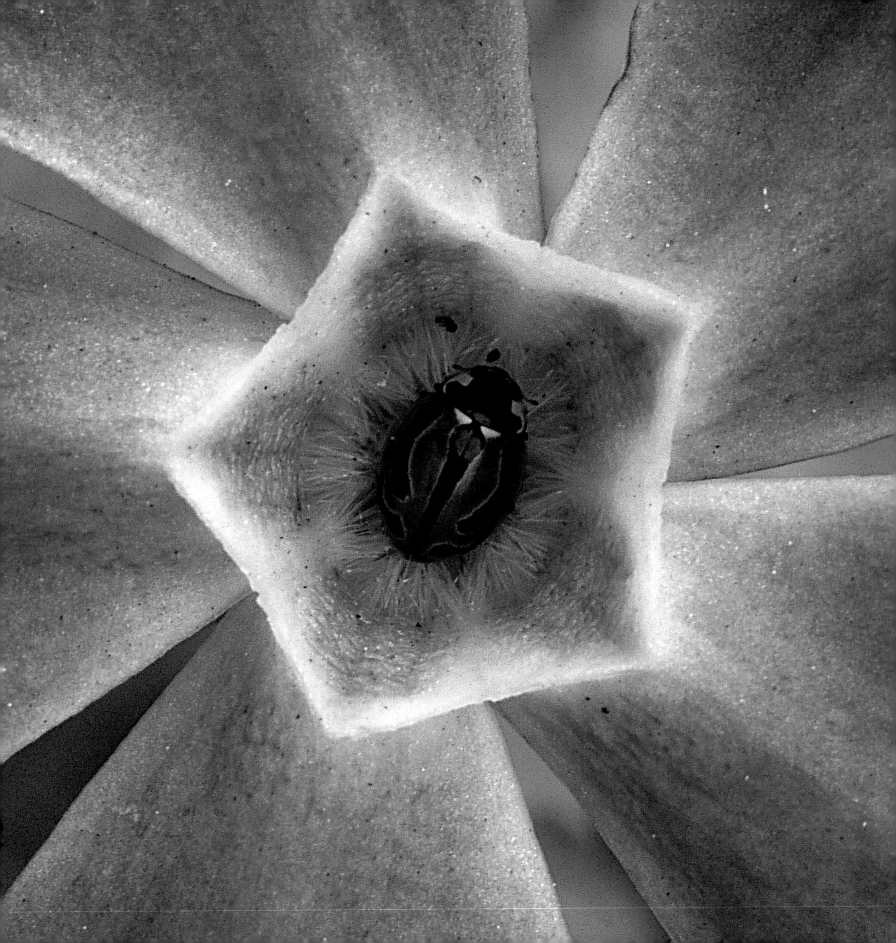

Close-focusing and depth of field

Most people use their cameras for taking snapshots, and only discover the limitations of their equipment when they try to home in on a garden flower or a wild bird picking up breadcrumbs in the park. In the viewfinder, your subject may be very tiny, luxuriantly surrounded by the space of its background. For those willing to persevere, however, there are several ways of overcoming this problem to capture great close-up images of any number of detailed subjects.

Left Periwinkle flower (*Vinca major*), shot on Mount Teide in Tenerife. To begin with I was interested in whole flowers, but then I spotted the small beetle in the middle of one of the flowers, and focused in very close using an extension bellows to achieve a magnification of twice life size.

Getting started: what do you need?

By far the most convenient—but also the most expensive—outlay is a specialist macro lens. This is an investment that probably only the dedicated photographer should be prepared to make, but for those intending to spend a lot of time exploring the close-up range, it will prove indispensable. A macro lens is effectively an ordinary lens fitted with an unusually long focusing screw which allows the lens barrel to be extended much further from the camera body. Macro lenses are normally designed to focus down to half life-size magnification, thus a subject measuring 10mm (⅜in) in height registers as a 5mm (⅛in) size image on film. Exceptionally, some macro lenses are capable of forming a life-size image. However, for the photographer willing to buy one, it is reassuring to know that macro lenses are usually built to a very high standard of engineering, and, as well as being extremely convenient for close-range operation, they also double as excellent lenses for everyday shooting.

For the beginner to macrophotography there are simpler ways of achieving close-range focusing using inexpensive accessories, such as close-up lenses or extension tubes. Close-up lenses, or "proxars", are said to diminish image quality, because they impose an additional glass medium between the main lens and the subject. I cannot personally opine on their effectiveness, having never used one, but they do have their advocates, and it is worth experimenting with them. I use a range of macro lenses of differing focal lengths, but in the past I have found that a standard lens equipped with an extension tube produces images that are just as good. Extension tubes can normally be purchased in sets with different lengths equivalent to fractions (½, ¼, etc.) of the nominal focal length of a standard lens. They can therefore be used singly or in combination to obtain a range of image magnifications.

Left Unfolding *Monstera* leaves. Here, we are just within the limits of close-up photography. The interesting feature is the gradation in character of the three leaves in progressive stages of unfolding.

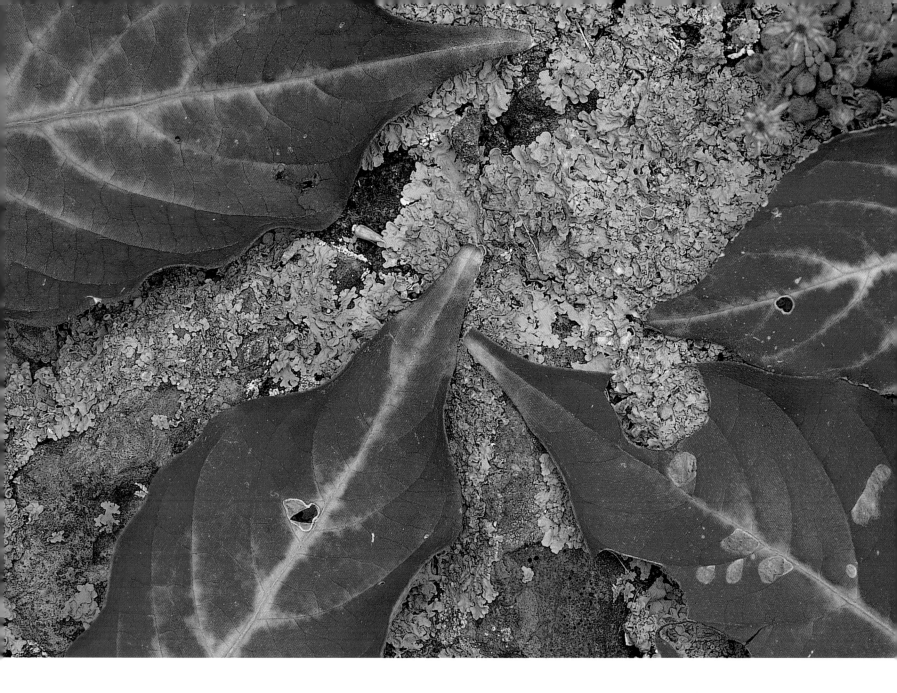

Above Leaves and lichen. Yellow
is a difficult color to photograph
satisfactorily because it easily
bleaches, particularly in bright
sunlight. This photograph was
taken in very dull conditions, which
muted the yellow of the lichen and
produced a more even balance of
colors across the composition.

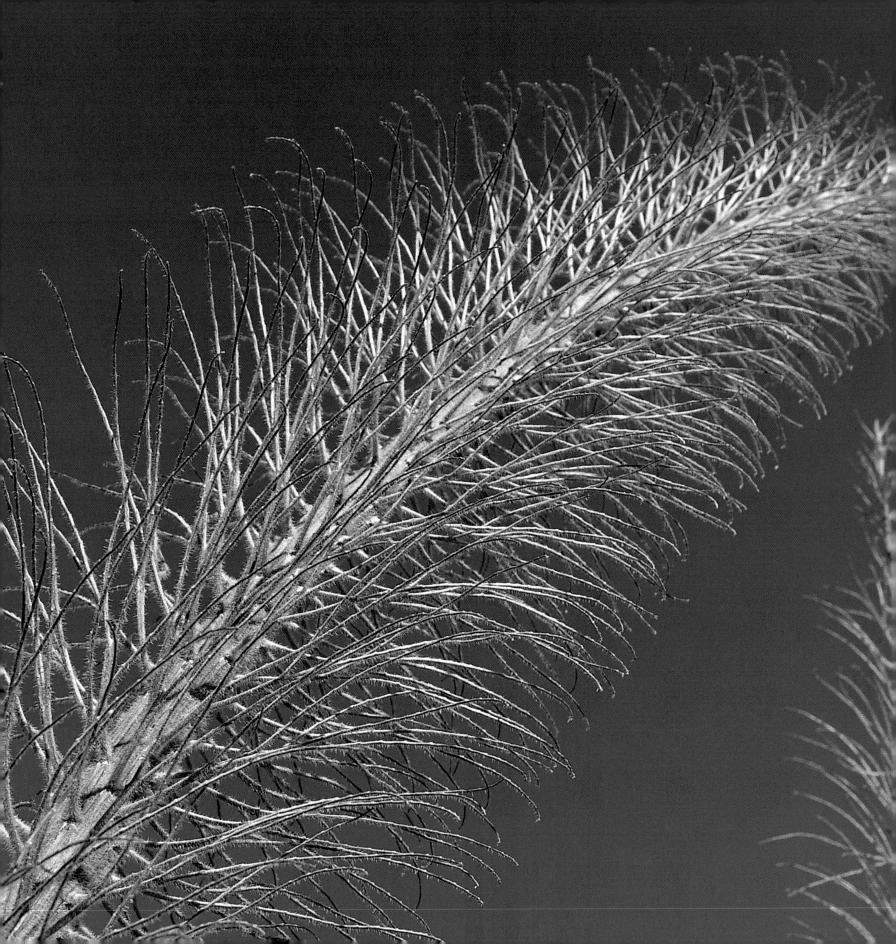

Focal length and image magnification

In close-up photography, the lens works like a low-power microscope because it forms a magnified image. Photographers use the term 'magnification ratio' to describe the relative size of image and subject. When a lens is focused at infinity, and extension is zero, the magnification ratio is insignificantly small. Measured at the film plane, the image of a tree in a landscape setting is obviously only a tiny fraction of the actual tree. Macro photographers regularly operate with magnification ratios in the range of one-fifth life size (magnification ratio of 1:5), through life size (1:1), to sometimes three or four times life size (3:1 or 4:1). It is useful to have a rough guide for calculating the extensions needed to produce a range of magnifications, and this depends on the focal length of the lens being used. Selection can be made by applying the following rule. To achieve 1:1 magnification, a lens needs to be extended by an amount equal to its focal length. Thus, a 50mm lens requires 50mm of total extension, a 100mm lens requires 100mm of extension, and so on. Part of this extension comes from the in-built focusing screw of the lens itself, the remainder must be obtained by the addition of extension tubes. For very long extensions, say two or three times the focal length of the lens, the infinitely variable extension bellows is preferable. This is a bigger investment, but brings the added advantage of enabling the entire camera body/bellows/lens assembly to be mounted on a tripod at its exact point of balance. This may be a critical consideration for eliminating camera vibration during high-magnification work.

The focal length of the lens affects not only the extension required to achieve specific image magnifications, but also the working distance in front of the lens. A larger working distance results from using a lens with a longer focal length and this may be a distinct advantage when dealing with live subjects, such as insects or small mammals, which react to the presence of the camera. A longer working distance also reduces the risk of casting the shadow of the lens barrel onto the subject when the sun is low in the sky and directly behind the photographer. But there are also disadvantages to working with a longer focal length lens in the close-up range. Focusing becomes much more critical, and any vibration of the lens is more likely to cause image blurring.

These considerations place a premium on using a very sturdy tripod, and severely curtail the circumstances under which one can rely on hand-held shooting. Even at the best of times, for example when shooting in full sunlight and using wide apertures, it is still preferable to use a tripod, but occasions do arise when a picture can be made either at once, spontaneously, or not at all. To invoke another rule of thumb, to avoid motion blur using a hand-held camera, the slowest shutter speed that should be selected is that closest to the focal length of the lens. Thus, in the case of a 100mm lens, you should shoot at 1/125th of a second or above. This rule, however, applies primarily to distance photography; with close-up shooting it is just about possible to obtain a sharp image of a profile of a large grasshopper using a shutter speed of 1/60th of a second on a 50mm lens. Even then, it's preferable to have your hand supported by a stable surface. But it is an unavoidable fact that, in any given light conditions, an inverse relationship will prevail between shutter speed and f-stop setting. So, using a fast shutter speed to expedite a 'one-off' shot of a fleeting subject inevitably sacrifices depth of field. The result can be disappointing, but photographic film is relatively cheap, and making mistakes is the food of learning.

Left Skeletal stems of dead giant bugloss (*Echium wildpretii*) photographed on a mountainside at 2,500m (8,250ft) altitude. The camera was tilted upward to contrast the bleached stems against the deep blue sky overhead.

Overleaf Wild Nasturtium (*Tropaeolum majus*) flower photographed in the Teide National Park in Tenerife. The weather had been dull and rainy, and I was drawn to the silvery veins showing through the droplet that had collected on the leaf.

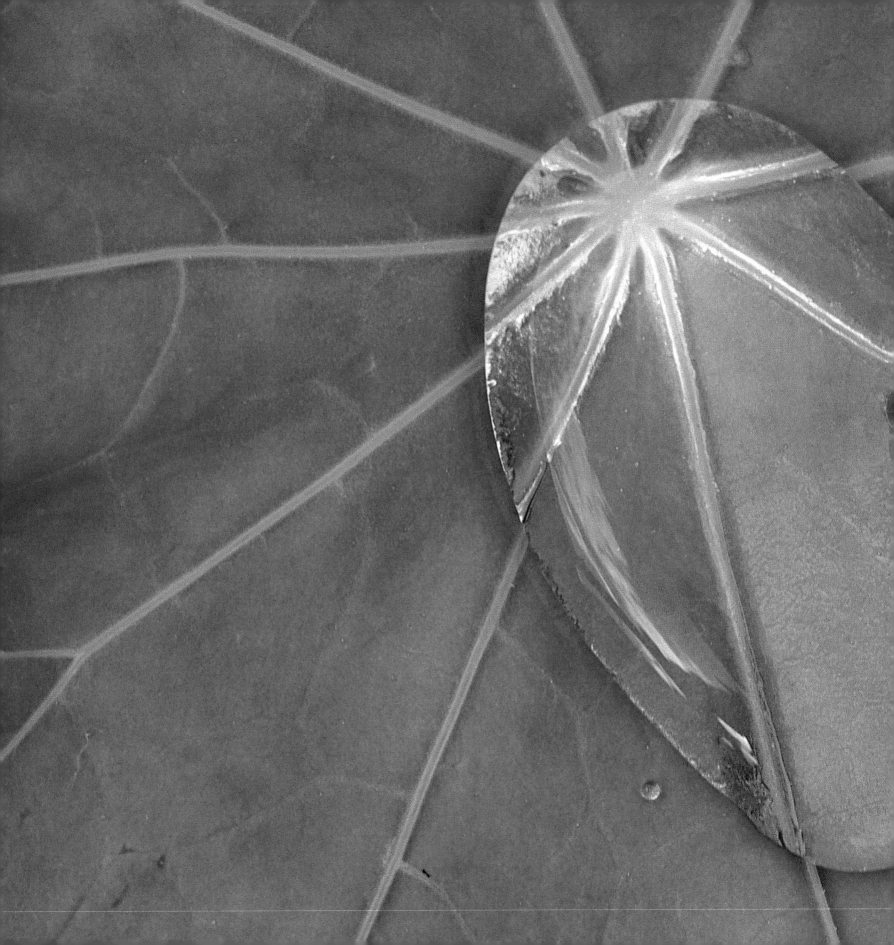

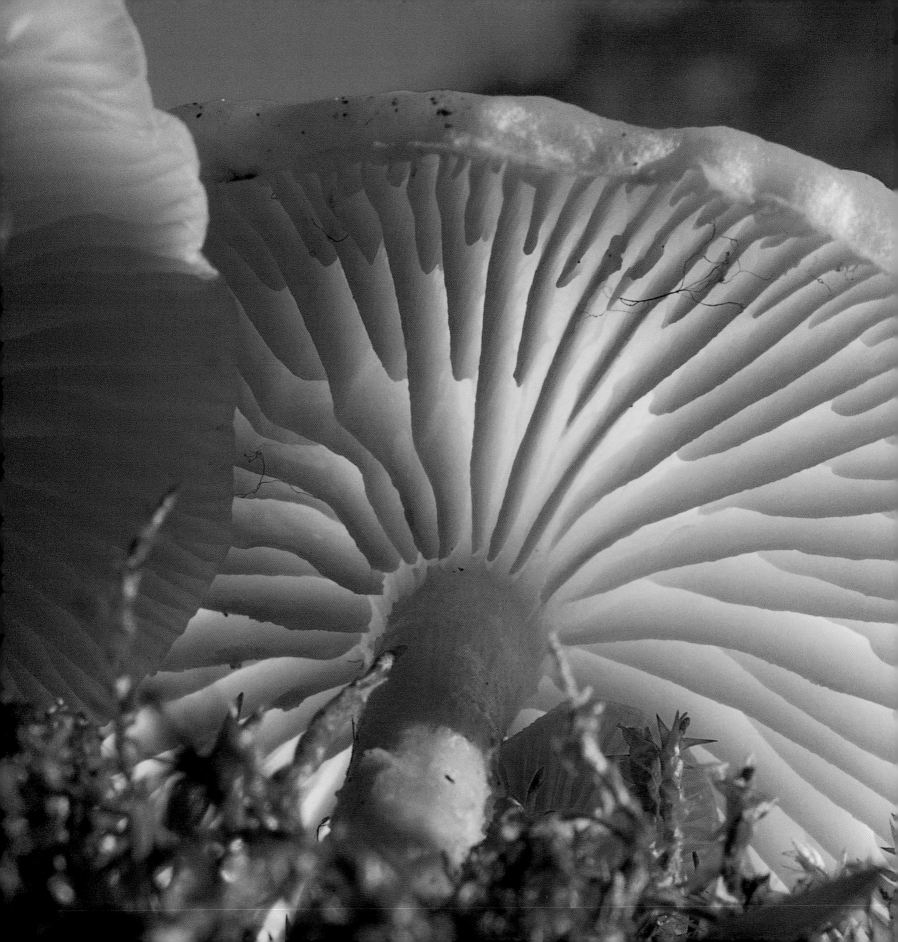

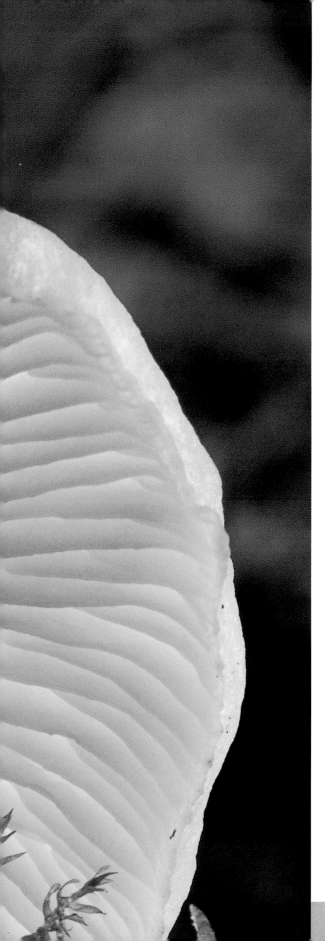

Left Toadstool. Here I focused
in very close on the delicate gills
on the underside of the plant.
The translucent quality of many
fungi allows the effective use of
back lighting.

Macrophotography and depth of field

Depth of field is one of the most difficult areas to deal with
in macrophotography and, in wrestling with it, one wonders
how it is that if our eyes can see close-up objects in focus
throughout their depth, why it should be so difficult for
the camera to do the same thing. The truth is that we only
think we can see the whole subject in focus at once because,
subconsciously, the lenses in our eyes are constantly
refocusing from back to front of the subject. Some animals
and birds automatically stop down their irises as they
scrutinize small objects at close-range, precisely to overcome
this limitation. Most objects viewed at the macro level are
three-dimensional and, whether we are talking about the
aperture of a camera lens or the iris of a human eye, the lens
has to be stopped down hard to f16, f22, or even f32, in
order that the subject remains in focus throughout its
depth. With cameras, as life, robbing Peter to pay Paul
has its price, thus increased depth of field can be obtained
by hard stopping down of the aperture, but at the expense
of cutting down the amount of light entering the lens.
Hence, the requirement for much longer exposures.

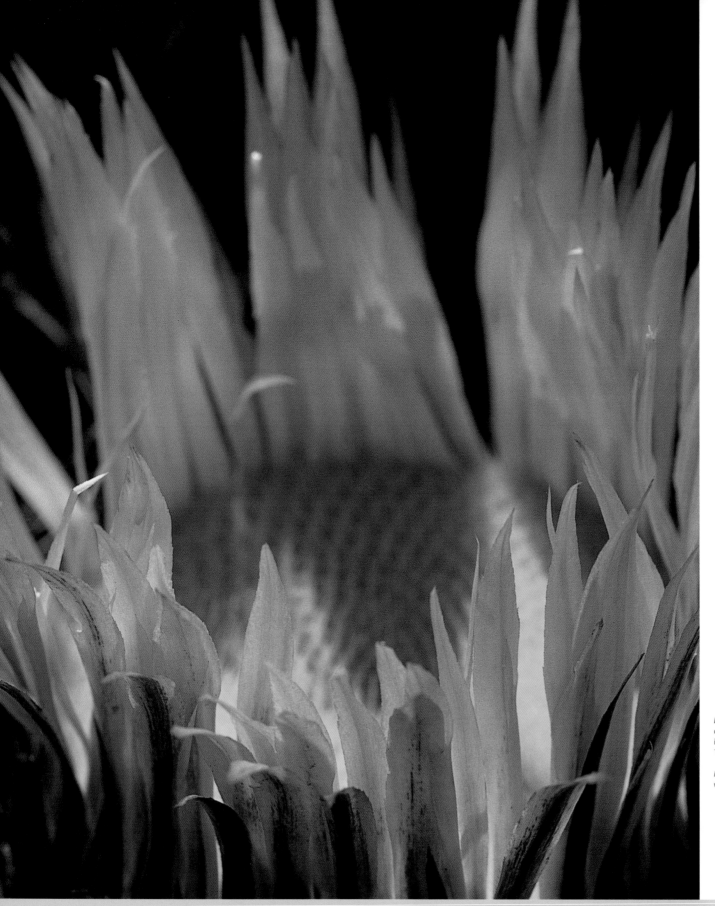

Left "Ring of flames" effect of a carline thistle Carlina acaule viewed in extreme close up. Ambient light, 1/30th of a second, Pyrenees.

Right Composition of carved wooden masks and a glass jar.

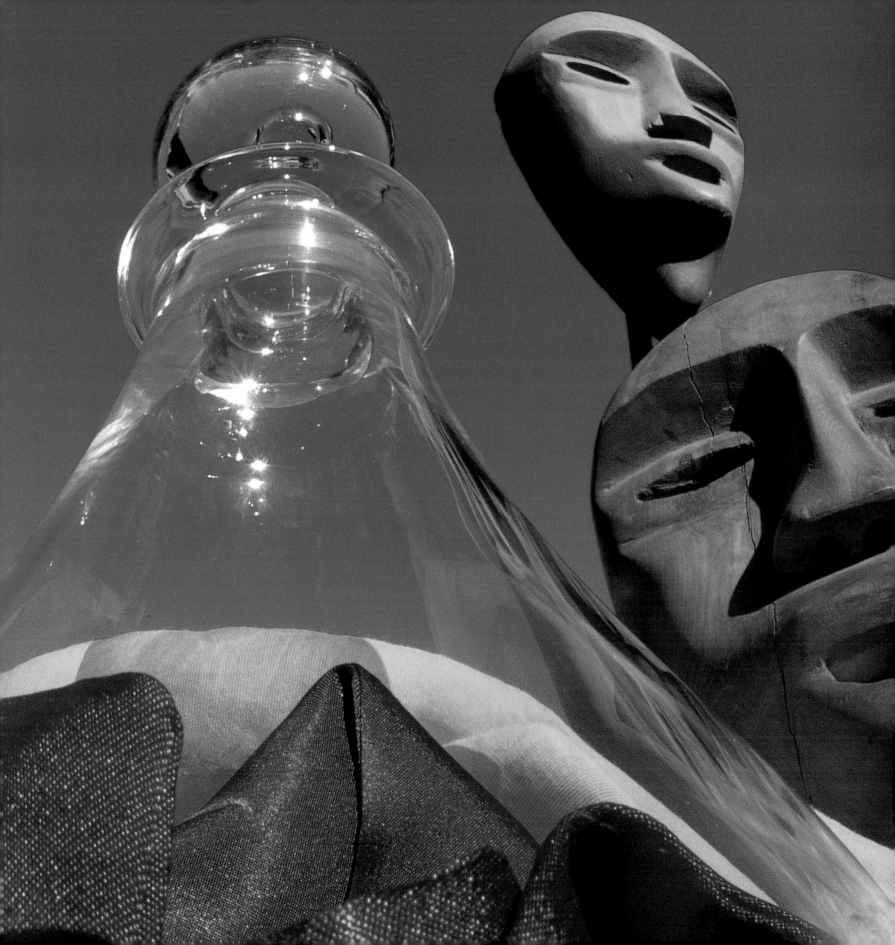

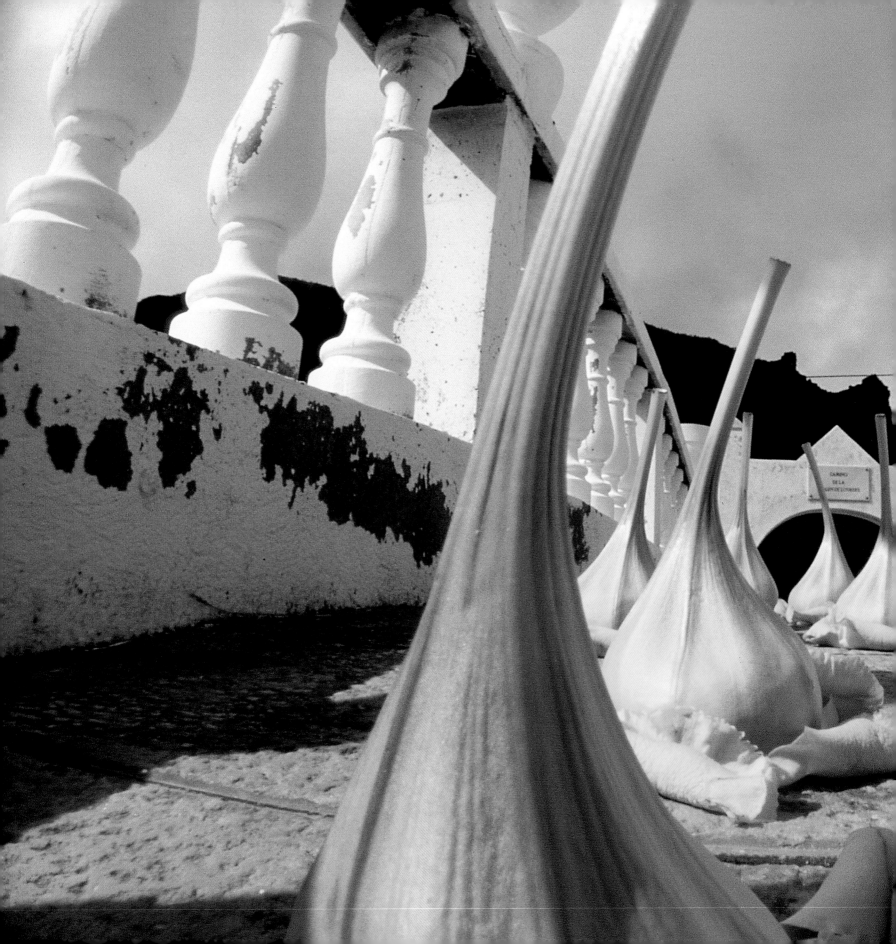

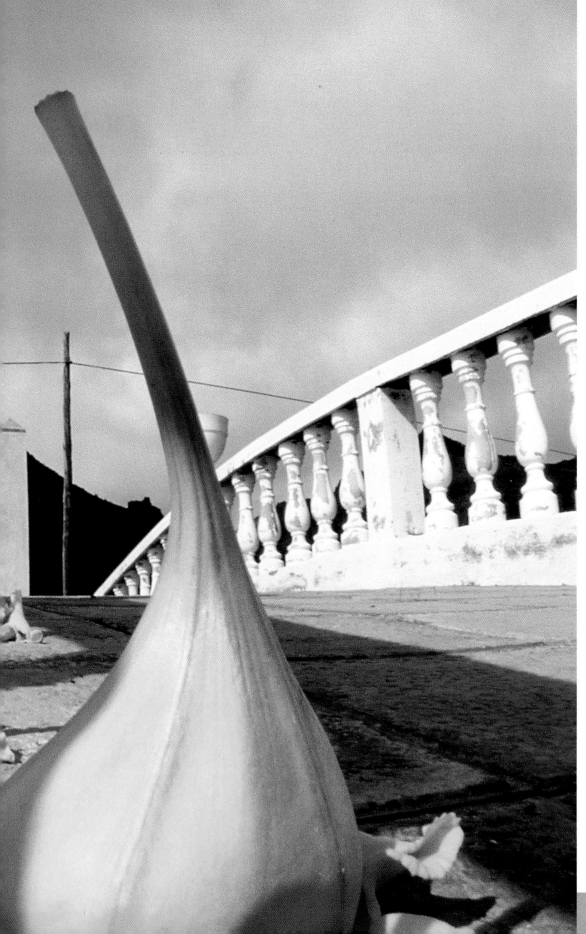

Left Composition of Chalice lilies
(*Solandra maxima*) arranged on a
humpback bridge.

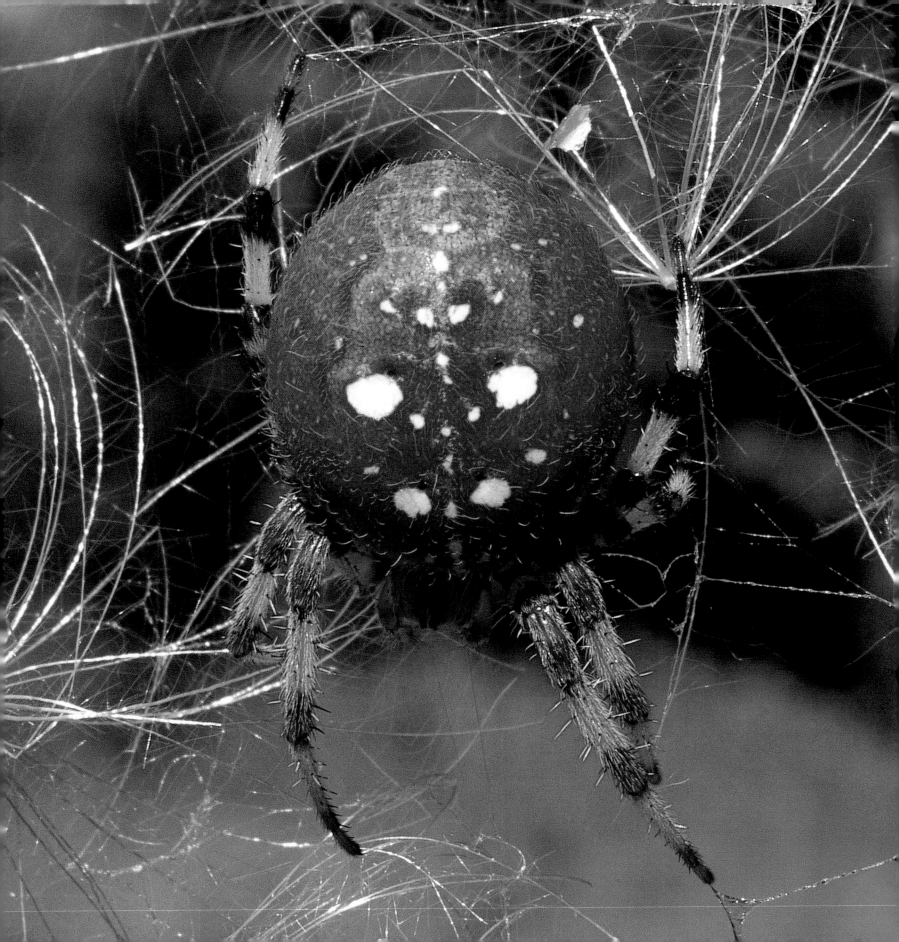

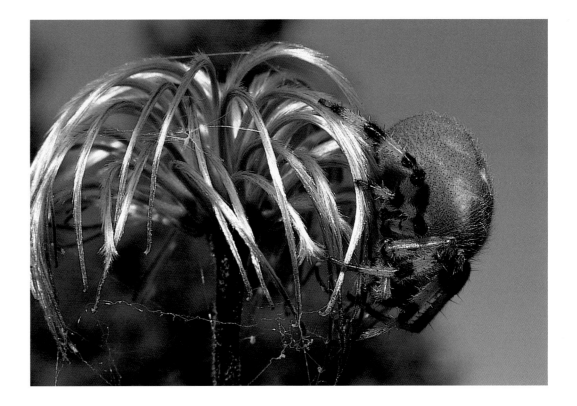

Critical focusing

To foray into the world of light rays, when the lens is very close to a subject, the cone of rays entering the lens from a point on the far surface of the subject is narrower than the equivalent cone from a point on the near surface. Each plane of the object therefore focuses at a different plane on the rear side of the lens. The result is an infinity of image planes only one of which, if the lens is not stopped down, coincides with the film plane. With critical focusing, the photographer can select exactly which plane of the subject projects onto the film plane, but he cannot do this for all of them simultaneously; unless, of course, the lens is stopped down through the aperture. Now, as you can imagine, the most divergent rays that hit the outer part of the lens—the points farthest from its center—are cut out, leaving most of the light to take the straightest course through the middle of the lens, and all points on the subject begin to come to a focus in the one plane behind the lens.

In absolute terms, the depth of field of a highly stopped-down lens working at high image magnifications is still very limited. At life-size imaging, stopping down to f22 or f32 may only generate depths of fields of 2–3cm (¾–1¼in). This is more than adequate to accommodate the thickness of the body of a butterfly viewed in profile with closed wings—in fact an f-number of f5.6 or f8 is all that would be required in this case—but it would barely cope with the same insect viewed in profile with fully opened wings. Both wing tips would exceed the zone of sharpness and be out of focus. Common sense would suggest a change of angle, perhaps to shoot the insect from above instead. In field conditions, the close-up photographer constantly juggles these considerations.

The photographer is also exquisitely aware that every tiny movement will be exaggerated on the film plane. At this microcosmic level, close to the surface of nature, the breeze never seems to stop dead. You are crouched over the viewfinder, finger poised on the shutter button waiting for the brief one-or-two-second window when the breeze halts. You learn that the breeze has a rhythm; it will breathe in and then out, and that, between, you have a pause. Miss it, and you may have to wait another five minutes for another tantalizing hiatus.

Left and right Fall is a good time for photographing web-spinning spiders because by now the dense summer vegetation has died back and the spiders are much more visible. The specimens shown are *Araneus quadratus*, or garden spiders.

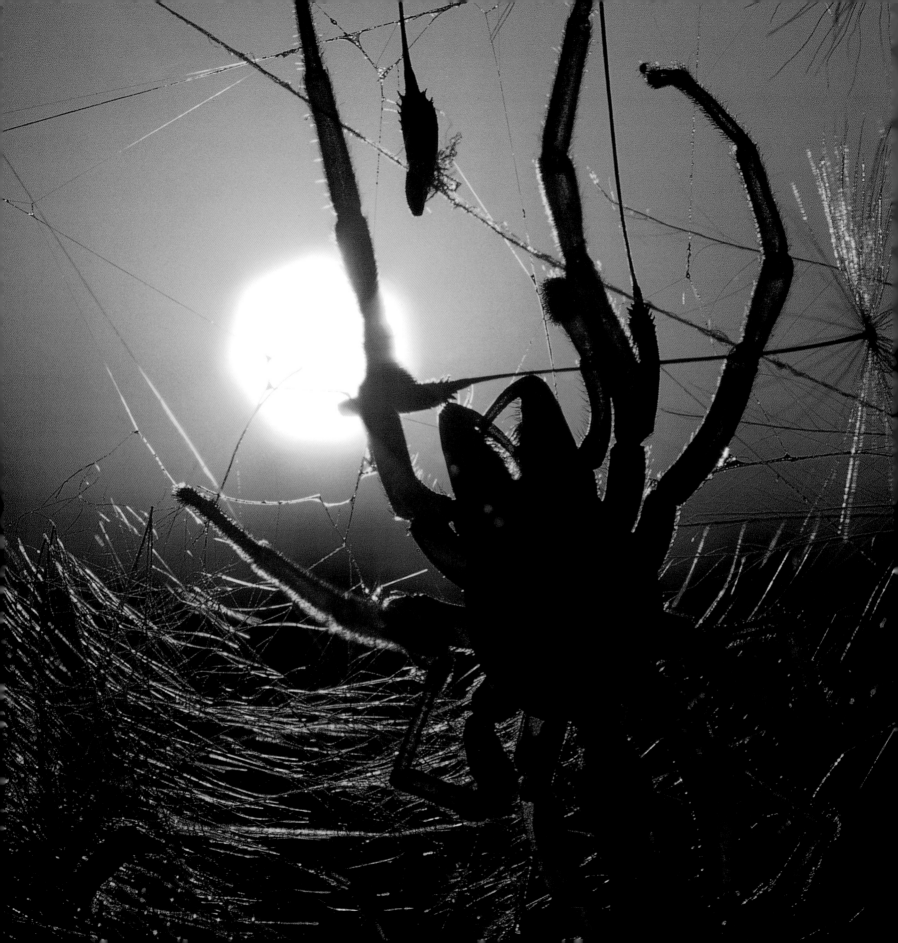

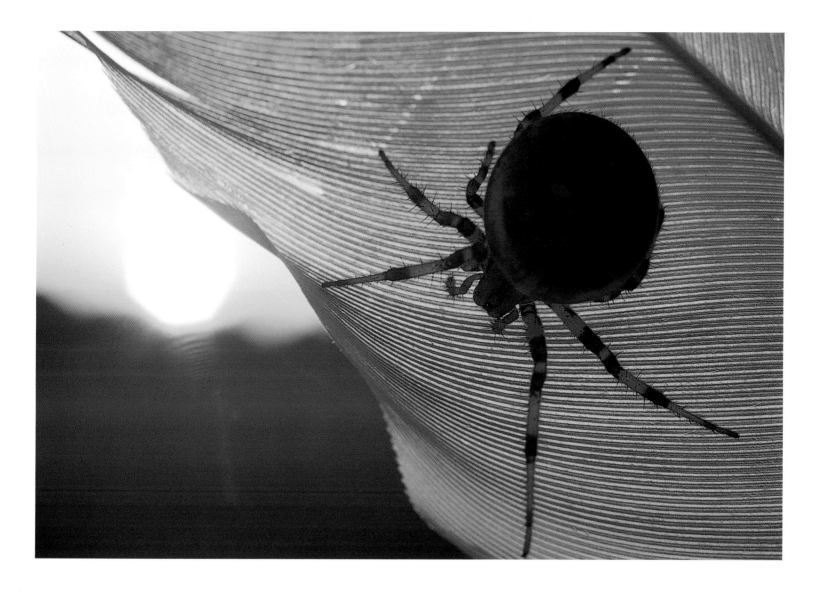

Left This particular spider (*Dysdera crocata*) was found dead in the web of another species. I lined up the camera so that the setting sun was nearly behind the creature's jaws.

Above Orb spider on feather photographed against the setting sun in late fall.

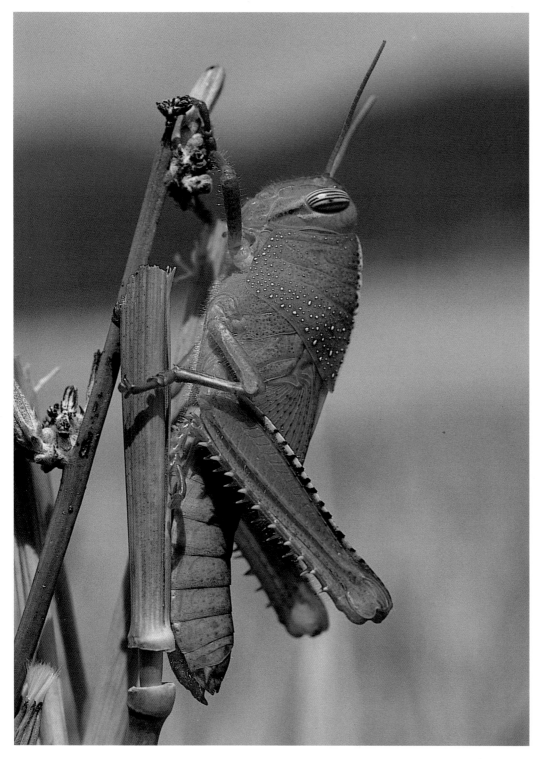

Getting creative

If I have portrayed depth of field as a difficult taskmaster, I would like to remedy this by asserting that it is not really the case. In macrophotography, narrow depths of field can be used to great creative effect. Telephoto lenses are ideal for delivering very narrow depths of field, even when used at high f–numbers, and this feature makes them especially popular with portrait, fashion, and bird photographers. Such lenses flatten—and flatter—the human face by compressing perspective and ironing out blemishes, and they also isolate the subject from potentially distracting backgrounds. These qualities nicely illustrate two important elements in the aesthetic of photography. First, subjects are usually perceived in relation to their environments, and, second, the way a scene is interpreted by the human eye defies simplistic analysis. Instinctively, the eye searches for contradiction or juxtaposition in the composition of an image. These qualities are indefinable in technical terms. For example, to return to depth of field, on the surface it may seem a contradiction that by reducing the physical depth of field of an image you can succeed in creating an impression of greater spatial depth. But the pictorial center in the human brain is not a slave to the literal image that the eye delivers to it. When the mind perceives out-of-focus elements in a picture it does not proclaim, "ah, limited depth of field, that's terrible!". It is more likely to respond to the effect with: "I like that sense of motion" or, "that impression of space creates a sense of calm". All of which brings me to another important element in photography. Technique is of little use if you have nothing to say.

Left Egyptian grasshopper (*Anacridium aegyptium*). This grasshopper is common throughout Europe and North Africa, and was photographed in bright sunlight. By viewing the insect in profile I was able to use a large aperture (f8), which gave adequate depth of field but also allowed me to shoot hand-held at 1/60th of a second.

Right Caterpillars of buff-tip moth (*Phalera bucephala*) feeding on leaves.

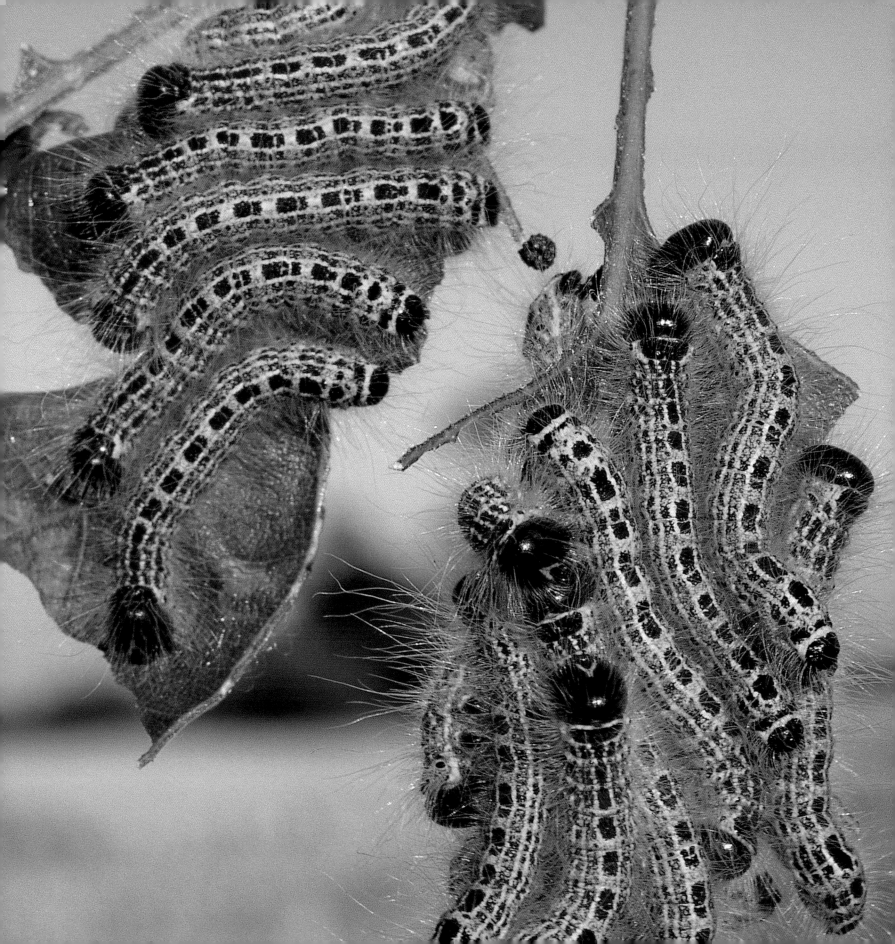

Developing your personal style

Photography is not just about reproducing nature; it involves interpretation. This does not eliminate the need for correct exposure, fine-focusing, and pleasing composition, but interest, imagination, and—on occasion—passion, also play a part. And, once a modicum of technique has been mastered, these forces begin to dominate. Even though close-up photography does not wrestle with the human condition in the way that portraiture and documentary photography do, it still demands that the photographer express his or her personal style. Pictures which may lack something technically may still contain other, sometimes surprising, elements which compel the eye and the imagination. And each picture is simply a useful point in the process of learning. Photography is a craft which thrives on learning from mistakes. Just remember not to show your bad pictures to other people.

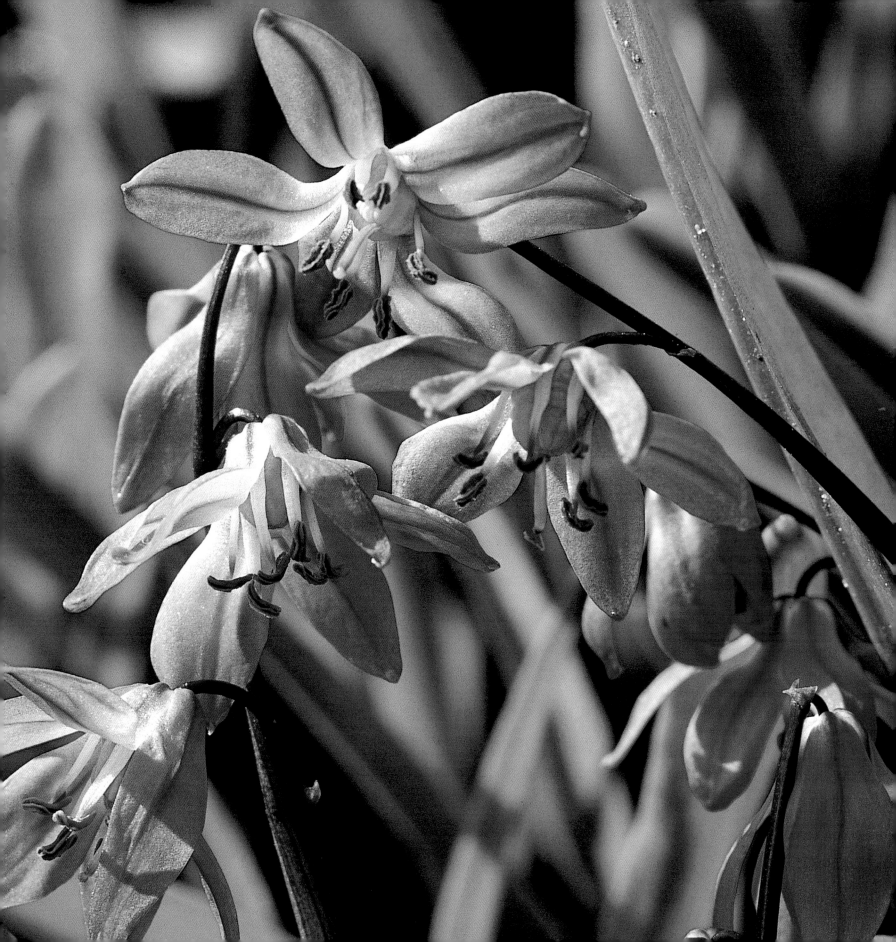

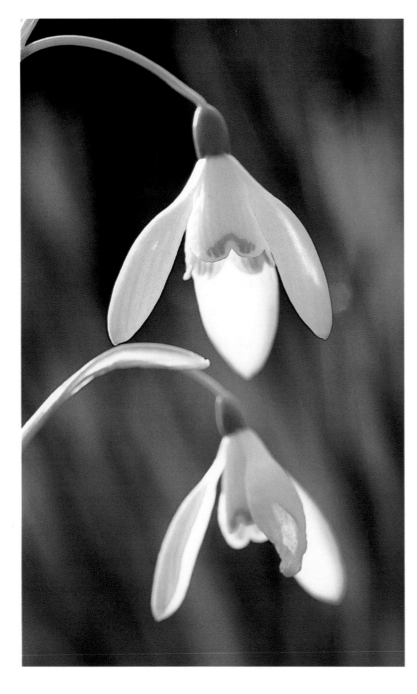

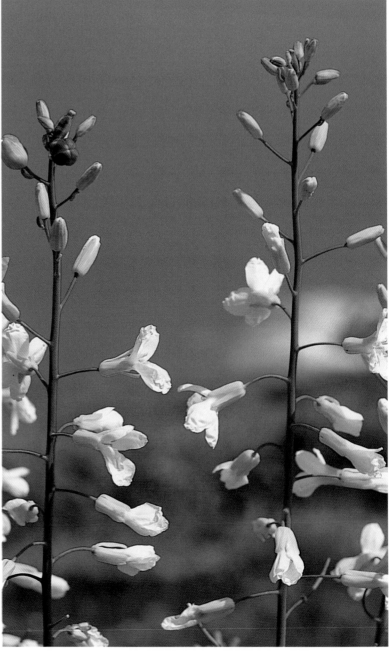

Above left Snowdrops
(*Galanthus nivalis*).

Above right Wild radish flowers.
What interested me about this
composition was the pattern of
cool complementary colors:
white, green, and blue.

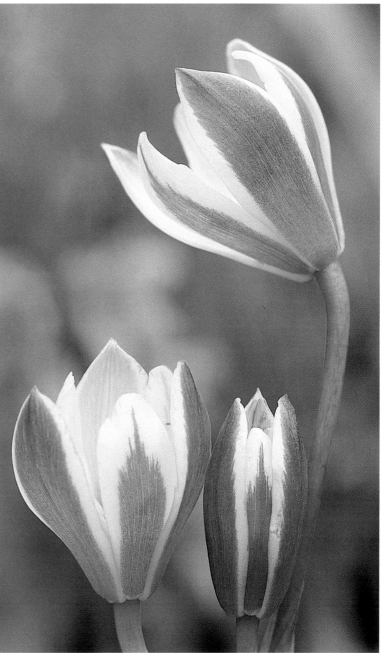

Above left I was interested in the unusual shape and color of these primulas. I deliberately selected a shallow depth of field to throw the background flowers out of focus.

Above right Star-of-Bethlehem (*Ornithogalum*). These were photographed in dull conditions, which demand slow shutter speeds, but avoid the risk of harsh background shadows that can result when flowers are photographed in bright sunlight.

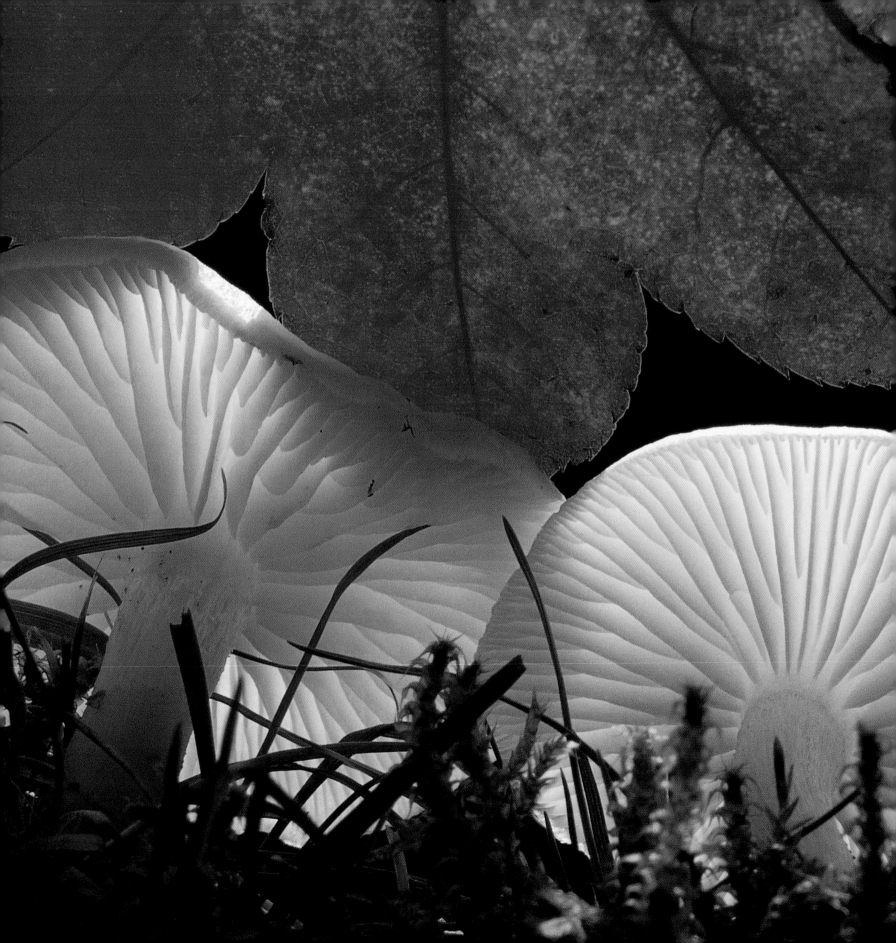

Exposure and lighting

If I were granted a single wish as a photographer, I would choose patience
above all. Without it, all the photographer's accumulated skills are of little
use. When little crises arise, patience is the first to unravel. If a photographer
has never felt the need to hurl his camera at a brick wall, he has either
not tried hard enough, or he has already been granted this one wish.
Patience is key for two reasons: partly because of the time involved to set
up a picture, but also, and importantly, because nature imposes its own pace
and rhythm. When you need time, nature hastens; when you are in a hurry,
nature slows down.

Left Fungi in fall, shown in
back-lit conditions.

For my second wish, I would choose an eye in the back of my head, to keep a check on the sun as it races helter-skelter across the sky, constantly altering the angle of the light falling onto my subject. If questioned, I imagine that portrait, landscape, and architectural photographers might have a similar view. In photography, you need to think ahead and visualize the final image in your head long before you press the shutter release. I cannot stress enough the benefits to be gained by using the stop-down lever, a simple device on the camera body that allows you to preview the image at a selected f-stop number. This operation provides important information about the depth of field of the picture and the texture of the background, but what a single lens reflex (SLR) camera cannot do is confirm correct exposures. Of course, digital cameras allow you to check within seconds of making a trial exposure. Either way, this facility is one of the few features of automation that an aspiring close-up photographer will find useful. Manufacturers of automatic cameras boast that they free the imagination by letting the camera take care of all the "mechanical" decisions. In fact, with close-up photography, the reverse is true, and nothing could be more irritating than a battle between you and the computer behind the viewfinder.

Taking a picture, even a simple picture, is always a challenge, and more experienced photographers than I concur that you only get out of a photograph as much as you put into it. Happy accidents do sometimes occur—those moments when you look at a picture that you have taken and wonder "where did that come from?". It may seem like an accident, but in reality you have spent years subconsciously preparing for it. I have taken pictures of insects frozen in flight which could all be described as happy accidents, but it took two years of preparation for the first one to happen. A close-up photograph can be taken by following a simple set of rules which very soon become second nature. Let's take a flower, for example. Suppose that the weather is dull, with little wind. The conditions may not sound auspicious, but in fact nature has been kind. Granted, you will have to choose a very low shutter speed, which means using a tripod, but, as the results will show, subdued light brings out floral colors to much greater effect than bright sunshine, which encourages contrasty shadows and burnt-out highlights.

Right Sage beetle.

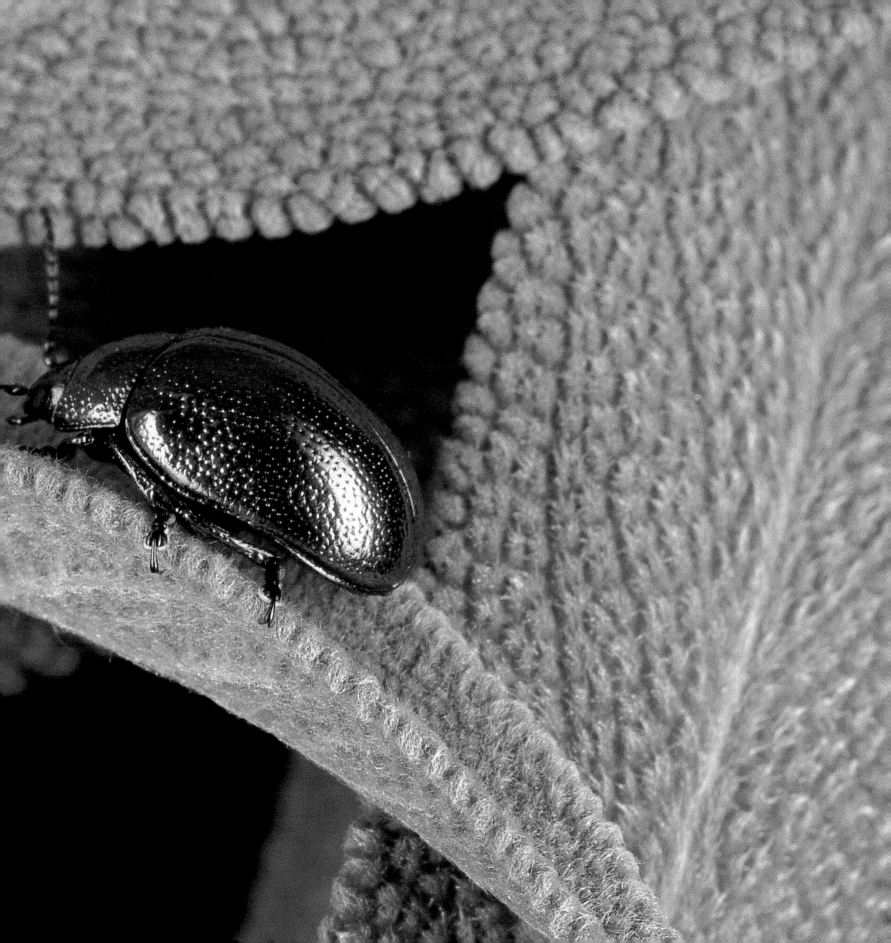

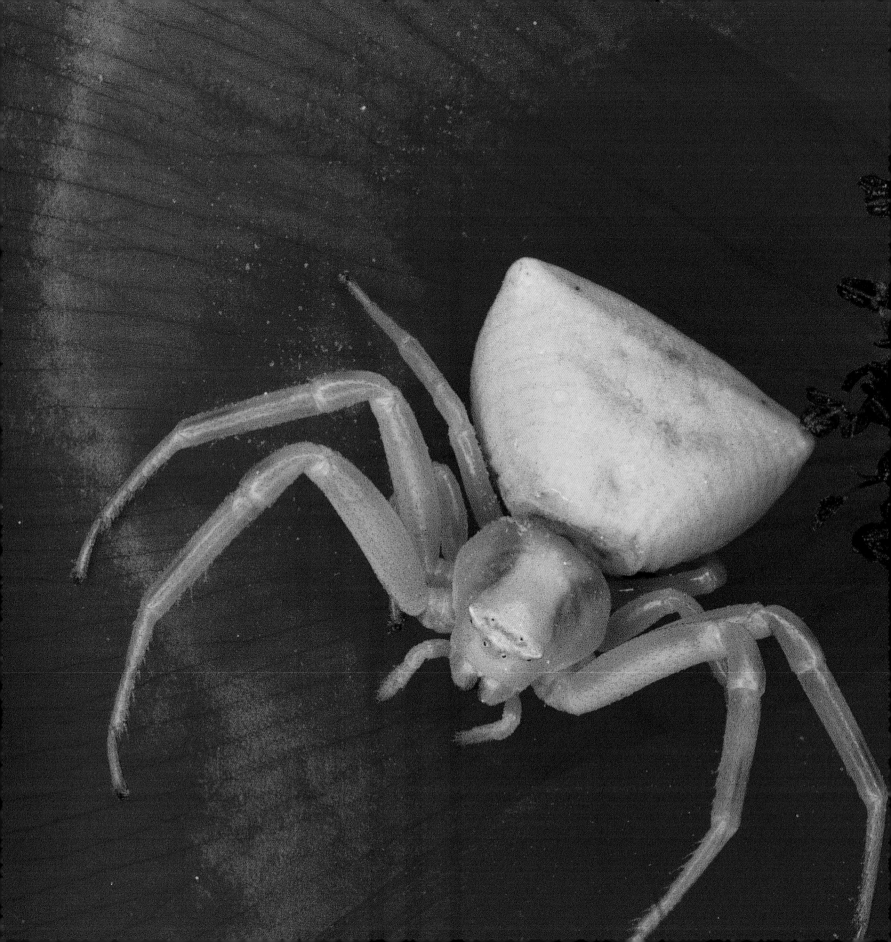

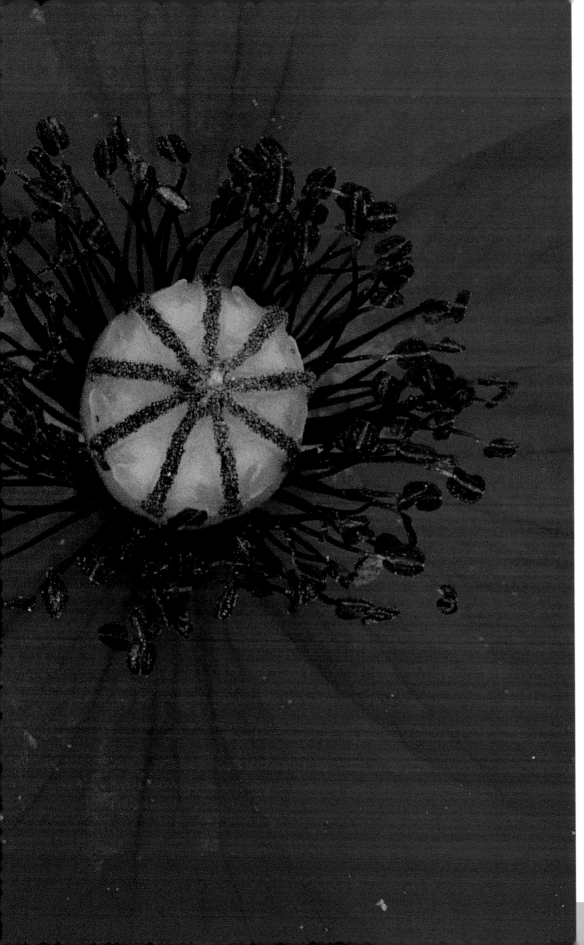

Left Flower spider (*Misumena*).

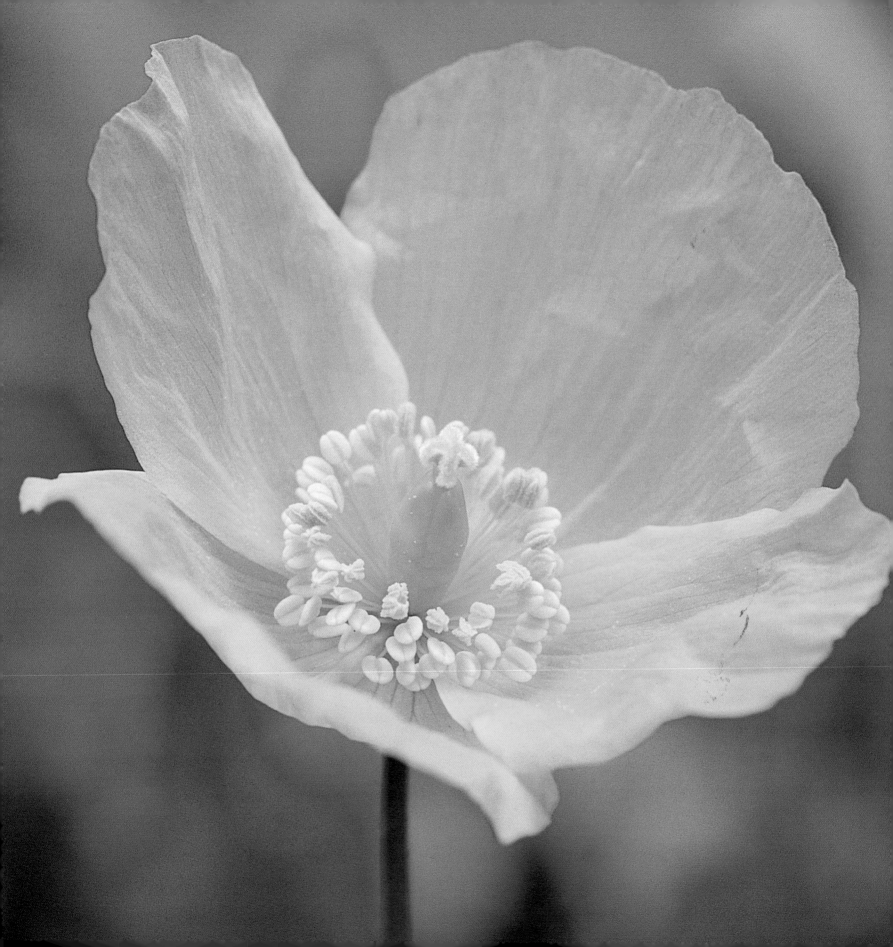

Filling the frame

Once your exposure, shutter speed, and f-stop setting have been taken care of you can start focusing in on the subject. So, the next question is: how close do you need to be? Photojournalist luminary Robert Capa said that if pictures are not good enough, it's because you are not close enough. Modern compact cameras, with their super wide-angle lenses, ensure that 95% of all family snaps fall into this unhappy category, and yet the solution is straightforward—step closer. Likewise in close-up photography, make sure that the subject fills the frame. In the example we have taken, filling the frame may produce a very satisfactory portrait of a flower but try focusing even closer; you may find that a more interesting composition of floral parts, colors, and other details begin to emerge which you were not aware of with the naked eye. You are now experiencing the magic of close-up photography: a world of discovery through the lens. The viewfinder is a window onto an endless range of possible compositions, all offered by the same subject, and the more you learn to experiment with it before committing the shutter button, the happier you will be with the final image.

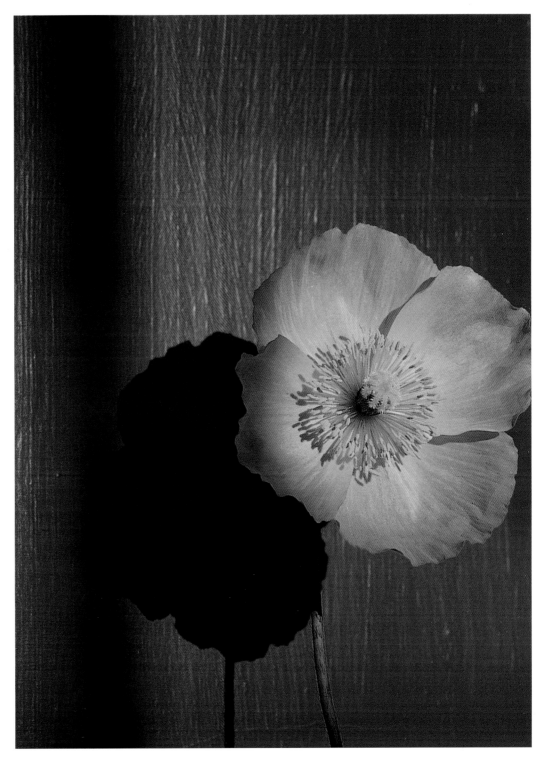

Left and right Yellow poppy (*Meconopsis cumbrica*). Like most brightly colored flowers, yellow poppies are prone to bleached-out highlights when photographed in sunny conditions. This can be avoided by using low, evening light or dull light on wet, overcast days.

Seeing the world with new eyes

The secret of photography lies in learning to see the world through a frame. Close-up photography makes this more of a challenge; we are not used to setting our sights so close to the surface of the material world. As babies we are born naturally short-sighted and become skilled at examining objects very closely but, as we grow older, we lose the habit. However, after spending several years scrutinizing pictures of insects frozen in flight through high-speed flash, I can now observe an insect flying in the wild and see, unaided, the motion of its wings slowed down. I discovered from a visit to the British Museum in London that, centuries ago, Chinese watercolorists seem to have acquired the same trick. The wings of their beautifully illustrated butterflies show twists and ripples that modern high-speed photography is only just beginning to discover. I can only imagine that their work is the result of intensely close study and a great deal of patience.

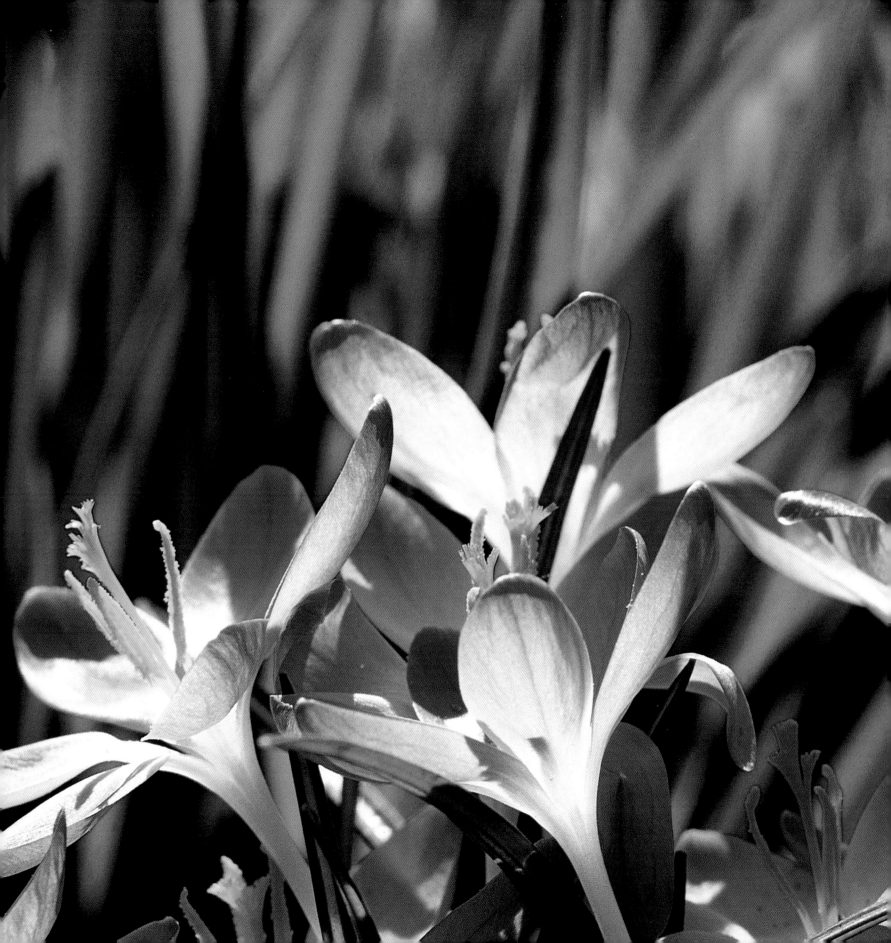

Floral considerations

With flower subjects, before you make an exposure, keep a watchful eye on the exposure meter reading indicated in the viewfinder. As you focus the lens closer, and the image of the flower grows gradually bigger in the viewfinder, so the meter reading progressively falls. If the exposure setting that you had made at the outset was correct, before you started focusing in, you will now find that it leads to an underexposure of perhaps one or two stops. Part of this drop in light level may be accidentally due to the changing pattern of light and dark areas in the frame as the image of the flower begins to fill it. But the main reason is simply that the scale of the picture is altering. When a small object, such as a flower, is viewed through the camera at a distance, the light from it falls onto only a small area of the film—in other words, the area occupied by the image of the flower. As the lens closes in, the image of the flower begins to occupy an increasingly large area of film space, but the amount of light falling on this area has not changed: the subject is neither more, nor less, bright than it was at the beginning. In fact, the light from the subject is being spread more thinly across the film. Hence a flower that may have been correctly exposed at infinity, is now underexposed at the given camera settings. The lens should now be opened up by one or two stops in order to ensure the correct exposure again. In practice, you are likely to prioritize aperture rather than shutter speed, so the extra light required would be obtained by adjusting the latter.

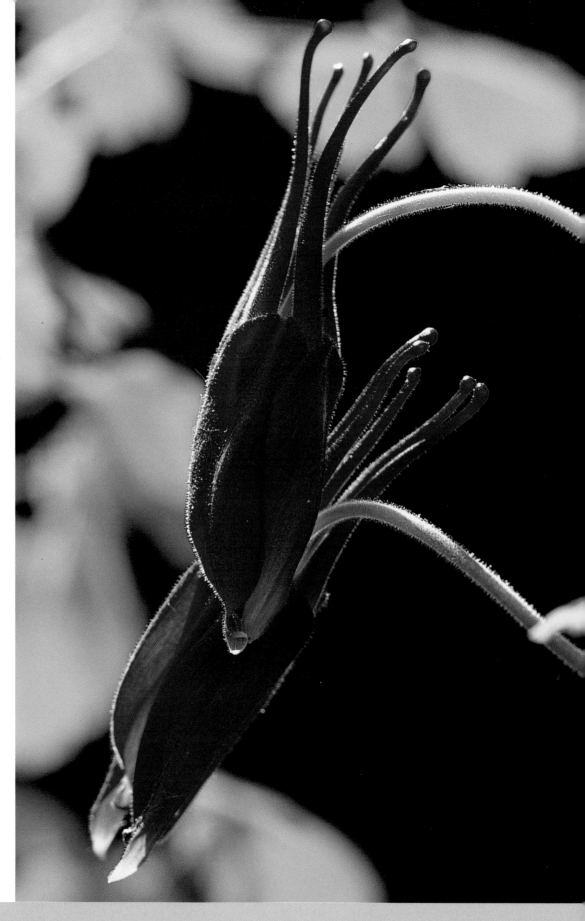

Left Columbine flowers (*Aquilegia* sp.) shown in back-lit conditions.

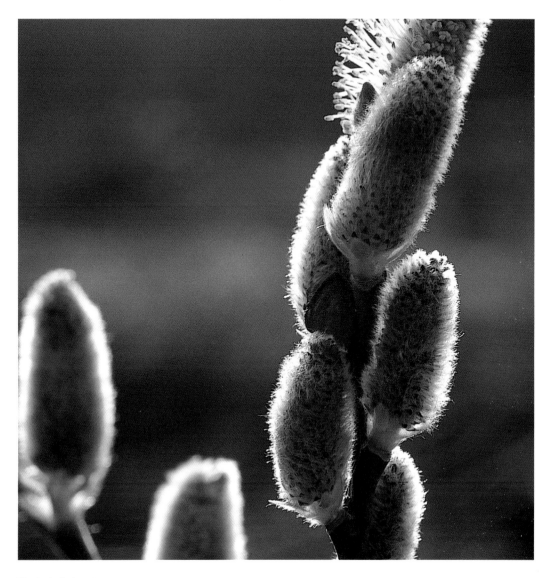

Faith and science

While I have written one or two discouraging things about camera automation, I do have a lot of faith in through-the-lens (TTL) exposure meters. It would be very difficult to carry out the adjustments that I have just described without them. Some practitioners still prefer to use a hand-held exposure meter, and while that may give a slightly more accurate measure of ambient light levels, it cannot perform the compensations necessary for close-up work, which the camera meter does automatically on the basis of the actual amount of light coming into the lens onto the film. There is a way of calculating this additional light requirement using a simple formula—and I hasten to add that anyone innocent of mathematics will not be immeasurably poorer by choosing not to read the argument that follows—but, if you do, it will help you to better understand exposure.

The technical part

The rule is that an image magnified by amount M needs $(M+1)^2$ more light for correct exposure than would have been the case if it had been viewed at infinity. Close-up photographers often find themselves working at image magnifications of $1/4$, $1/2$, or even 1. By inserting these fractions into the above equation, the light requirement is roughly 1.5, 2, and 4 respectively. This is the equivalent of opening up the lens by a half stop, one stop, or two stops respectively. In the unlikely circumstance that you find yourself on location with a functioning hand-held light meter but a camera whose battery has failed, you would still be able to take a successful close-up picture. Exposure meters work on the assumption that the object or scene from which the light is being collected is of a neutral gray color. This is the basis of the Kodak Graycard which can be used as an ideal reflector to calibrate the exposure meter.

Exceptionally bright or dark objects easily fool the meter into under- or over-estimating the value of the required exposure, and stray shafts of light, or glare from highly polished surfaces, regardless of their color, can send the meter rocketing off the scale. The simplest solution—in the case of a bright flower, for example—is to take a reading from something with a more muted color, either adjacent foliage or a nearby road surface, being careful not to alter the original focus setting of the camera. These adjustments can only provide an approximation because the "best" exposure is a subjective quantity, governed by the distribution of light and shade across the picture as a whole, and not only by the brightness of the object in the forefront. Since it is impossible to predict perfect exposures in advance with an SLR, good practice suggests bracketing plus or minus one or two stops, in half-stop intervals.

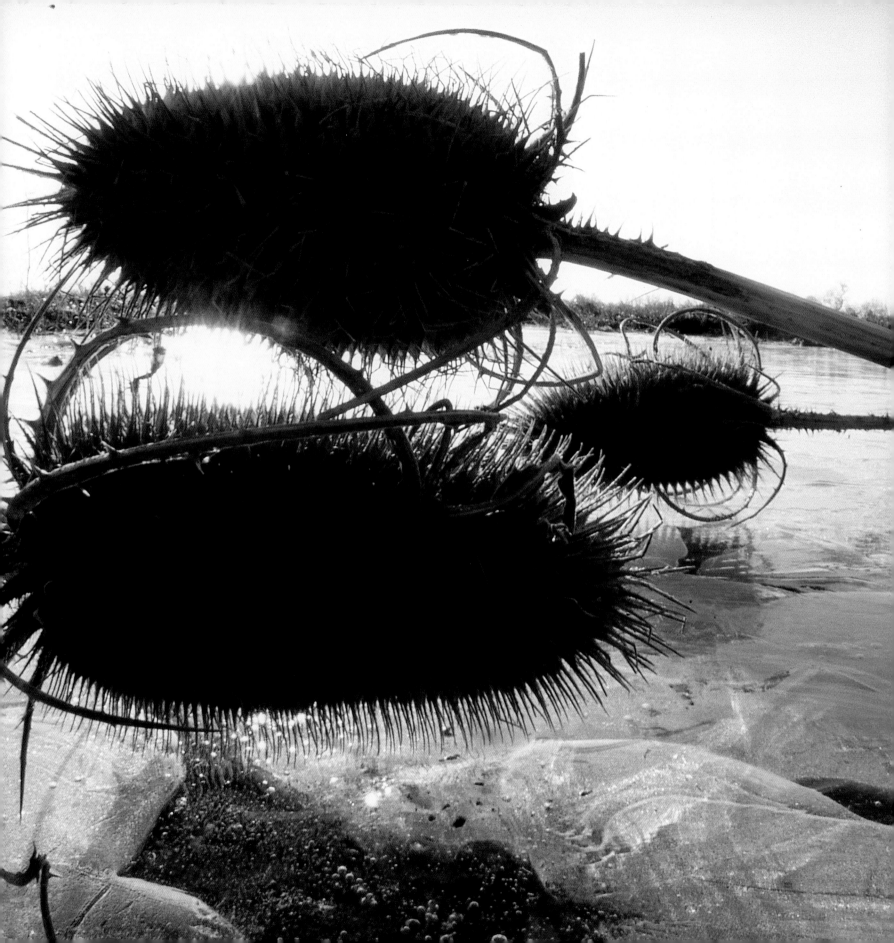

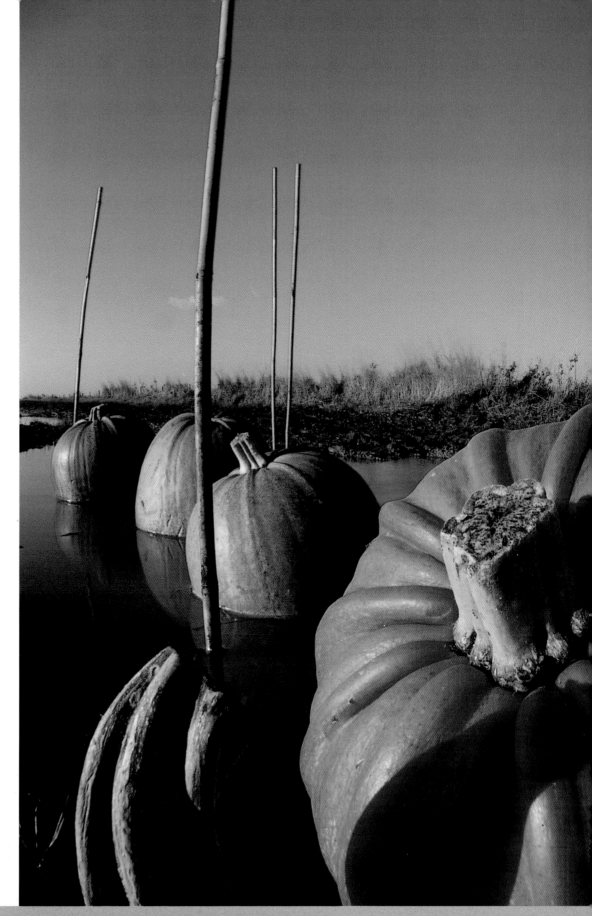

Left Teasel heads (*Dipsacus laciniatus*) photographed late afternoon on an icy winter's day.

Right Composition of pumpkins and canes.

The speed of light

Earlier I alluded to the photographer's love–hate relationship with nature. Plant specialists, for example, will recognize the frustration of waiting for the wind to drop before they can take their picture. An even greater test lies in wait for those who attempt to photograph insects. Whenever an insect spots an approaching photographer, it colludes with the elements to undermine him. The Scylla and Charybdis of the photographer's plight are that when the weather is dull, the insects remain still, but there is not enough light to photograph them; when the weather is fine there is glorious light aplenty, but the insects are pulsating with activity. A feeding butterfly may not look especially animated from a distance, but through the macro lens its body is a series of starts and quivers which render photography at conventional close-up speeds impossible. This presents a dilemma, because a picture of a colorful butterfly going about its business may be more interesting than a nicely composed portrait of the same creature sullenly clinging to a grass stem on a damp day. One way to cope is to use flash, which is essentially daylight speeded up; it has the same spectral characteristics as daylight but delivers as much of it in 1/250th or 1/500th of a second as the sun and sky would normally deliver in half a second. In my opinion, the handiest form of flash for macro is ring flash, which can be fitted directly onto the end of the lens, thus bringing the light very close to the subject. Since the light source is bigger than most macro subjects, it bathes them in non-directional light and eliminates the harsh shadows that might be created by a conventional flash gun held remote from the subject. Its main disadvantage is that, if fitted to a lens of short focal length, it reduces the working distance. And really close subjects may become isolated in the "cold spot" in the middle of the flash, and underexpose.

Right Leaves of caper-spurge (*Euphorbia lathyris*) shown in back-lit conditions.

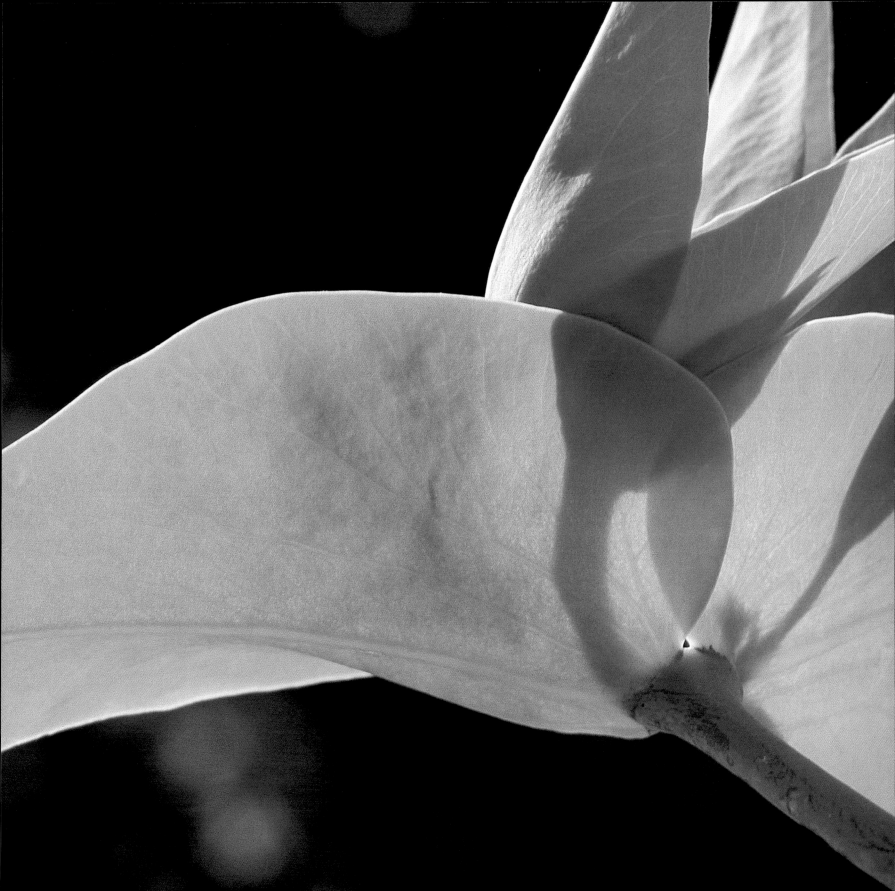

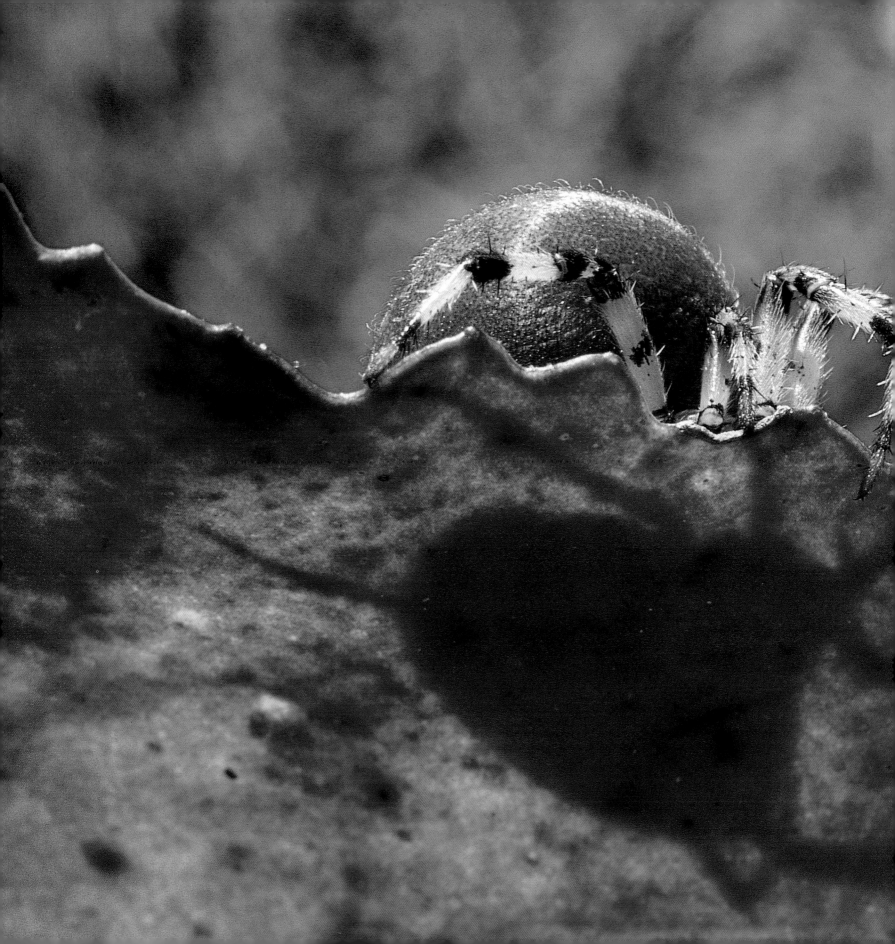

Sources of light: natural versus artificial

Ambient light levels vary greatly depending on the time of day, the weather, and location. Another factor may be air quality; clear skies over mountains and windy, subtropical islands may contain clearer light than desert skies which, although proverbially lit by a blistering sun, are often suffused with a milky haze. Subjects receive their incident light directly from the sun's disc, or indirectly from the sky and by reflection from the ground. High reflection can be expected from glowing sand, bleached desert rocks, and snow-covered ground, whereas dense vegetation absorbs most of the incident light. The darkest vegetation also contains the darkest shadows because there is little internal reflection. The different contribution of the sun's disc and the sky to illumination on the ground is immediately apparent in the shadow of a standing person. The shadow is lit only by the sky and, although it appears dark when starkly contrasted with the sunlit subject, it still contains a considerable amount of light. Consider the light bathing a room. It has entered the room from the sky via the window, not directly from the sun (except early morning and evening), yet the room is perfectly well lit for normal requirements. The dark shadows outside may actually be brighter than the interior of the house. It is intriguing to think that an astronaut sitting in a similar room on the moon, with a naked sun blazing overhead in the middle of a pitch black sky, would not be able to see well enough unless the windows were set so low in the walls that they allowed light in from the ground outside. Most photographers dislike working with light from a high, midday sun because it creates harsh shadows and bleached colors. These are not always obvious to the naked eye, and the results prove all the more disappointing when the film is processed. A far softer light ensues when the sun becomes covered by a layer of high, thin cloud which helps to disperse the shadows on the ground. Bright, fleecy clouds scudding across blue skies offer a similar function by acting as downward reflectors of the sunlight.

Left A garden spider (*Araneus quadratus*). This image would have been quite ordinary but for the spider's shadow on the leaf.

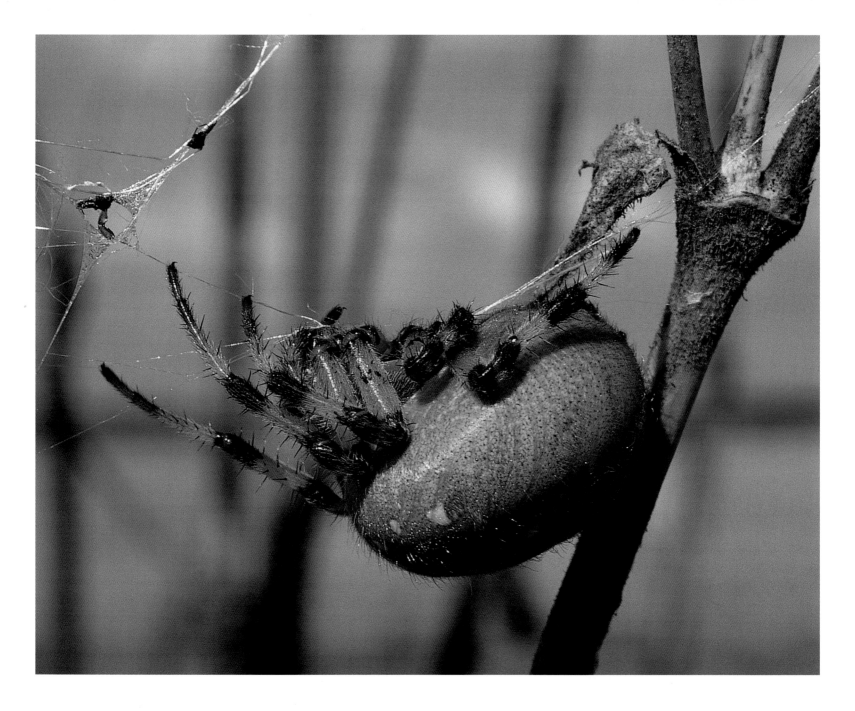

Above Garden spider (*Araneus quadratus*) photographed in flat daylight conditions in early fall.

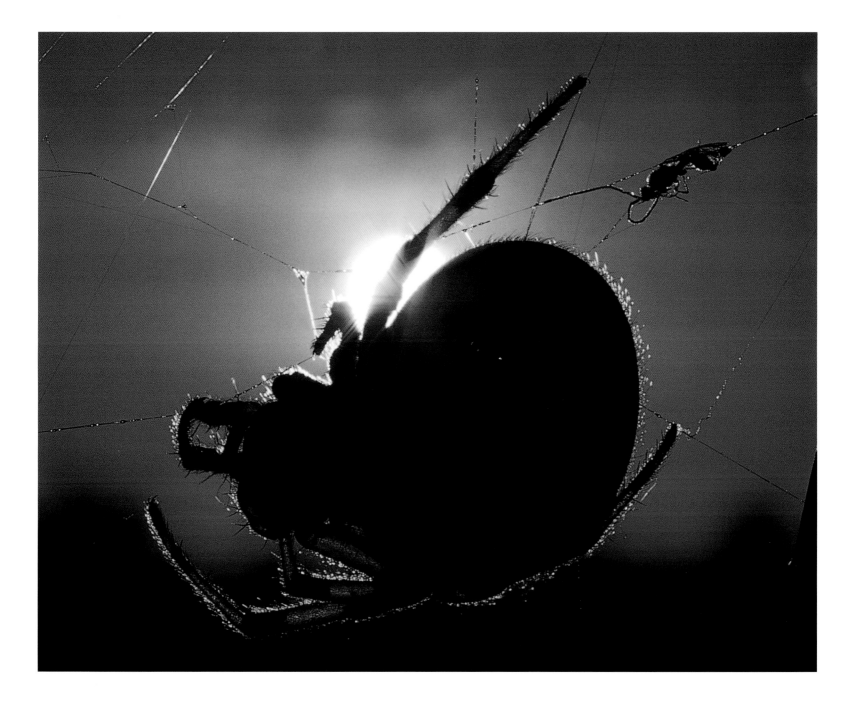

Above Garden spider (*Araneus quadratus*). Taken in early fall when the sun is always low in the sky, offering good opportunities for side or back lighting.

To flash or not to flash?

People divide into two camps over the use of flash. Enthusiasts need no convincing once they have seen the crisp, color-saturated images that it is capable of producing, and in the most ideal conditions it is virtually impossible to obtain the same combination of resolution and depth of field using ambient light. The purists view with distaste the flattening effect that flash imposes on its subjects. For them, it can never reproduce the subtle modeling given by natural light conditions, and it can isolate the subject against what appears to be a black sky. This is the inevitable result of the fact that flashlight falls off rapidly with distance, and any surface beyond 10 or 20cm (4 or 8in) behind the subject is likely to remain unlit. There is no perfect answer because it is a question of different tools being better at doing different jobs. Flash can never convey the elusive beauty of nature with the same subtlety as natural light. On the other hand, for anyone who wants to record the behavior of insects and other small creatures, flash is an obvious choice.

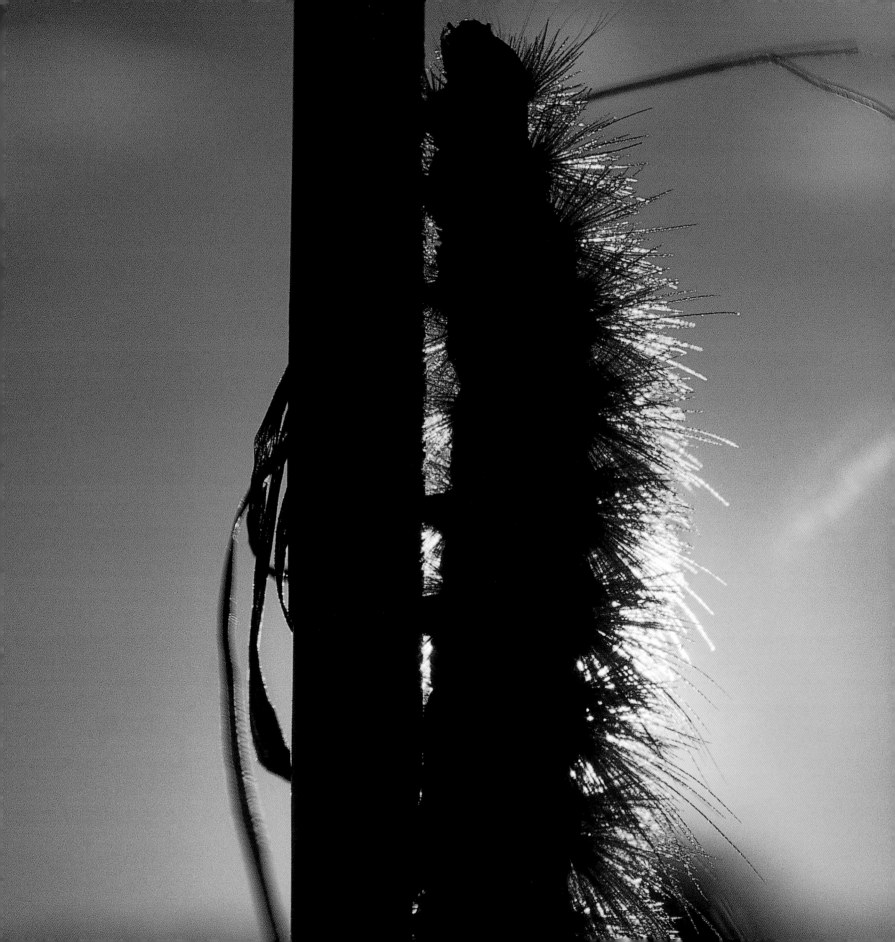

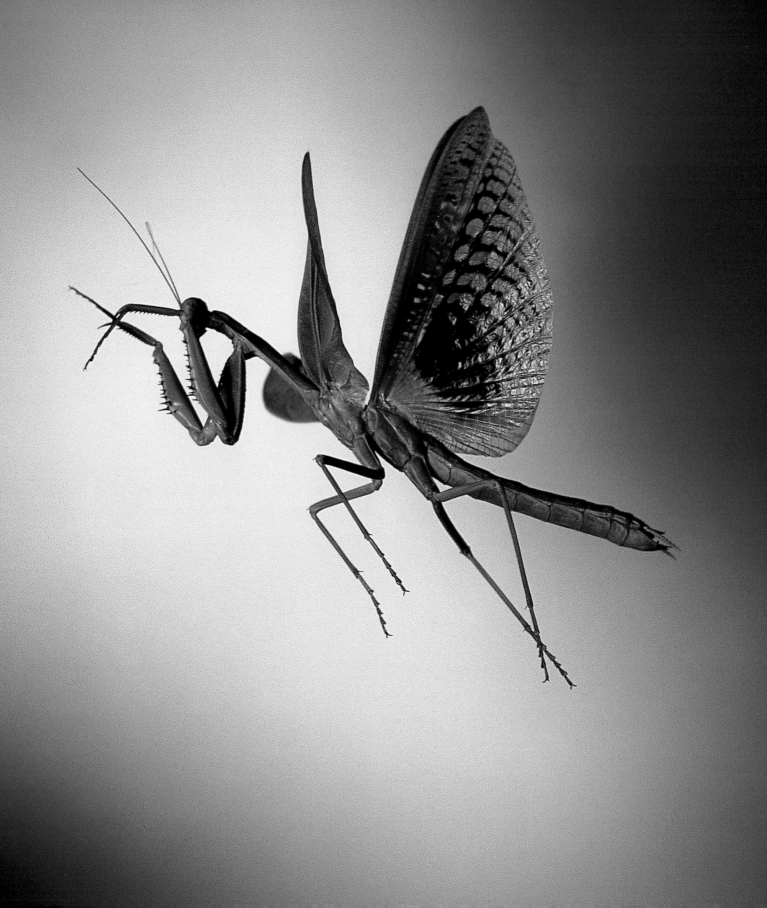

Shooting action in close-up

The subject of vision crops up periodically throughout this book and this is perhaps not surprising. Eyes reveal a lot about a subject, particularly human beings, but also a great deal about the activity and behavior of animals, fish, and insects. Macrophotography offers a unique opportunity to explore this aspect of your live subjects—to really capture a glimpse of the fast-moving interior of their worlds.

Left A mantis (*Iris oratoria*), photographed in flight using high-speed flash. An artificial background was used to create a sense of space.

In the blink of an eye

Capturing a subject close up, and to freeze the action
well enough to obtain a pin-sharp image of it is a compelling
challenge, and one that has often kept me busy for long
periods of time. Whether the subject is a human eyelid, or
an insect in flight, one might imagine that shutter speed is
pretty central, but in fact shutter speed is hardly relevant at
all, since all the light for the exposure will be supplied by the
flash. The flash is so brief it can slot into any reasonable
shutter-speed—1/30th or 1/60th of a second—just as long
as the selected speed is fast enough to keep out stray
ambient light. The real difficulty is shutter-opening time:
the time that elapses between the trigger being activated
and the shutter opening. This must be reduced to a few
milliseconds to catch the action in its tracks which means
using an electromagnetic shutter. This can be screwed to the
front of the lens and opens virtually without delay as soon as
it receives the signal from the photocell detecting the beam.
This shutter will be essential when we examine freezing the
action of flying insects using high-speed flash.

By now we are all familiar with high-speed pictures of
sneezing and coughing subjects, spraying water into the air
like whales. In the deeper recesses of clinical laboratories
researchers have even been known to photograph the
fluttering of tonsils inside the mouths of sleeping patients.
In the fields of technology and machine design, engineers
routinely measure—with the aid of high-speed photography
—the displacements and vibrations of small moving parts
such as spindles, rotor arms, and bearings. Ballistics experts
and forensic scientists document the motion of bullets issuing
from gun barrels, and the patterns they make as they impact
onto their targets. Many of these are far more exacting
applications than the example I have given, and are far
beyond the means of ordinary photographers, but they all
rely on similar methods.

Right A dragonfly (*Sympetrum* sp.)
exhibiting behavior that can be
photographed without the use of
flash. This insect has adopted the
so-called "obelisk" position, where
the wings are swept forward in
front of the head. The picture was
shot in hand-held conditions at
1/60th of a second. The eye,
which appears to be staring at
the photographer through the
transparent wings, adds interest
to the image.

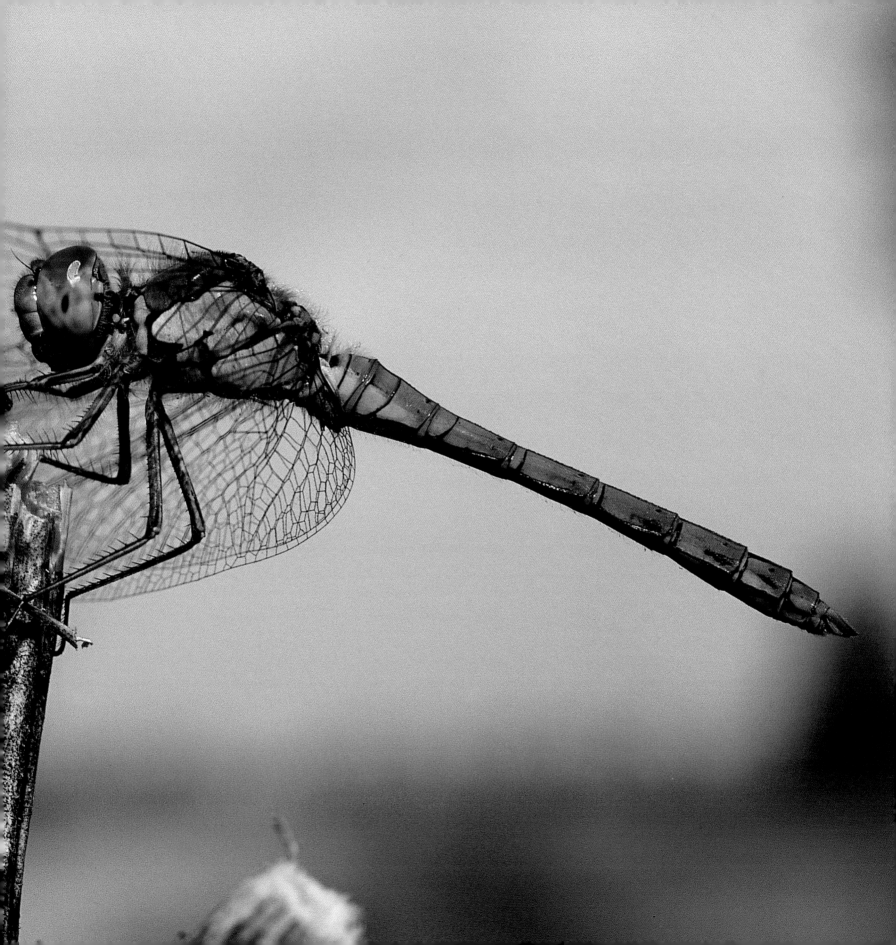

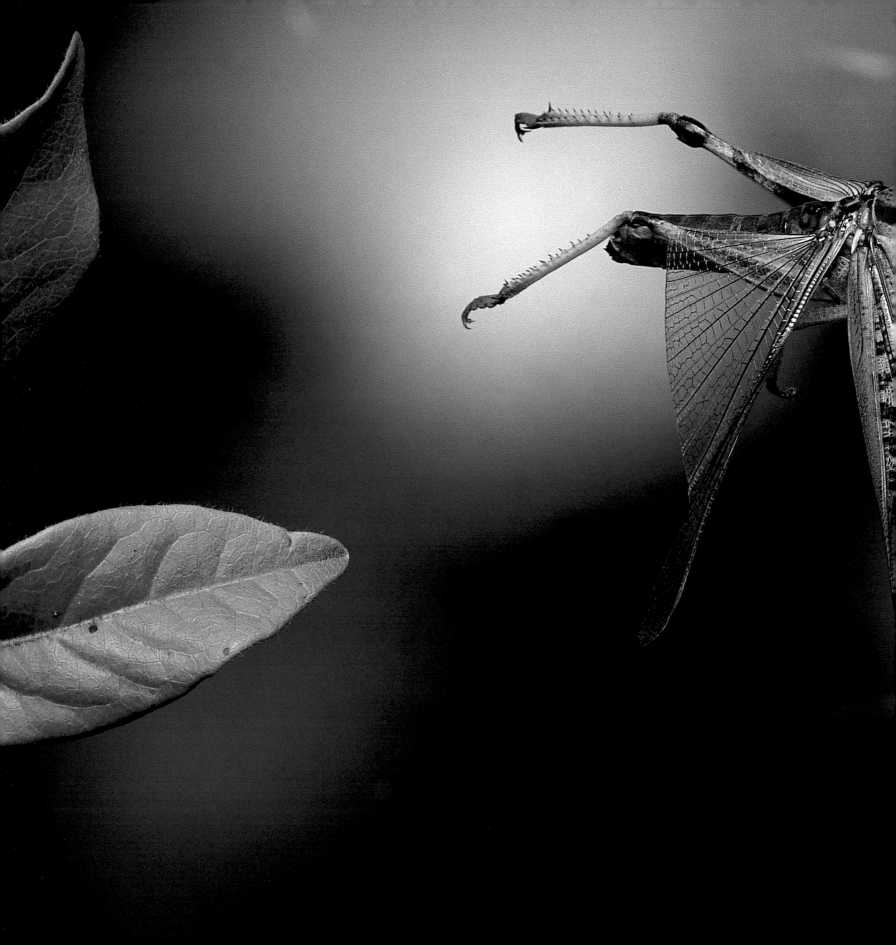

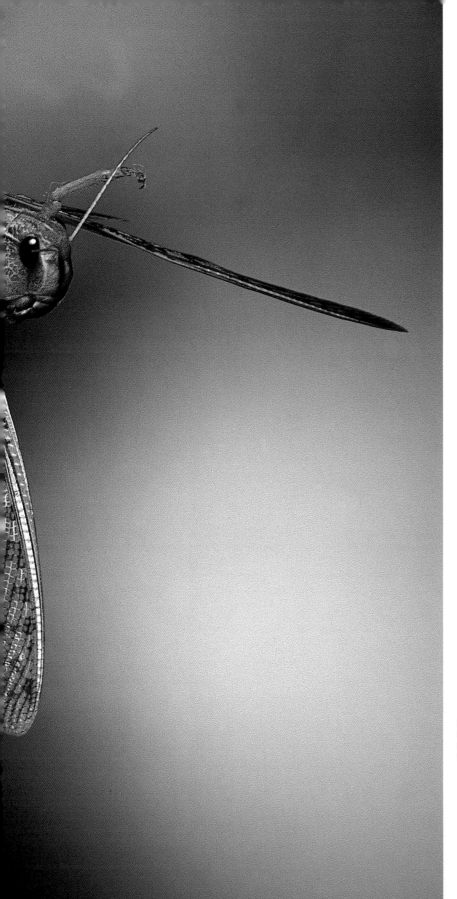

Left A locust, photographed in flight using high-speed flash. An artificial background was used to create a sense of space.

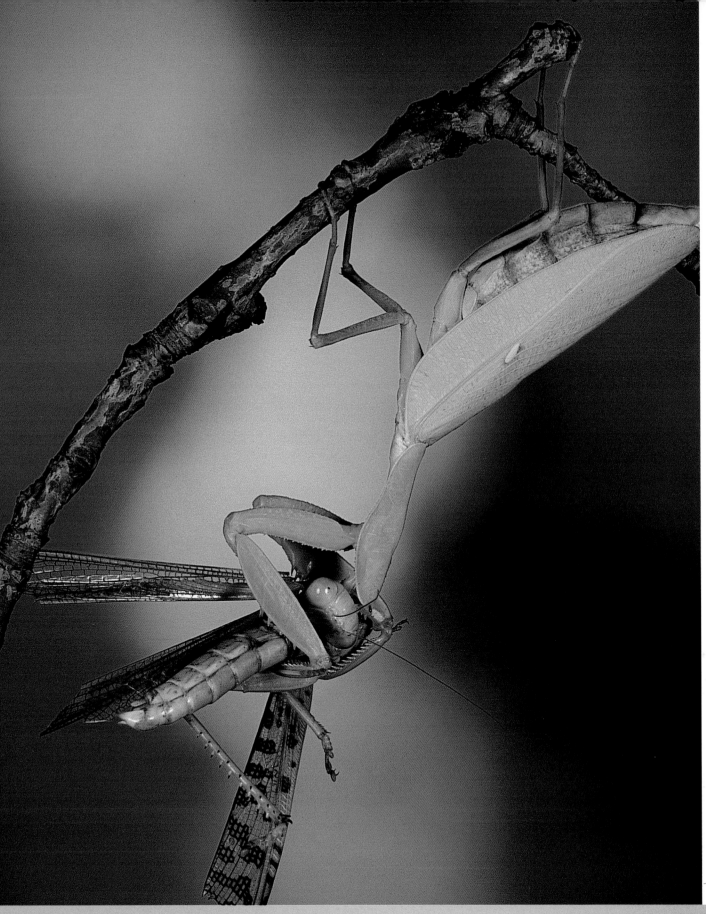

Left The head and body of feeding insects, such as this mantis eating a locust, are constantly in motion, and sharp images can only be obtained by using flash. This insect was photographed against an artificial background which was back-lit using a second flash gun.

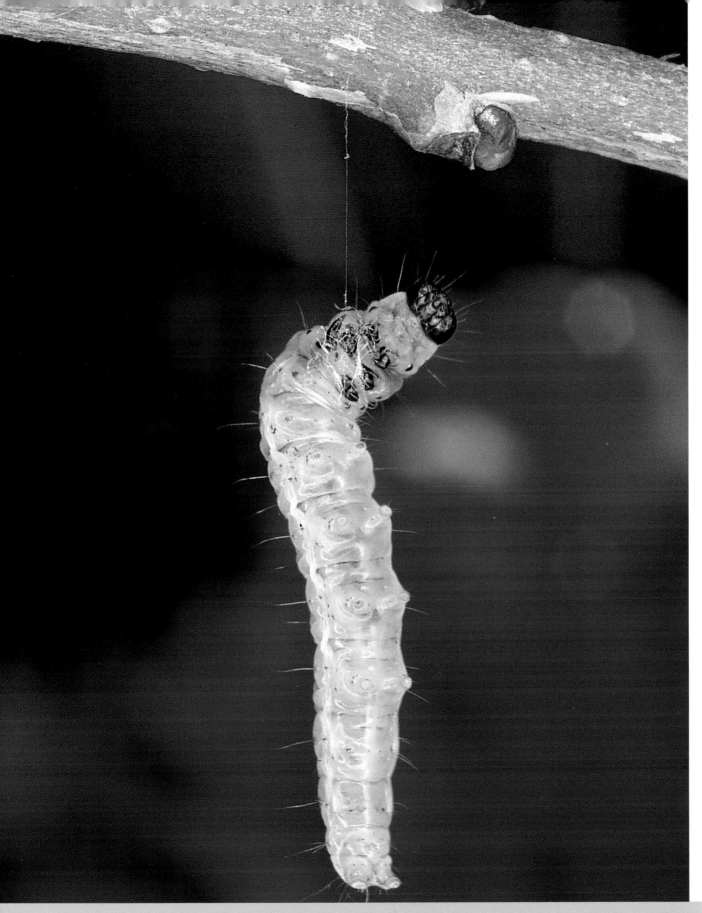

Right This tent caterpillar (*Yponomeuta abbreviana*) is hauling itself up a life-line, winding in the spare silk as it goes into a ball between its legs. This kind of moving subject can only be shot using flash.

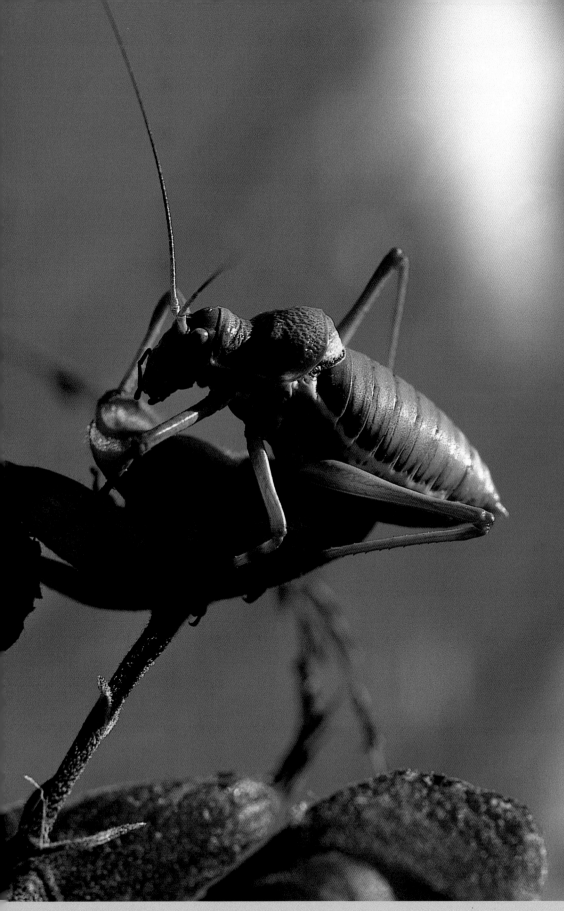

Close-up action in nature

For most of us the natural world offers a much more convenient source of subjects for close-up action, so where would you start looking? As I mentioned in the previous chapter, virtually any aspect of animal behavior comes into this category: even photographing a crawling snail in close-up demands much faster shutter speeds than you might imagine. An illuminated aquarium teeming with tiny colorful fish and gently undulating sea anemones offers marvellous scope for macrophotography, but be wary of light levels. Artificial lighting is usually much weaker than daylight even though it appears bright in the confines of a room, and you will probably have to use flash to freeze the movements of these gorgeous, restless creatures. This is a modest example compared to a request I have received to supply an image of a bombardier beetle squirting acid at its enemy. This is truly one of nature's high-speed phenomena—a sort of miniature version of the spitting cobra—but can you imagine trying to encourage one of these irritable insects to shoot its chemical spray through an infra-red beam? If you are a plant specialist, you may have heard about exploding seed capsules such as the broom pod, which shrivels in the sun, squeezing its seeds until they are popped out like tiddledywinks.

Left Bush cricket *Ephippiger*, photographed in hand-held conditions at 1/60th of a second.

Or the balsam plant whose Latin name *no lime tangere*, or "touch-me-not", alludes to its propensity for hurling out its seeds in a bolero-like fashion at the slightest touch. The squirting cucumber is even more alarming. Pumped up with water pressure, it is basically a hydraulic bomb waiting to be detonated by a passing sheep or goat. Less well known are the jumping maggot, the self-wheeling caterpillar, and the self-drilling seed, all of which I have dealt with personally, and the inventiveness of which is matched only by the craftiness of the photographer who is willing to encourage their performance in front of a camera. They all proved to be priceless treasures in their own ways and, apart from testing my skills to their limits, threw up many hilarious moments. I will spare the reader a diversion into what amounts to animal psychology as much as close-up photography except to say that the self-drilling seed found its way onto British television. Viewers were treated to the sight of this curious, inanimate object suddenly brought to life by a droplet of rain, and proceeding to dance a series of delicate pirouettes to the sound of Tchaikovsky's *Swan Lake*. Maggots and itchy seeds may not be to everyone's taste, but I hope they give you some idea of the endless range of possibilities that are available, if you go about your work with a keen eye.

Right A modest amount of movement blur, together with the use of back lighting, has emphasized the impression of the seeds being 'blown' from these creeping thistle heads (*Cirsium arvense*). On this particular day the wind was quite gentle; a stronger wind might also have blurred the silhouetted part of the seed head, producing a less satisfactory result.

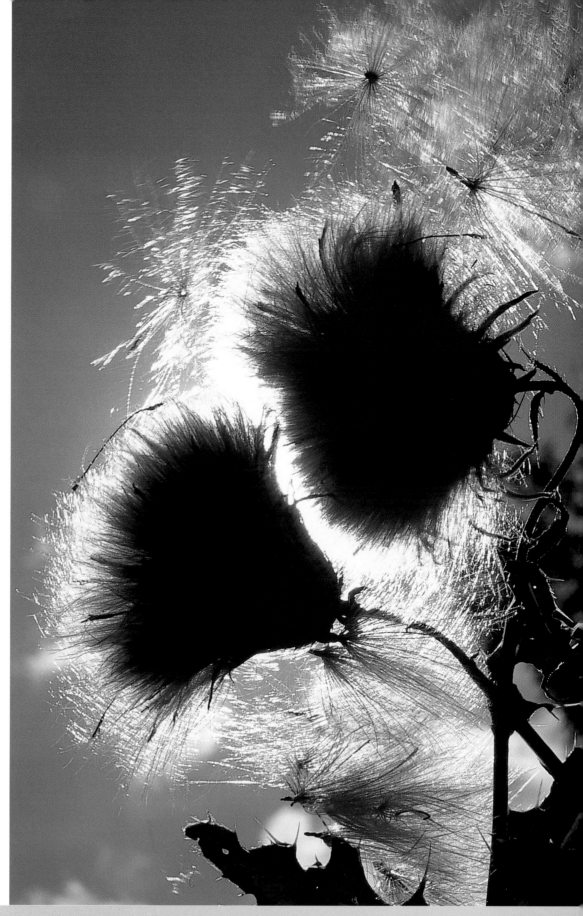

Up close and personal

The secret to capturing a fast-moving subject is to acquire an in-built knowledge of its idiosyncratic behavior. Bird photographers are particularly well known for their patience and skill at stalking their prey, and the same qualities are needed in the case of insects. I have never known an insect that would respond to kindness or cajolery. It is impossible to enter their world, so any project involving them is bound to be a battle of wills. As soon as you attempt to photograph flying insects you will need additional electronic help that reacts much more quickly than you do. Picture the scene: the insect—perhaps a patrolling dragonfly or a red admiral butterfly—is making a beeline for your nose as you stand, camera in hand, and is trying to see you off its patch. You wait for the decisive moment when the body of the insect looms large in the viewfinder and eagerly press the shutter release. When the film returns from the processing lab you see nothing but space—not even a blur. The lethargy of the human brain and the inertia of the hand-held camera have combined to defeat you, because your mental decision to take the picture takes half a second or more to translate into the final opening of the shutter. Such are the delays between nerve cells and the mechanical linkages inside cameras. By this time, of course, the insect is totally out of focus.

Right Even very slow-moving subjects, such as snails, can produce a blurred image if shot at low shutter speeds. In this case motion blur was just avoided using a shutter speed of $\frac{1}{4}$ of a second. The snail was crawling over a back-lit leaf, and the fiery colors of the leaf are showing through the translucent lower part of the snail's body.

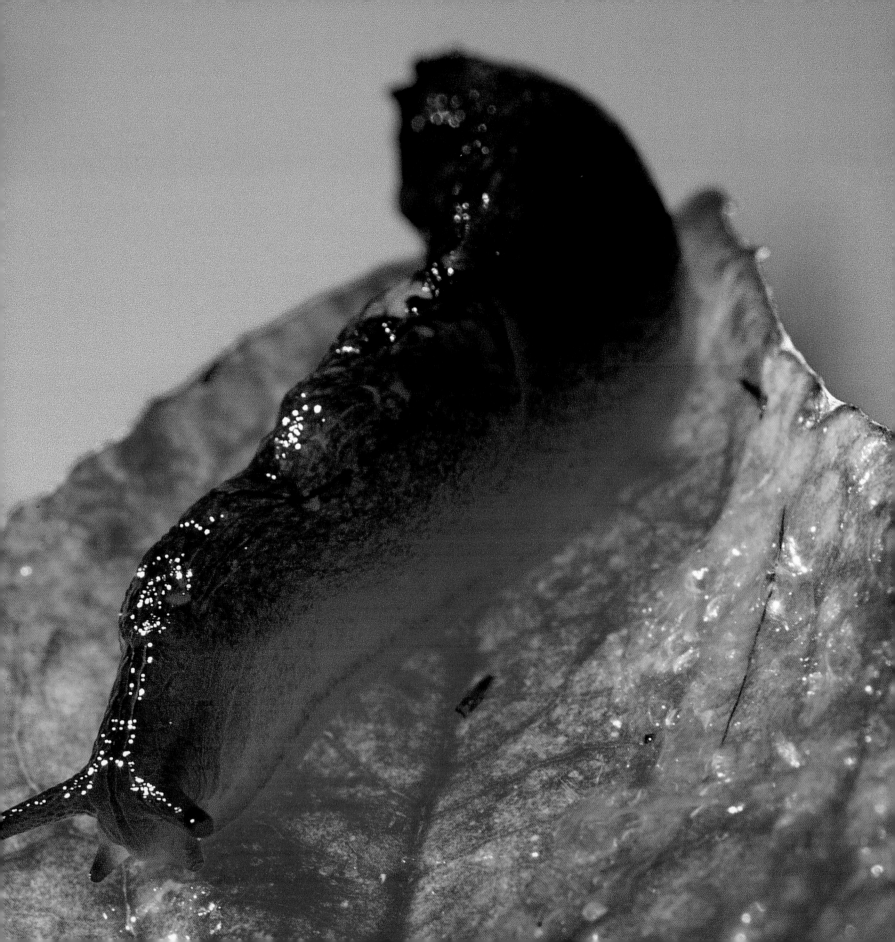

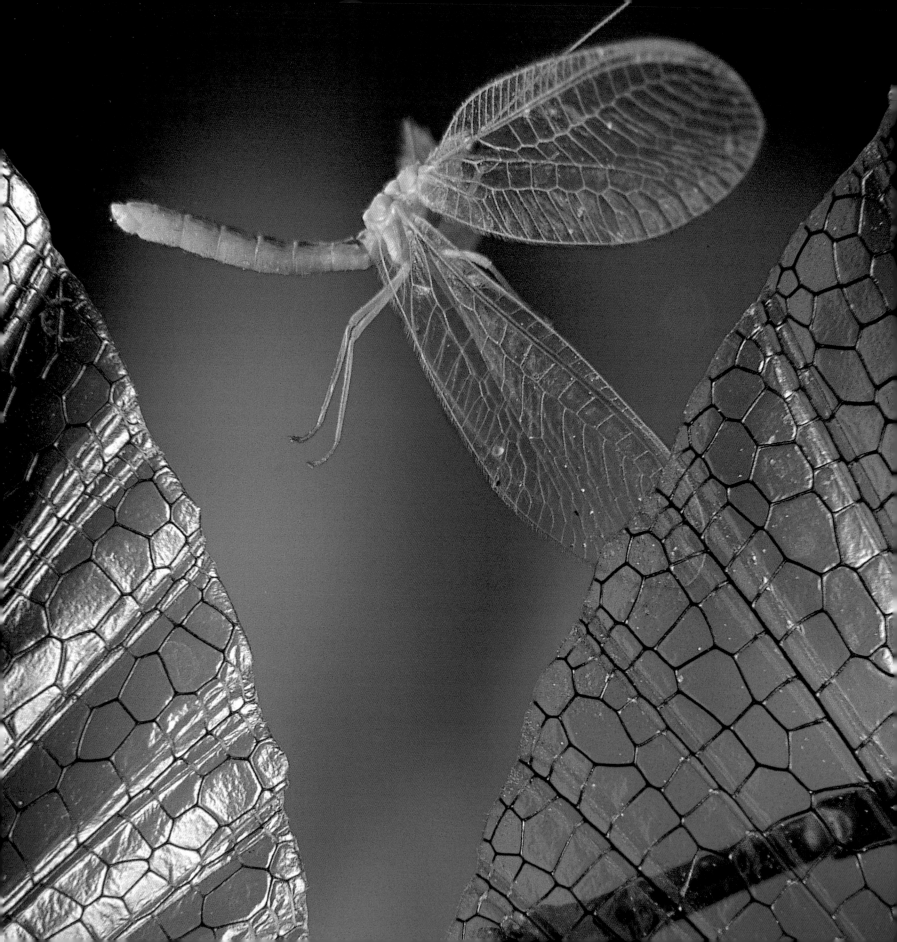

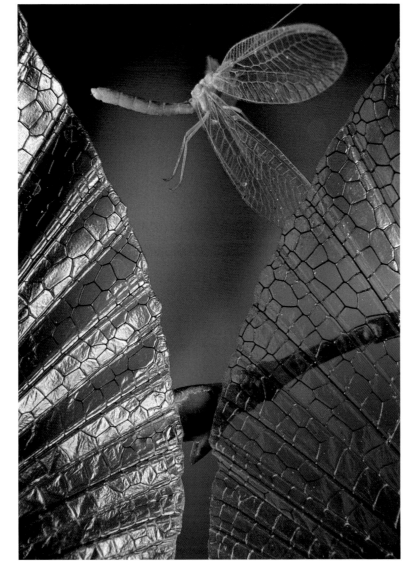

Left and right Green lacewing Chrysopa in flight. This image uses a combination of high-speed photography and the twin lens technique. This enabled the flying insect to be seen through the transparent wings of another insect in the foreground. The idea is to convey, simultaneously, an impression of the strength and delicacy of wings.

Getting the shot

The problem of capturing fast-moving subjects is solved by screwing a fast electromagnetic shutter either onto the front of the lens, or between the lens and the camera body. The shutter is of the light-tight "iris" variety, so the in-built focal plane shutter of the camera itself is made redundant and can be left permanently in the open, or "B" (bulb) position. Similarly, since the "iris" of the electromagnetic shutter also serves to set the aperture of the lens, the in-built aperture of the lens can be fully opened up. The system is triggered either by an infra-red beam or a laser beam rigged up in the path of the flying insect. In my work, the beam has to be narrow enough to be triggered by the body of something as small as a flea-beetle (2mm/$\frac{1}{16}$in). The sequence of events works as follows: (a) the insect breaks the beam; (b) the electromagnetic shutter opens three milliseconds later; (c) the flash gun discharges one millisecond after this; (d) the shutter closes. All this presupposes that the insect has broken the beam at precisely the tiny window of time in which your camera lens has been pre-focused.

Happy accidents

With the technical arrangements in place, the photographer
needs to step back and wait for happy accidents to happen.
Of course it is rarely that simple. All my aerial shots are of
insects in free flight so I cannot control the path they follow.
On the other hand insects never fly completely "blind".
You do not need to be an expert entomologist to know that
when a fly is trapped in a room it always flies to the window.
To an insect, a window is simply a square of sky glowing
with intense ultraviolet light, from which it is separated by
an invisible barrier. Insect eyes are exquisitely attuned to
UV light and associate it with the freedom of the open
air. With this in mind, the best I can do to encourage my
subjects to fly at least in the general direction of the laser
beam is to suspend it in front of a large open window
(if I am working in the studio), or a large gap in the canopy
(if I am working in a patio or outdoors). This is my equivalent
of the bird photographer luring a hawk by placing a dead
vole on a perch. My interest in photography began with
insects, and despite all the frustrations that they have
wrought, they continue to feed me with ideas.

Right A mantis (*Ameles spallanziana*) leaping in space.

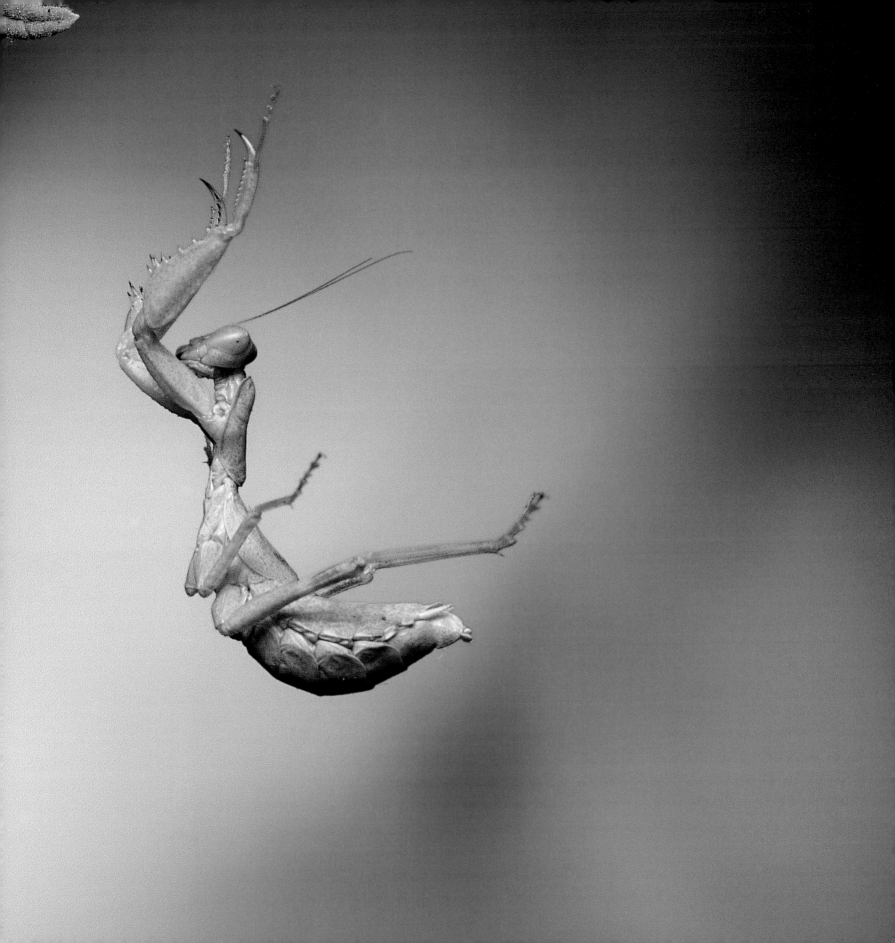

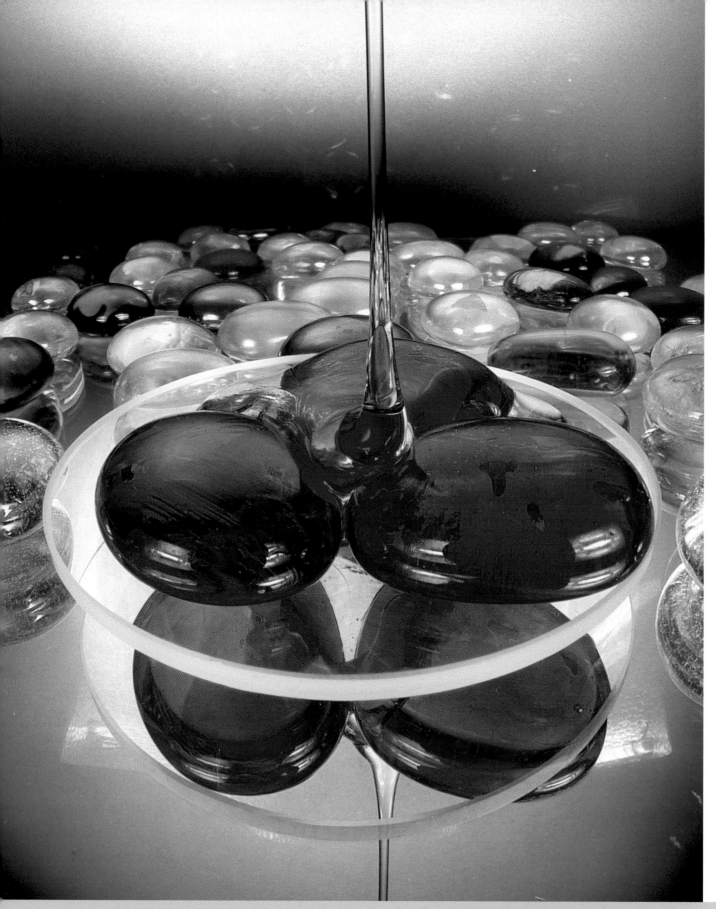

Left Composition of glycerine pouring onto colored glass beads.

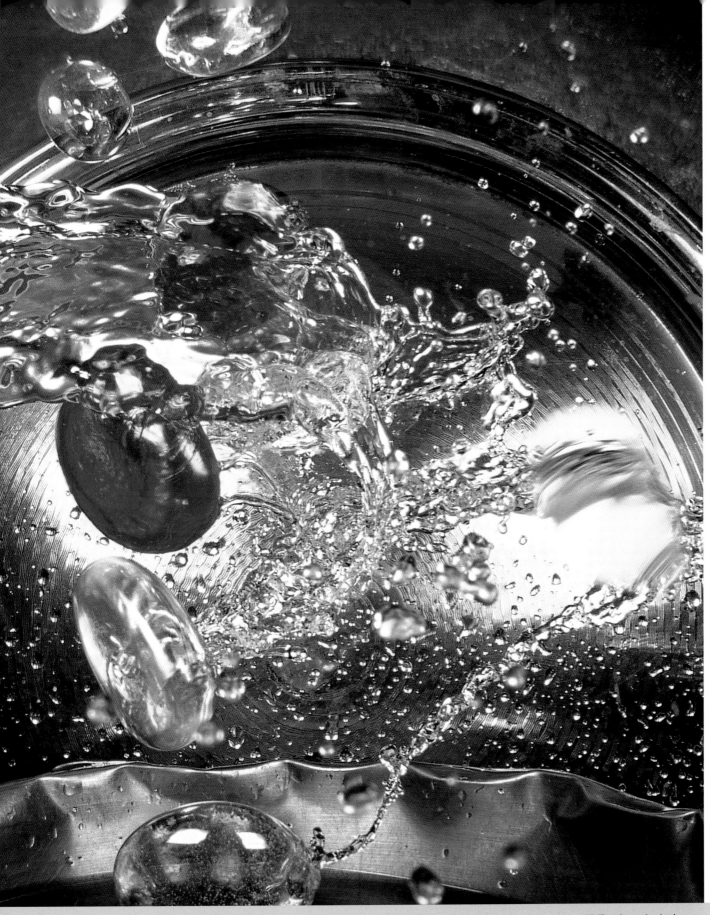

Left Jewel-like, colored beads
tumbling through a jet of water.

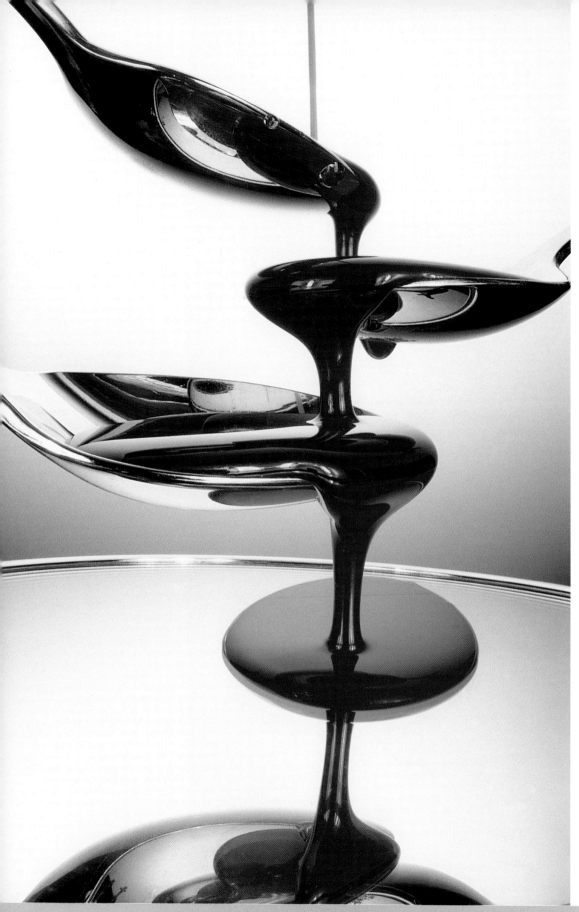

Left Cascade of red oil pouring down an arrangement of spoons.

Right Breaking eggs.

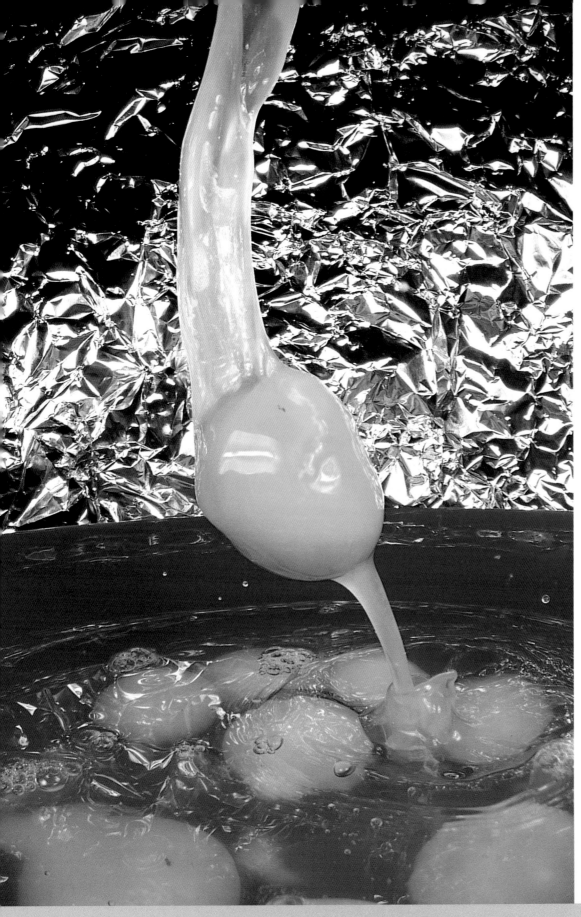

Ready, steady, shoot

Other close-up action shots are shown here, featuring cooking oil cascading down a staircase of tablespoons, and breaking eggs. A cracked egg yolk falls through the air with unexpected speed—so quickly in fact that I was forced to abandon the so-called high-speed commercial flash unit that I was experimenting with at the time, in favor of my trusted custom-made guns. This supports the point that I made earlier in the book: that any kind of movement is enormously exaggerated at the film plane whenever the subject is viewed in close-up.

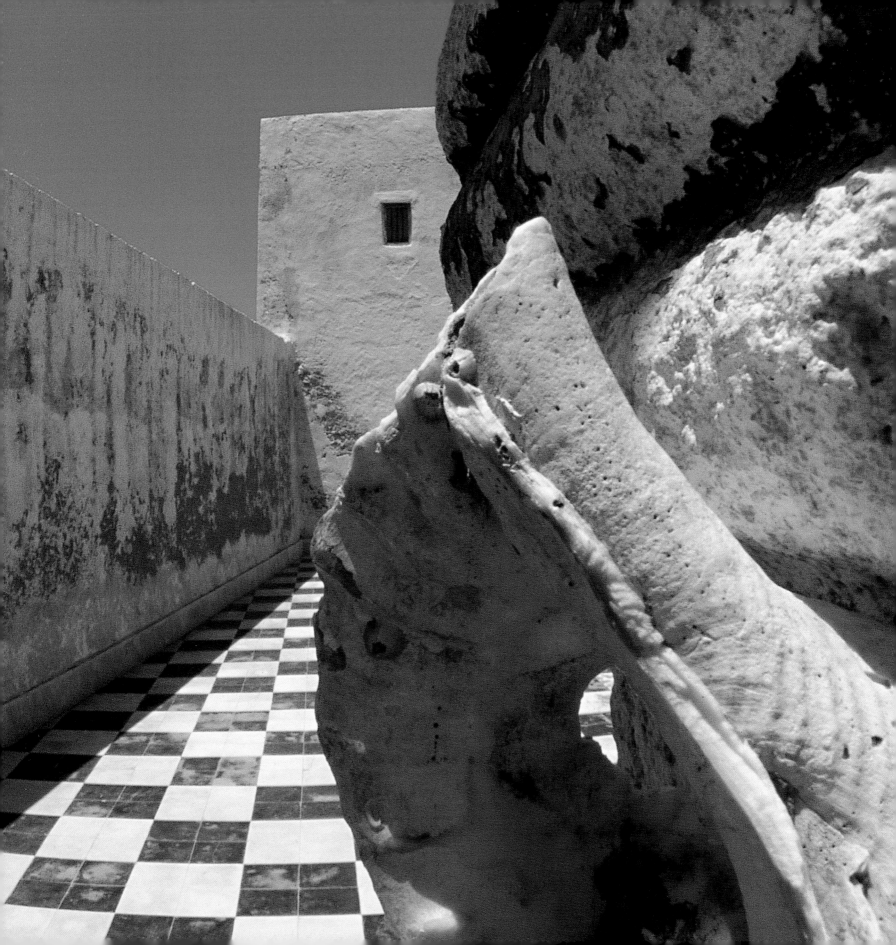

Panoramic close-up photography

When novelist Christopher Isherwood famously said, "I am a camera," he may not have been fully aware of the implications of his claim. He meant that his mind was a window through which the passing history of the world could be witnessed and recorded for posterity. But, at a more physical level, his comparison is flawed. A camera and a human eye are indeed comparable instruments, but they do not see the same scene in exactly the same way. When you survey a scene only one point in the middle of your visual field is in sharp focus at any single moment. This tiny "bull's eye" of good vision is surrounded by a penumbra of truly bad, grainy vision. We build up a picture in our mind's eye by allowing the "real" eyes to rove around the scene like spotlights. The brain can only focus on one thing at a time, and it cuts out "noise" by closing down the outer visual field. We constantly deceive ourselves when we take photographs in believing that what the camera recorded in that instant of time is the same as what we saw.

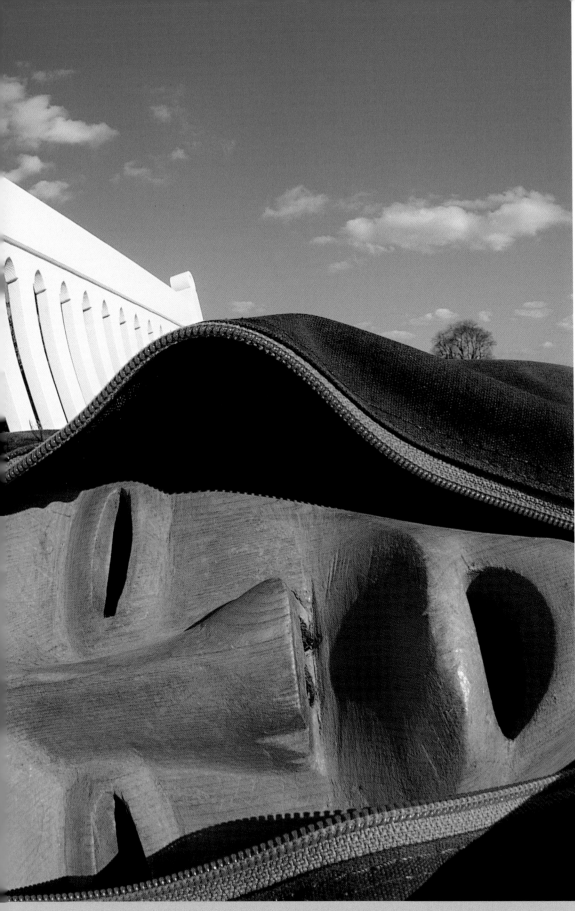

Photographic perspective

Comparing eyes with cameras raises other questions. Why, for instance, were we born with eyes that see the world through the equivalent of a 50mm lens? What is so special about the perspective and field of view of the 50mm optic? We would quickly understand why if we donned a pair of spectacles fitted with extreme wide-angle lenses. Worn day in, day out, you would soon find yourself clutching at apparitions, instinctively reaching out toward objects which turned out to be much farther away than you expected. In time, however, your brain would grow accustomed to the new presentation of the information it was receiving, and everything would become normal again until you took the spectacles off.

These observations on human vision *are* relevant to photography! Try to imagine a landscape as a person who had been blind from birth might envisage it. How would such a person reconstruct this landscape in their mind? Through sound and touch. If asked to describe their surroundings on paper the way they visualize them through touch alone, it would be markedly different to the scene witnessed by a seeing person with a camera. The perspective is utterly different. For a blind person, the transformation of close-up and faraway objects is incomprehensible at first because nothing in his or her experience gives them a reason to believe that things should appear to be smaller because they are farther away. Everything is equidistant when experienced through the immediacy of touch. Yet for a person with sight, perspective—the relationship between close up and distant objects—is one of the ground rules for making sense of the world.

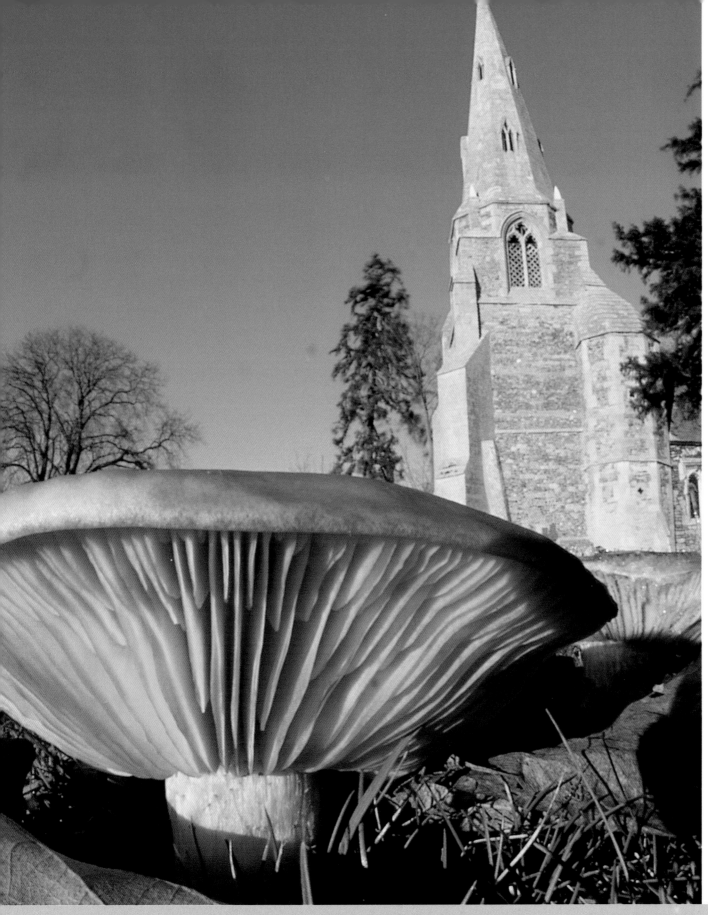

Far Left Wooden mask peeping out from my camera bag.

Left Toadstools in a churchyard.

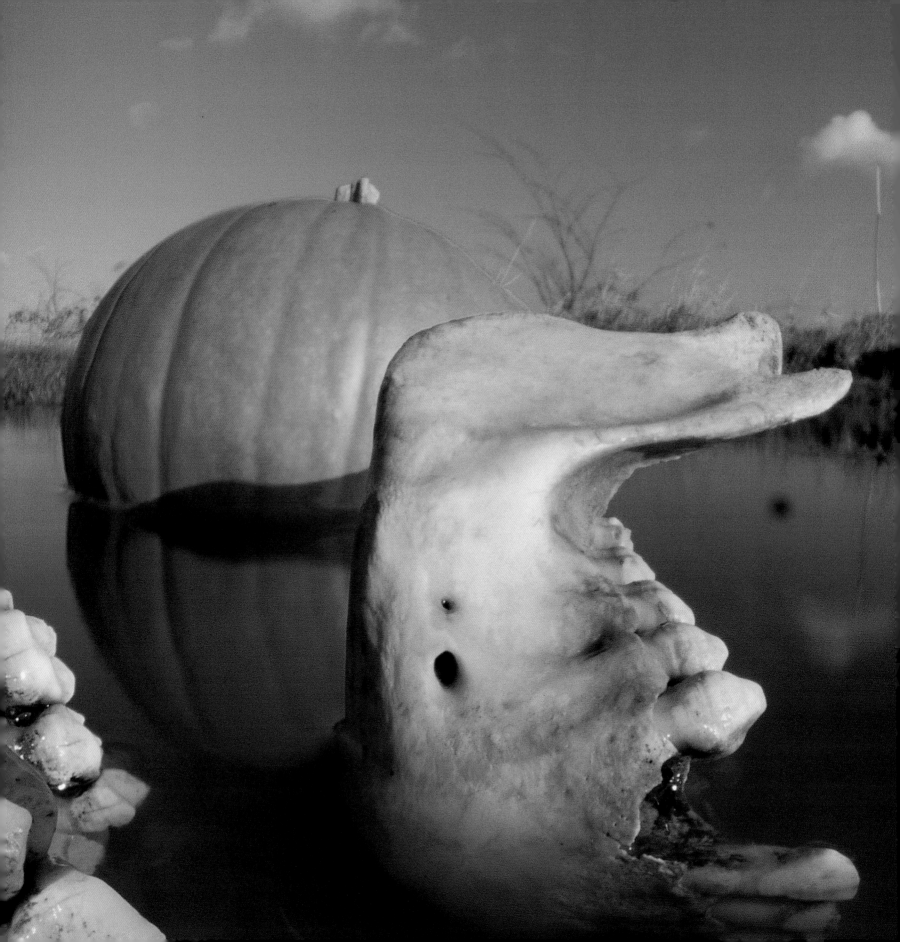

So, who has the most accurate world view? Can widely divergent experiences of the landscape converge in any way? In some sense, yes. Unwittingly, the blind person's view of the world is in some ways how it would be seen by a sighted person looking through an extremely long telephoto lens. With such a lens there is no "background", everything crowds forward, demanding equal attention, claiming its "close-upness".

There is no absolute perspective, only the one by which we happen to be conditioned. And it can easily alter to another equally valid perspective. Photographers do it all the time simply by changing the lenses on their cameras. Lenses replace one valid perspective for another, and we are now so used to seeing the results that they no longer strike us as being in any way unusual. Yet no-one has ever seen with his or her own eyes a landscape in the same way that it is portrayed photographically: through a wide-angle lens. No-one has ever seen through their own eyes the face of another person in the way that it is portrayed through the telephoto lens. We live in an era of phenomenal visual sophistication and take such things easily in our stride. Yet if Plato or Aristotle were transported to the present and asked to look through the viewfinder of a modern camera they would be astonished at the ease with which we can fool the eye, and the brain, into witnessing and accepting a transformed world.

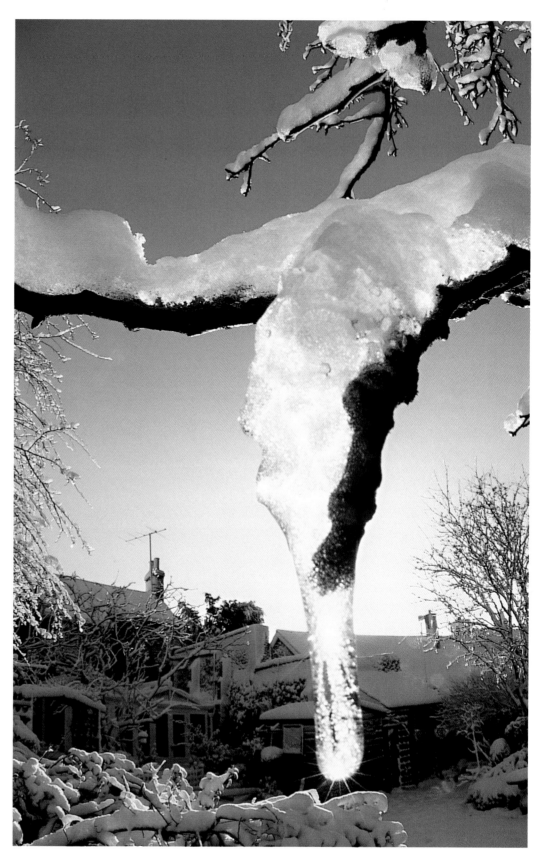

Left Monkey jaws.

Right Icicle catching the light.

Perspective and perception

Philosophers, psychologists, and artists have wracked their brains over the difference between the real world and the world that we perceive through our senses. In *The Republic,* Plato sketched out a "vision of truth" which sought to lay bare the difference between pure "intellectual" vision, and the flawed or "confused" vision which the senses convey. Since vision is central to the photographer's world, he or she has an important stake in this debate, too. In infanthood we acquire fluency in the language of seeing, taking on board the rules of perspective without which it would not be possible to do the simplest operations. And even though we learn instinctively to use these rules of perspective to help us to walk, it can be much more complicated to translate this instinct into creative image-making. This is why all "seeing" is subjective: we interpret it as individuals. In purely photographic terms, those who spend their time critically analyzing modern photography often make the same point: there is no such thing as the objective photograph.

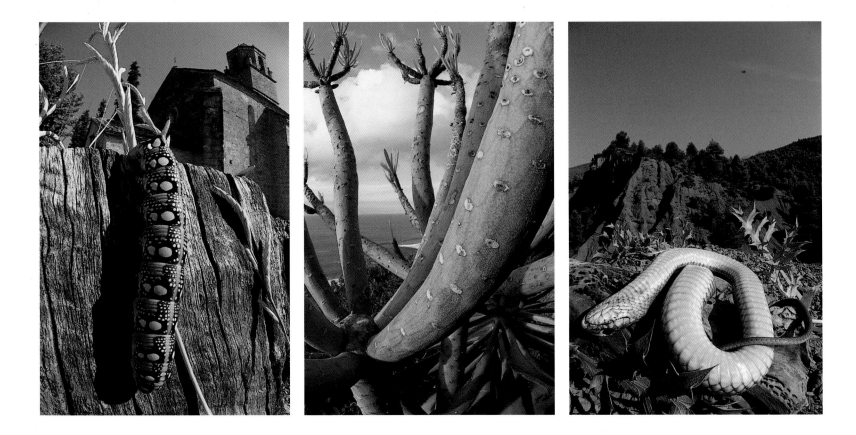

Borrowing perspectives from nature

Human eyes offer only one view of the world but is it possible to identify alternative world views in other living things? Yes. A spider sizes up its prey using a telescopic eye; an insect sees its world superimposed on a goldfish bowl. One species of bug spends its life on the surface of the water. It has little interest in what is going on either above or below the water. Its world is flat. Pointing my camera at various living subjects I wondered what they see as they gaze into the other end of the lens. I have become conscious of a paradox. When photographers concentrate on very small subjects in close-up, they reduce the rest of the world behind the subject to a mere blur. But that isn't the way a small subject sees its own world. While virtually impossible to imagine how a bee "sees", I am quite sure that it views the rest of the world beyond its immediate neighbor—hive, sky, and clouds—all in focus.

The evolution in this thinking was born of an accident that revealed itself in one of my photographs of flying insects. An insect was about to be hit by a droplet of water. I was intrigued as to why some insects flew undeterred in the rain. In the surface of the droplet poised above the head of the insect I saw a reflection of my equipment. The droplet was emulating a wide-angle lens. To demonstrate how this works, fit a macro lens to your camera and look at a water droplet hanging from the underside of a twig on a rainy day and you will see a reflection of the entire canopy of the tree and the sky above it. This vision crystallized for me the answer to the problem of the panoramic close-up image. I would need to find a lens with a very short focal length—much shorter than a fish-eye or other lens in 35mm photography, and then devise a means to project the image from the lens onto the 35mm format.

Top left Spurge hawkmoth caterpillar (*Hyles* sp.), Spain.

Middle left Candle plant (*Kleinia neriifolia*), Tenerife.

Above Young, dead snake, Spain.

Right Crocuses.

The mechanics of the panoramic close up

Such a lens can only be found outside the realms of 35mm photography. The water droplet and the bulging curve of the insect's eye both act like truncated—probably less than 1mm—focal length lenses. Microscope lenses have even shorter focal lengths, but it is not practical to convert these into photographic lenses. I have considered video and television lenses. An extreme wide-angle video lens may have a focal length of as little as 3–4mm, but the image from it projects onto a very small area. It's a compromise, but it can be made to work. With the set-up I devised, the video lens is mounted onto a bellows unit. Interposed between it and the camera is a reverse-mounted standard 35mm wide-angle lens which acts as a magnifier for the image projecting from the rear of the video lens.

For correct focusing, both the video lens and the magnifying lens have to be independently focusable. The whole unit is mounted on a sturdy tripod. The aperture of the system can be set by either of the lenses. The down side of the system is a very large trade-off in light requirement. When I first looked through the viewfinder I was forced to focus on my subjects at an aperture of f16, which is very dark. The apertures I eventually used were between f64 and f256. I was reluctant to use anything other than my regular slow film (ISO 50), so it was necessary to employ long exposures, and extra vigilance against shutter vibration, even when photographing in bright, sunny conditions. Living subjects had to be almost perfectly still, at least for the duration of the exposure, and this presented an additional problem.

Normally, even in close-up work, you assume that sounds made by your camera are not loud enough to disturb your subjects. But with the panoramic close-up assembly, the lens was only 2–3cm (¾–1¼in) from the subject. Getting this close—bearing in mind the logistics of tripod adjustment and focusing—takes all your patience and experience. And then I found that some of my subjects actually heard the shutter mechanism winding out long exposures and would shudder—once as the shutter opened and again as it closed—thereby ruining the image. Sometimes I've used fill-in flash, but again, the very small apertures are problematic. Even a powerful hammerhead unit needs to be held within 10–15cm (4–6in) of the subject.

As a rough guide, the correct exposure is approximately six stops below a normal incident light reading. In practice, I rely heavily on the TTL light reading given by the camera and usually bracket by plus or minus one or two stops. There is one further problem. The design of the lens assembly means that the viewfinder image is inverted and I have yet to work out a convenient way of reversing it back to normal.

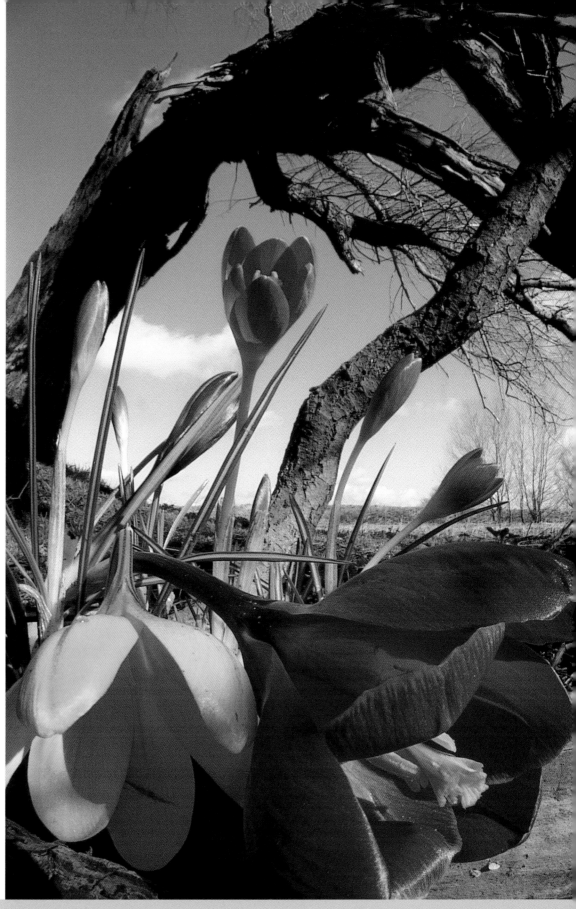

Left Roosting seven-spot ladybirds
(*Coccinella septem-punctata*).

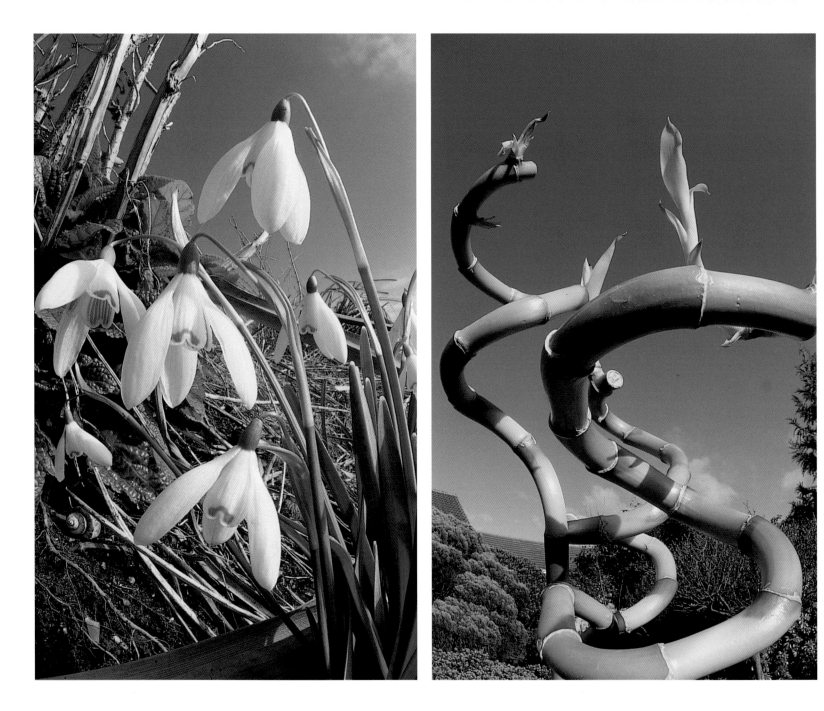

Above left and right
Snowdrops (*Galanthus nivalis*),
bamboo plant.

Above left and right
Toadstools, Jewel beetle (*Julodes* sp.)
in Wadi Rum, Jordan.

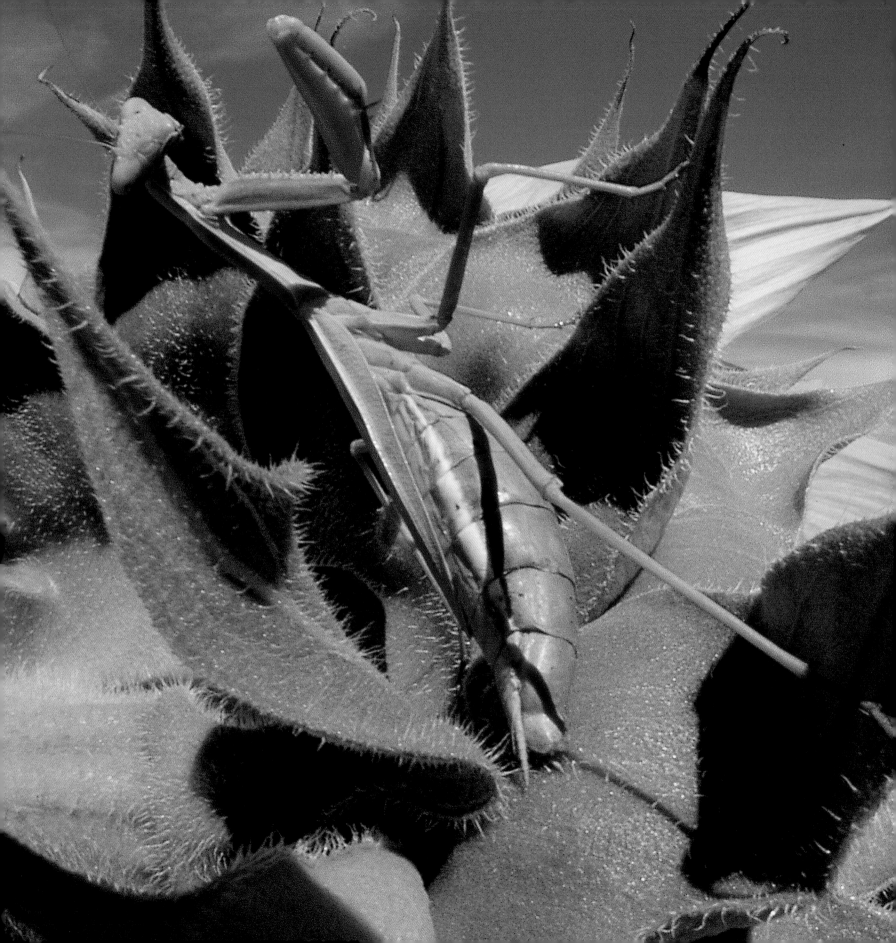

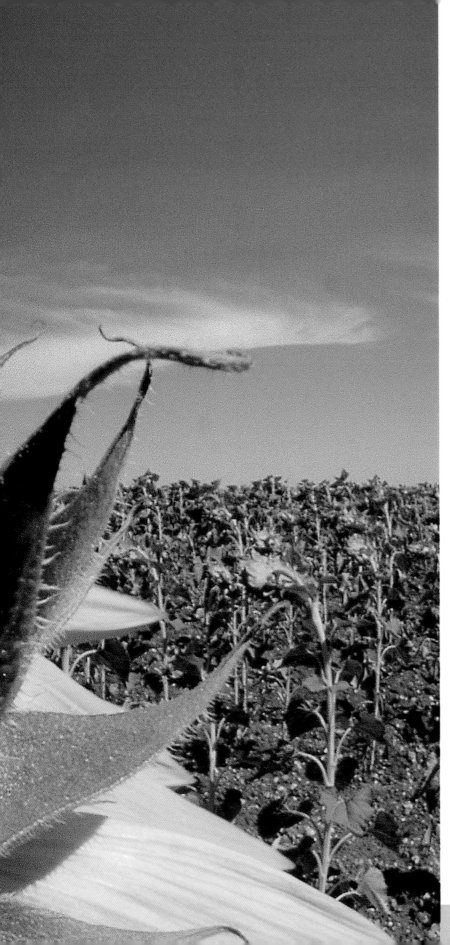

The learning curve

As I've already mentioned, you only get out of a photograph what you put into it. Photography is a two-way learning process: you take the pictures and you learn from the results. In the early stages of developing the panoramic close-up, I tried to imagine how the world would look to an inch-high human being standing in front of a toadstool or a snail's shell. Having taken lots of panoramic close-up pictures, I see that my hypothetical Lilliputian would see exactly the same kind of image that you or I would see if we were standing in front of a two-story house. The difference is only one of scale. To Lilliputians, a toadstool is no longer a macro subject. They see it like we see the house—all in focus—and so is the panorama of the earth and the sky behind it.

Left Mantis in sunflower field, Spain.

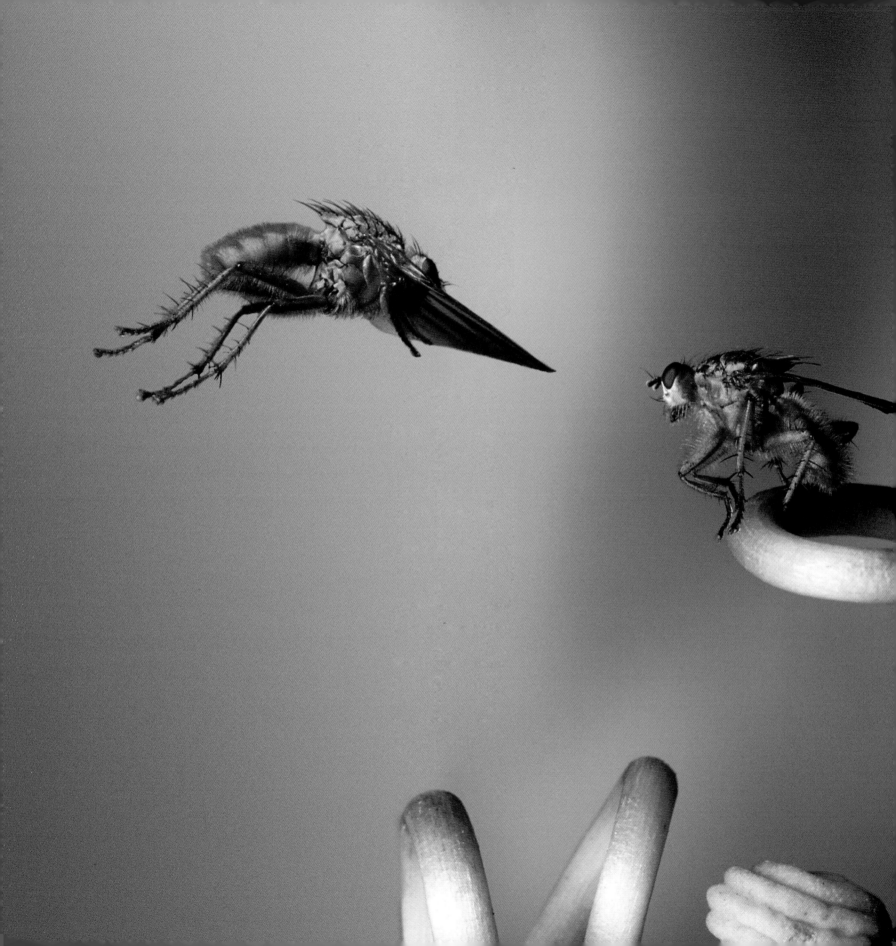

Combining techniques

When planning my photography I find it useful to divide projects into two types: short term and long term. It is the difference between things that are ephemeral and things that endure.

Left Dung flies
(*Scathophaga stercoraria*).

The long and the short of it

Short-term projects have a specific objective and are over and done with when it has been achieved—for example, snapshots for the family album, and occasional opportunity shots. At the professional level, it might also include commissioned work by personal and business clients, such as a wedding portfolio.

On the other hand, long-term projects are more open-ended and organic, and are normally of a more personal, creative nature, rather than for financial gain. These are the kind of projects that keep you awake at night—almost in danger of completion, but rarely actually doing so. Thus, long-term projects are intoxicating and exhausting at once. One idea opens up another, one project leads to another. This process is healthy but, without self-discipline, can also lack focus. The difference between a professional and an amateur photographer is precisely that: *focus*. For someone who lives by their camera the focus is imposed from outside, from a client who sets a deadline. Those who take pictures for love—and that is the true meaning of the word "amateur" —must impose their own focus entirely by their own strength of will and purpose. It is the longitudinal efforts, not the casual snapshots, that sustain an individual's interest in photography. And this is precisely the way in which the development of my panoramic close-up photography occurred—with love, time, and focus.

Right Egyptian grasshoppers (*Anacridium aegyptium*).

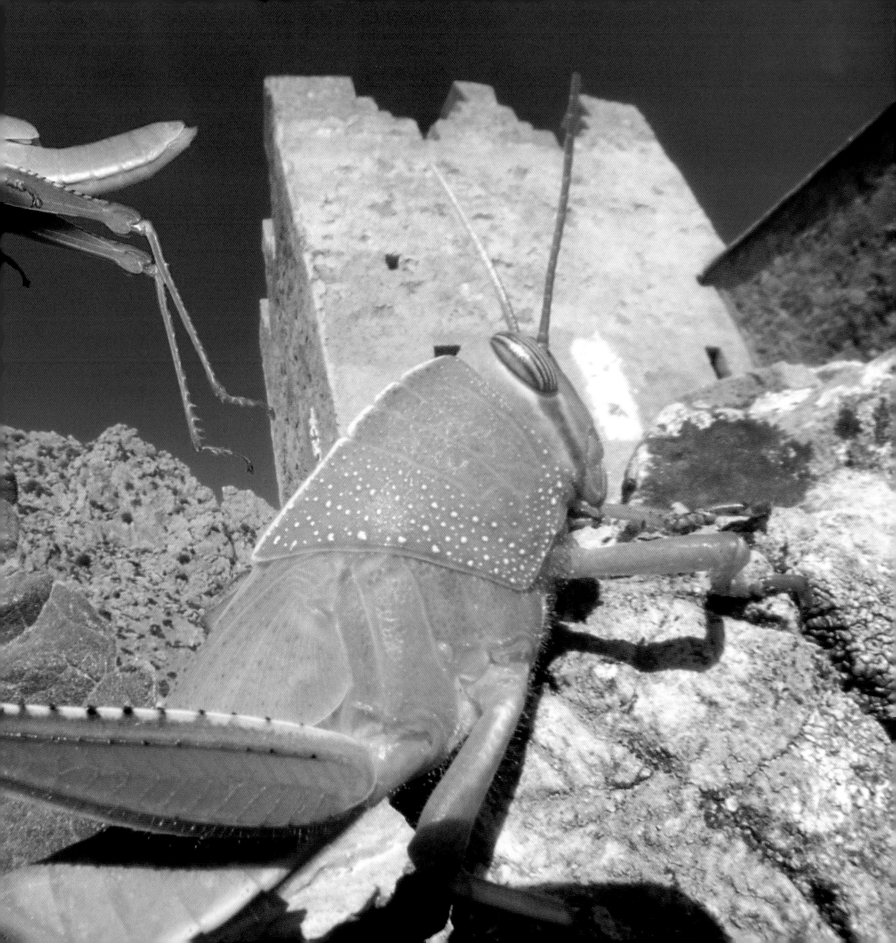

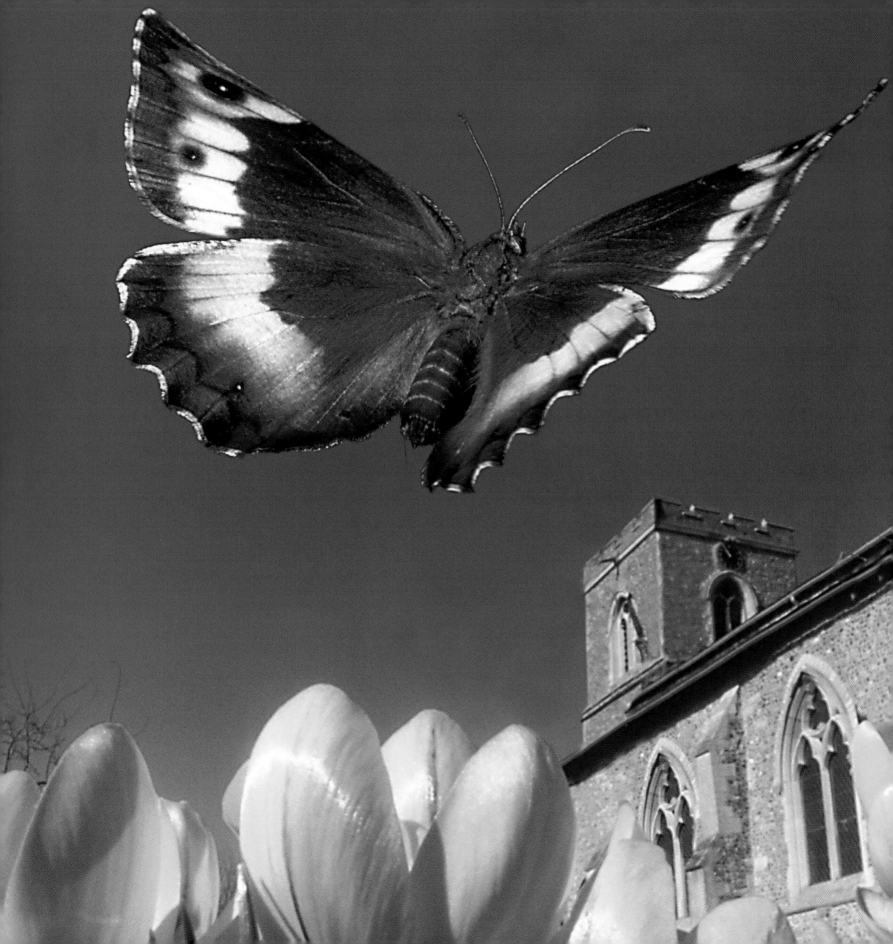

Left Grayling butterfly (*Brintesia* sp.).

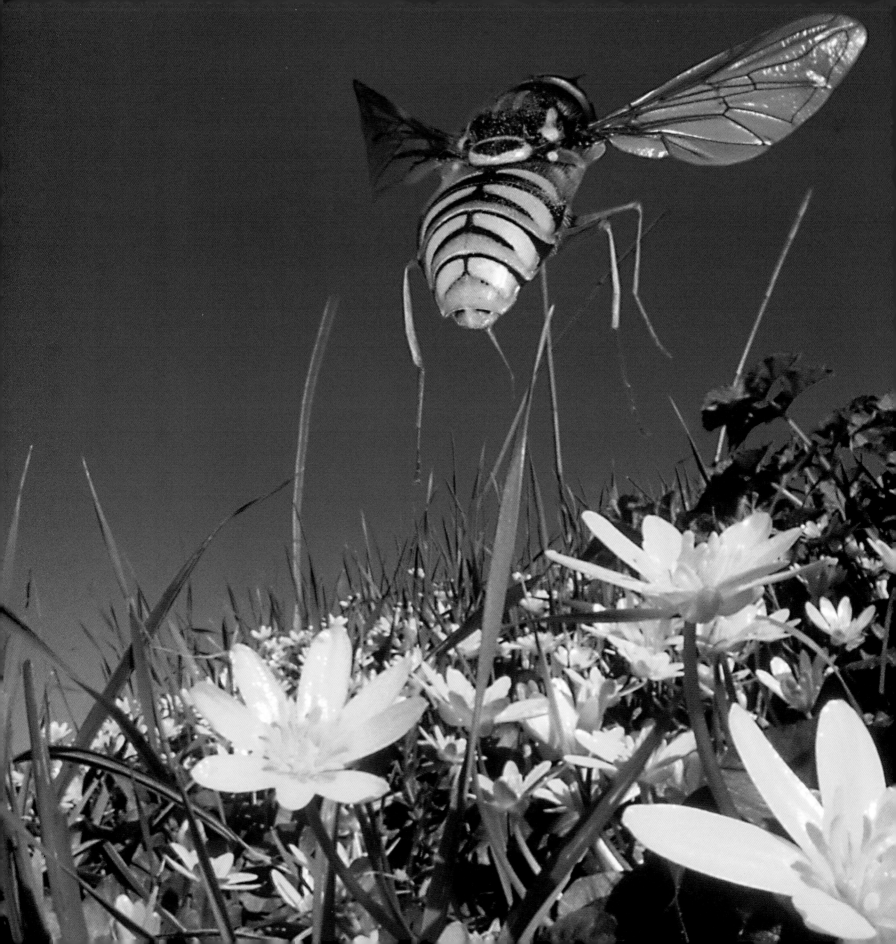

Going beyond the panoramic still life

The lengthy exposures required for the panoramic close-up technique have often restricted my choice of subject to stationary or inanimate things. Anything living and active must remain still long enough for its picture to be taken, and this limits my choice to the one or two species of insect that instinctively "play dead" when confronted by something perceived to be threatening, such as a camera. Having used this technique to simulate the world of an insect as it might be seen by the insect itself, I had a further objective: the insect must be caught in the act of flying. To capture the event meant marrying the two techniques that I developed for close-up panoramic photography and high-speed flash photography. The dilemma was the immense difference in shutter speed required for the two methods. Panoramic close-ups require exposures as long as two seconds, whereas high-speed flash requires an exposure of 1/20,000th of a second.

I puzzled long and hard over this problem, which at first seemed utterly intractable. I conducted covert visual experiments as I walked through the countryside, looking for juxtapositions in nature that would give me a clue to the solution. Eventually, I assembled some ideas, and tested them out. Of two methods which were successful, the first— part of a project that I called "Time and Motion Suspended"—involved combining techniques for both panoramic close-up and high-speed flash photography.

Solving time and motion

For my first method, rather than use a conventional shutter, I employed a laser-chopper, a device normally used in communications networks to break a continuous laser beam into a series of pulses. The chopper is simply a small hole, protected by an iris which can be activated with virtually zero delay by an electronic signal. I used the chopper as a means to control the admission of light into the camera rather than as a conduit for a laser beam. The flash guns shown in the photograph are exceedingly powerful custom-made units which discharge with an audible bang, but nothing less would serve the greedy light requirements of the panoramic set-up.

Left Hover fly
(*Chrysotoxum cautum*).

Left Bush cricket.

Using Photoshop to enhance an image

Using the same equipment to photograph flying insects in the field raised problems of a different kind. The exposures required a lengthy exposure for the background using available light, and, inserted into the middle of this, a burst of flash to expose the flying insect. The insect risks being doubly exposed, particularly if it is shot against a bright background. The problem was less acute if the subject was shot against a dark background, such as a deep blue sky. To obviate this difficulty, I began to take separate exposures, one for the background and a second one, using flash, for the flying insect. For the "action" exposure the shutter was set at 1/20th or 1/30th of a second, just brief enough to prevent ambient light from entering the camera and fogging the film. This meant that the insect was seen against a black background and made the third stage of the compositing process much easier: digitally combining the two images.

With macrophotography, many subjects are captured in one brief moment. But as this book demonstrates, the "decisive" moment is often the result of a lengthy session behind the camera waiting for the ideal combination of subject, background, light, and composition. Sometimes those moments just don't happen, or the macrophotographer wants to experiment with his image-making, plus the image-manipulation technology available makes it possible to creatively enhance an image by combining two or three different elements to form a single, perfect shot.

Left The resultant image of two combined images: one of the insect and foliage in the foreground, plus one of the background sky. With some judicious manipulation in Photoshop, a digital photography professional and I were able to create one great panoramic close-up. Ideally, the macrophotographer would be able to capture this in nature, but sometimes you can't beat digital know-how.

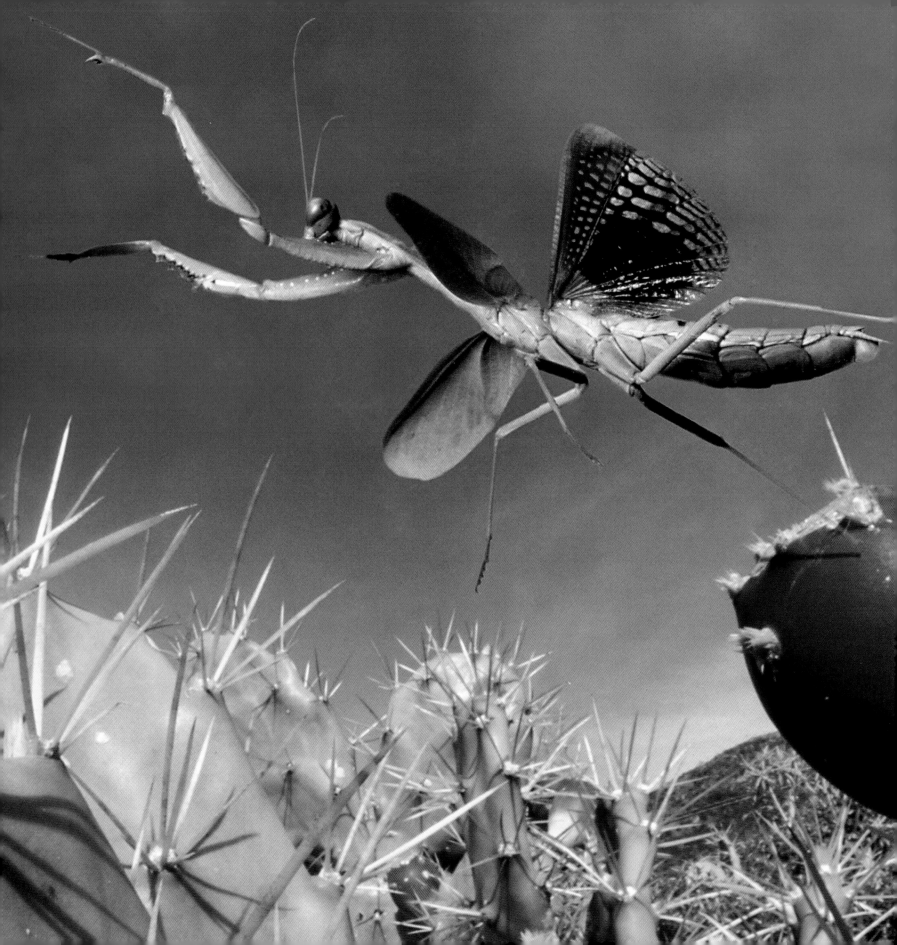

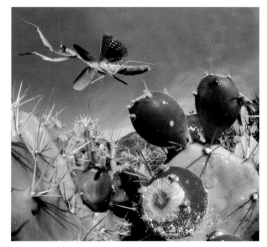

Left and above Mantis
(*Iris oratoria*).

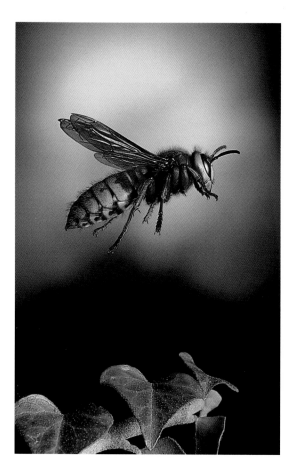

Above Hornet in flight.

Right Hornet resting on a poppy
seed head.

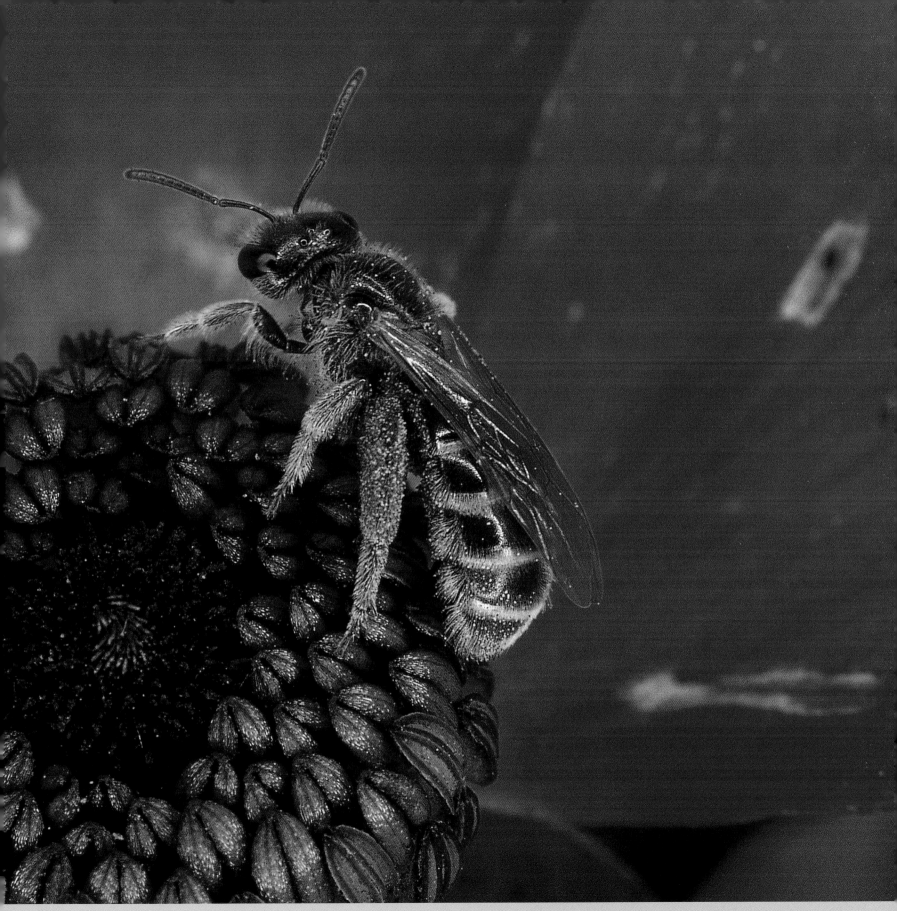

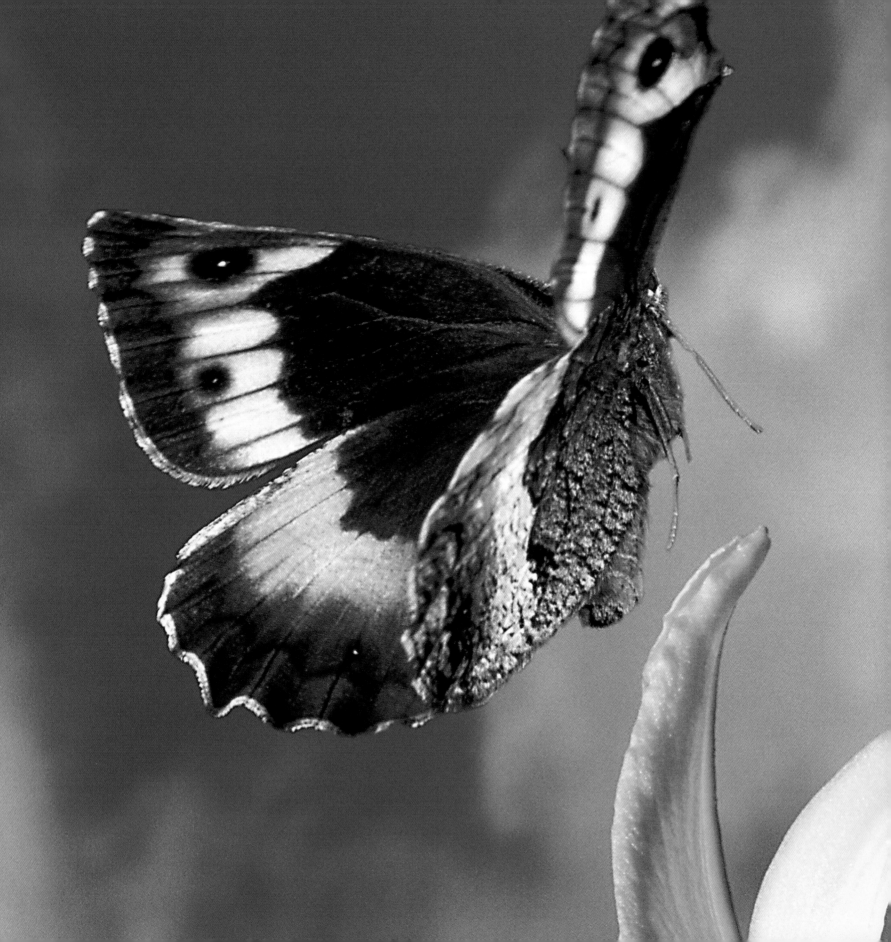

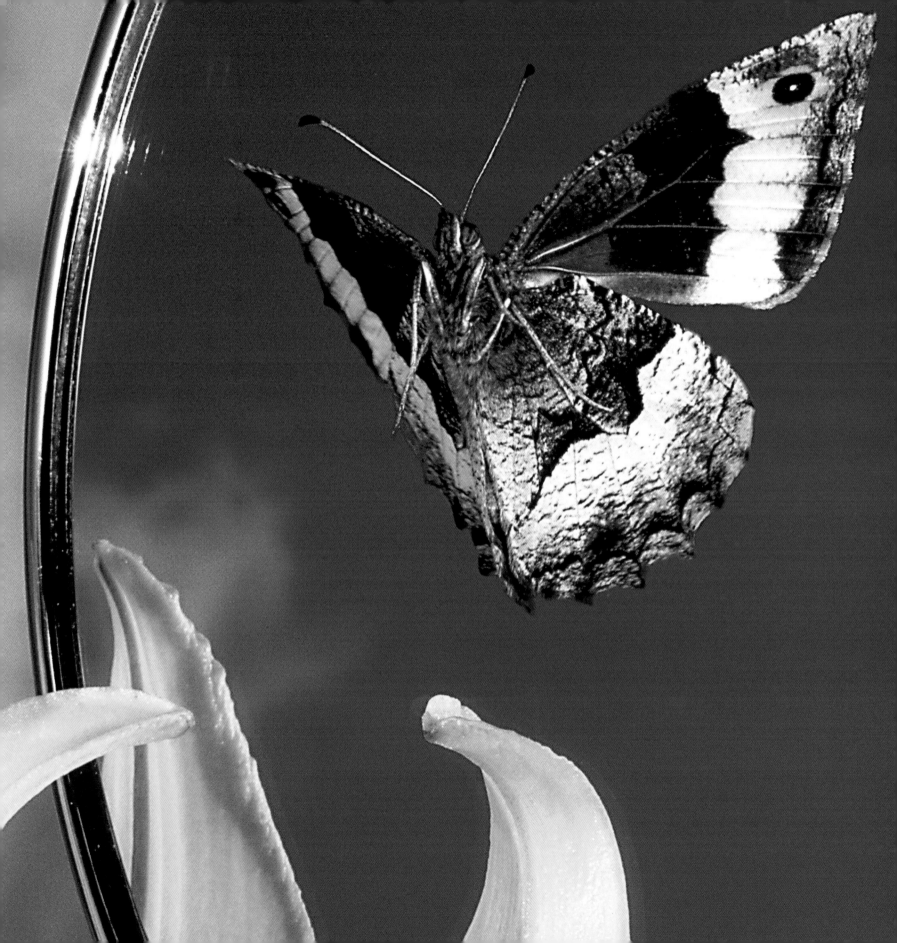

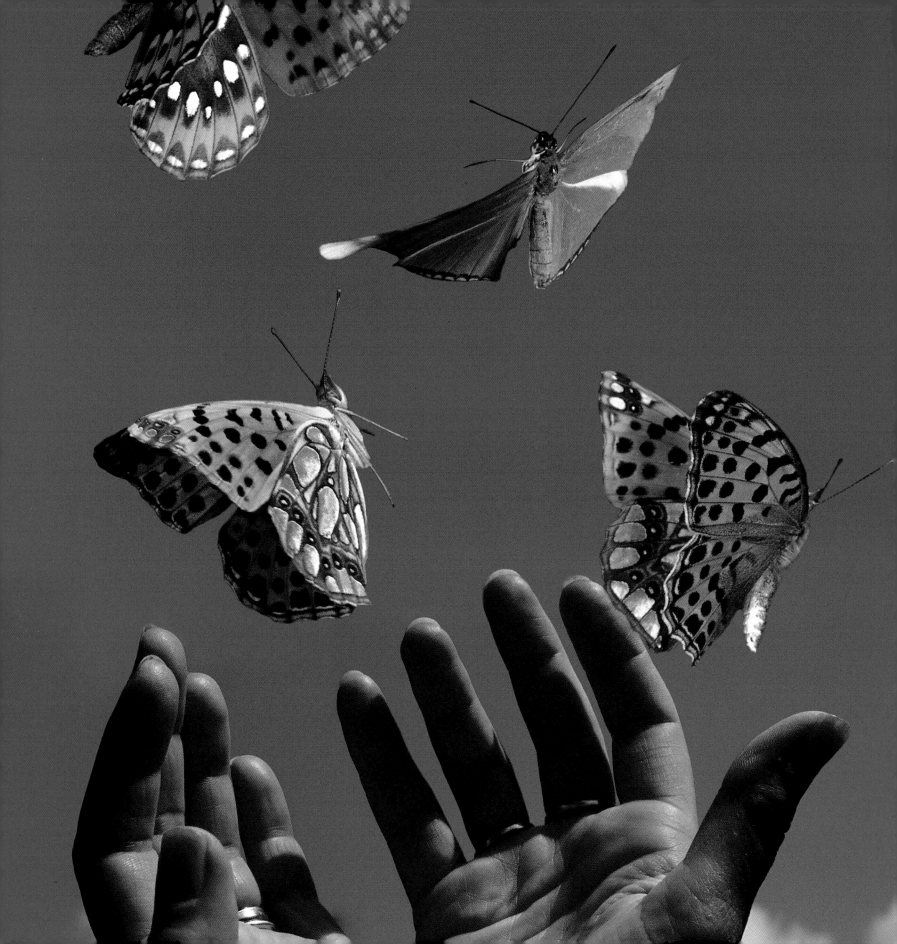

Self-assessment

As the experiments in the previous pages show, every project is a minor Rubicon and, having crossed it, you look back over it with feelings of relief—and, inevitably, some regret. Earlier I wrote about the value of periodically taking a hard look at your photography to identify the points where it might have become stale or one-dimensional. The very worst time to indulge this is immediately after the latest batch of pictures has arrived from the processing laboratory. Almost all my own work is on transparency, and my first viewing of completed work is nearly always a disappointment. Instinctively, one's eye searches for the blemishes rather than for the aspects that make it successful. When you examine the pictures again two or three weeks later they improve tenfold. True, 50% of them can still be discarded, but amongst the remaining 50% are some that definitely pass muster.

So much for the short-term review. But the pendular swings between doubt and satisfaction grow once you begin to explore the deeper archives of your own work. The questions begin to emerge: should I have done something in a specific way, or are there alternative approaches? Have I been using light in the most creative way? Should I have spent more time shooting into the sun rather than away from it? Are all these pictures too close, or not close enough? Have I been missing fresh angles in my photography? Should I have waited for the warm glow of evening light for convenience, rather than accepting the rather harsh light of mid-afternoon? Do my pictures tell a story, and if so is it the story that I intended?

These are all perfectly legitimate questions, but the answer to all of them is a practical one, and that is that you can only agonize for so long in the circumstances. The really important question is: did I make use of the opportunities that came my way? If you can answer in the affirmative, you can forgive yourself for nearly every other setback, as long as you have made a genuine effort. You cannot always rely on accidents and opportunities to feed your photography. In such fallow times, the long-term project really comes into its own. You need to be able to fall back upon an ongoing theme that will ensure sustained motivation and interest. Challenging the boundaries of macrophotography is the long-term challenge that sustains mine.

Previous pages Grayling butterfly (*Brintesia* sp.).

Left Butterflies (*Queen of Spain fritillary, dark green fritillary, Julia*).

Right Sand wasp (*Ammophila sabulosa*) and small wooden carving.

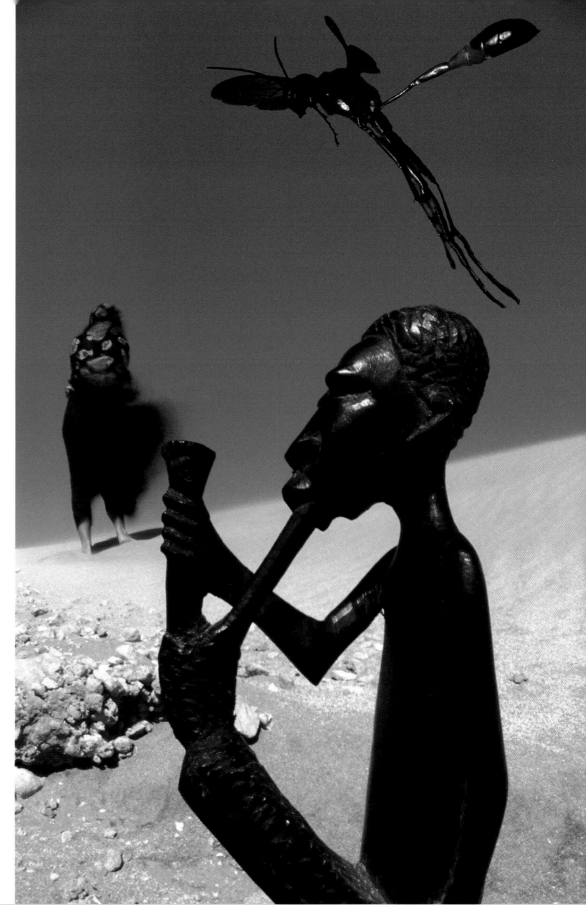

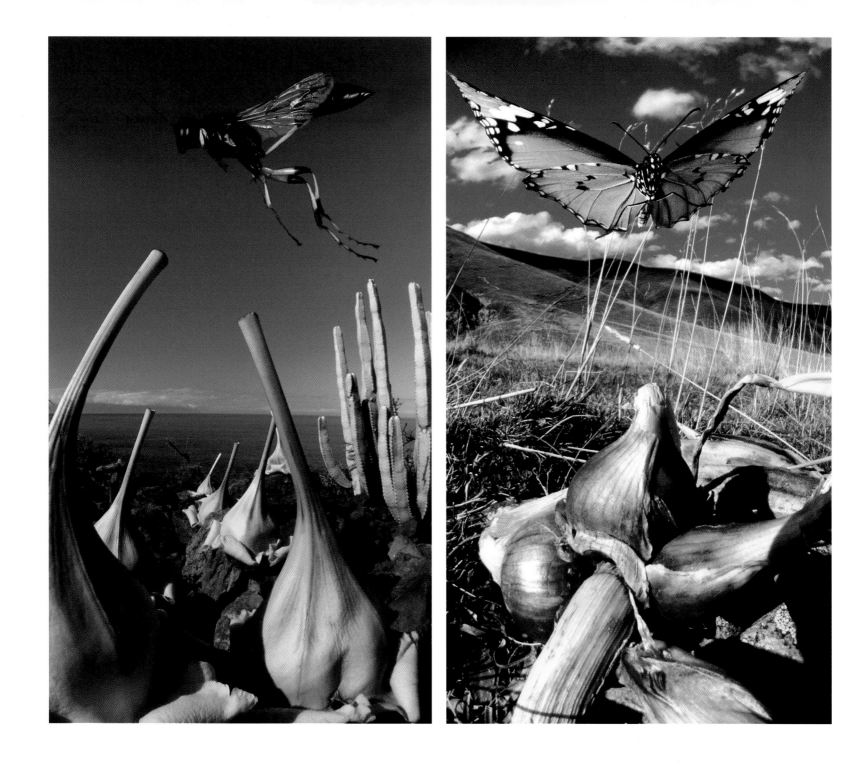

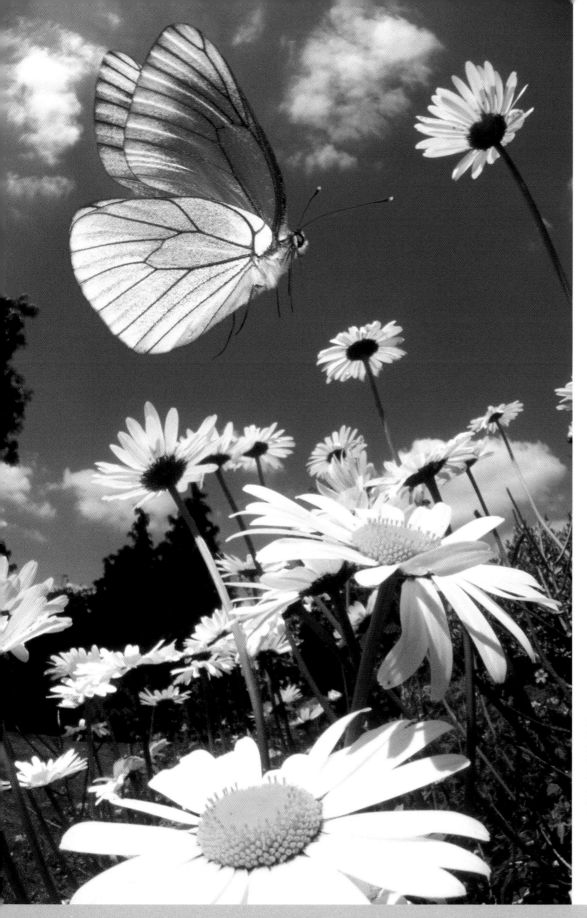

Far left Spider-eating wasp
(*Sceliphron destillatorium*).

Middle Tiger butterfly
(*Danaus chrysippus*).

Left Black-veined white butterfly.

Overleaf Butterflies
(left to right: black-veined white,
dark green fritillary, grayling).

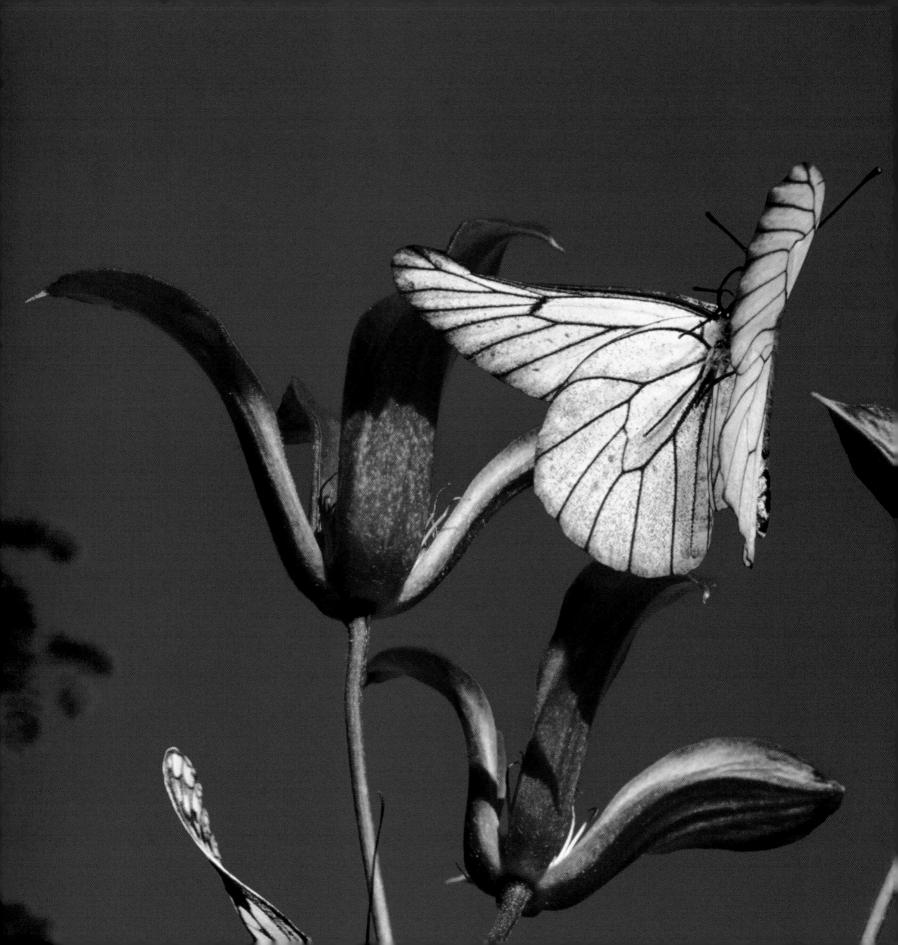

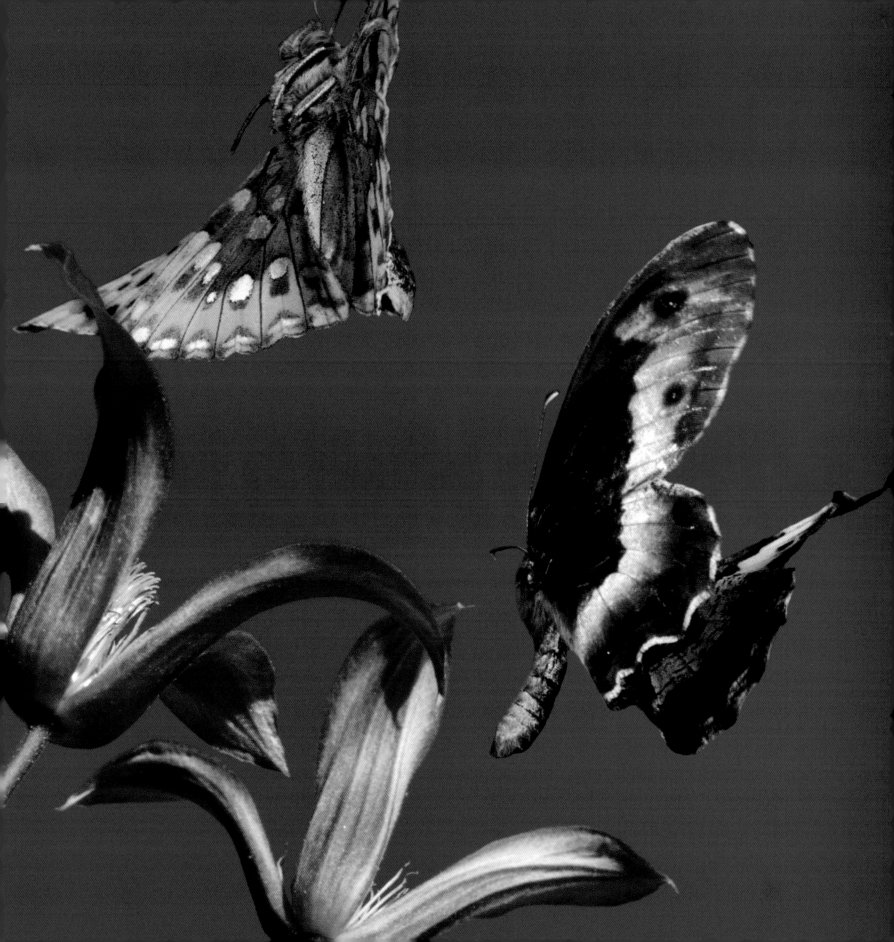

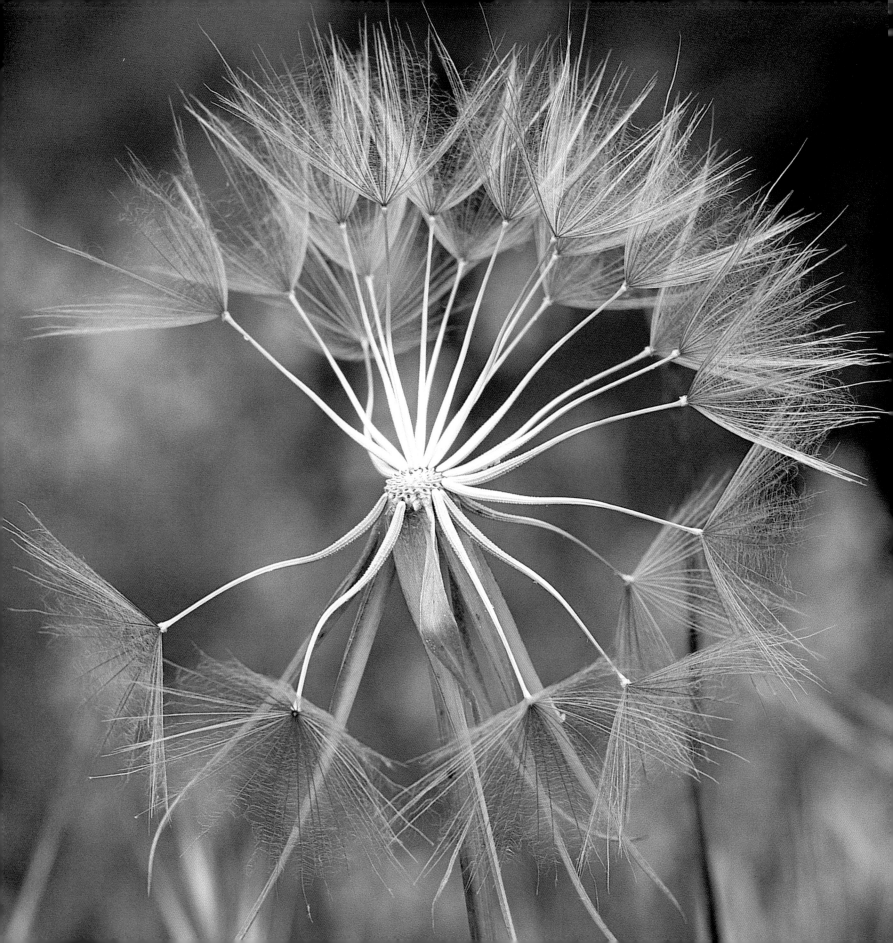

Inspiration and motivation

Getting fresh inspiration can be difficult, but keeping motivated is sometimes a challenge in itself. Believe me—I know! There are ways to help sustain your interest: camera clubs, magazines, exhibitions. All these things help to feed your own projects. But, most important, is to find self-belief.

Left Seed head of goatsbeard (*Tragopogon* sp.).

Making connections

It is not my intention here to conduct a surgery for lost souls in photography but I can offer some suggestions for regaining motivation. When a photographer takes a long look at his or her collected efforts and says, "Yes, there are some good pictures here, but I can't see what's linking them together", the solution lies there in their own words—start thinking about links. Develop a habit of thinking ahead to the next photograph, and the one after that, even as you are busy taking one. Each effort then becomes part of a continuous chain of idea- and image-making in your photography. Once you've established a proactive approach, and some continuity, it becomes much easier to accept the ups and downs in your work because you know that the whole is now greater than the sum of the parts.

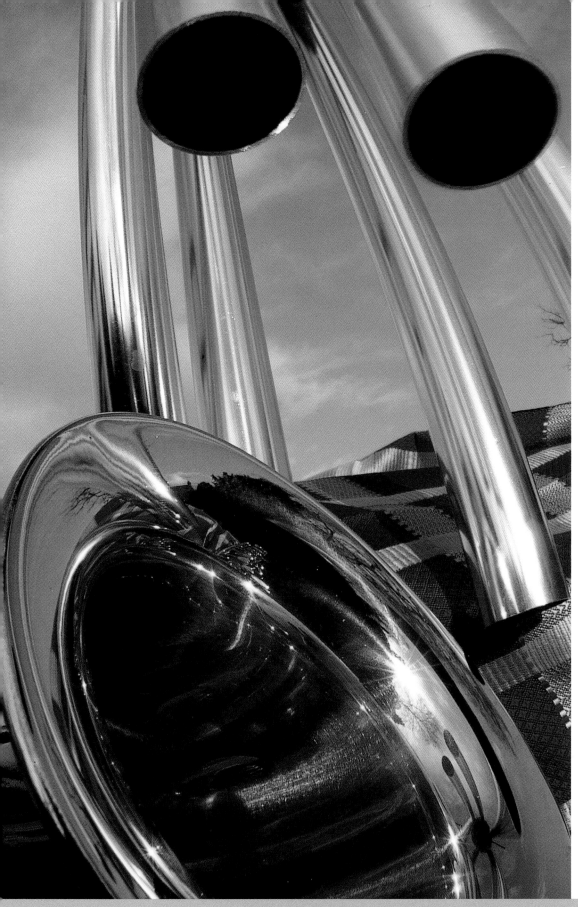

Identifying themes

What does this mean in practical terms? It means first of all searching your own mind for ideas and themes. They are there, even though you may not be immediately aware of it, and a little practice will soon lure them out. Everyone has a special interest, something that they may not yet have had time or opportunity to develop, and may not even have thought of in a photographic context. Now is the time to start making use of it. If it can be done by other means, it can also be done using a lens. The world is not short of yachtsmen who became marine photographers, reserve wardens who become nature photographers, civil servants who started compiling portfolios of civic buildings, and fashion models who turned to the other side of the lens. They simply discovered how to channel their life's experiences into a new direction.

Here is a very simple example. I am acquainted with several photographers whose passion is dragonflies. Most of them nurtured their interest from childhood but only later thought of immortalizing their subjects on film. Now they have an even greater incentive to travel widely in pursuit of that which gives them pleasure. Some of these individuals are now preparing specialist portfolios for submission to panels of judges in competitions or on the boards of various societies. They aren't simply snappers of every conceivable variety of dragonfly; their aim is to portray their subjects in as many and varied photographic lights as possible.

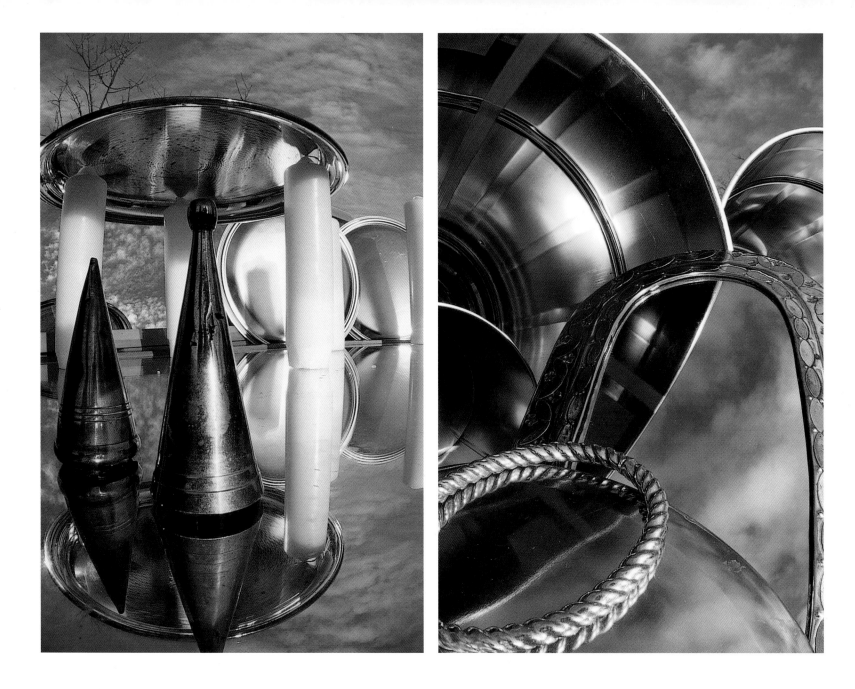

This page and facing opposite
More images from the series of
themed photographs of brass
objects and instruments.

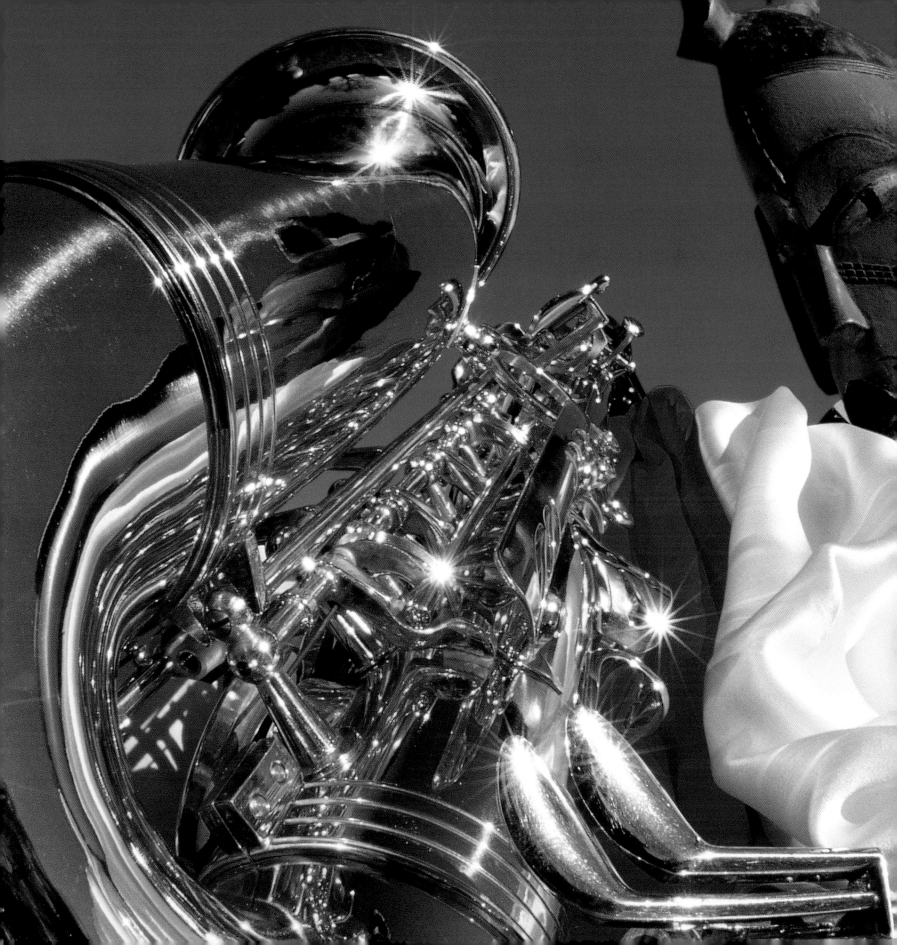

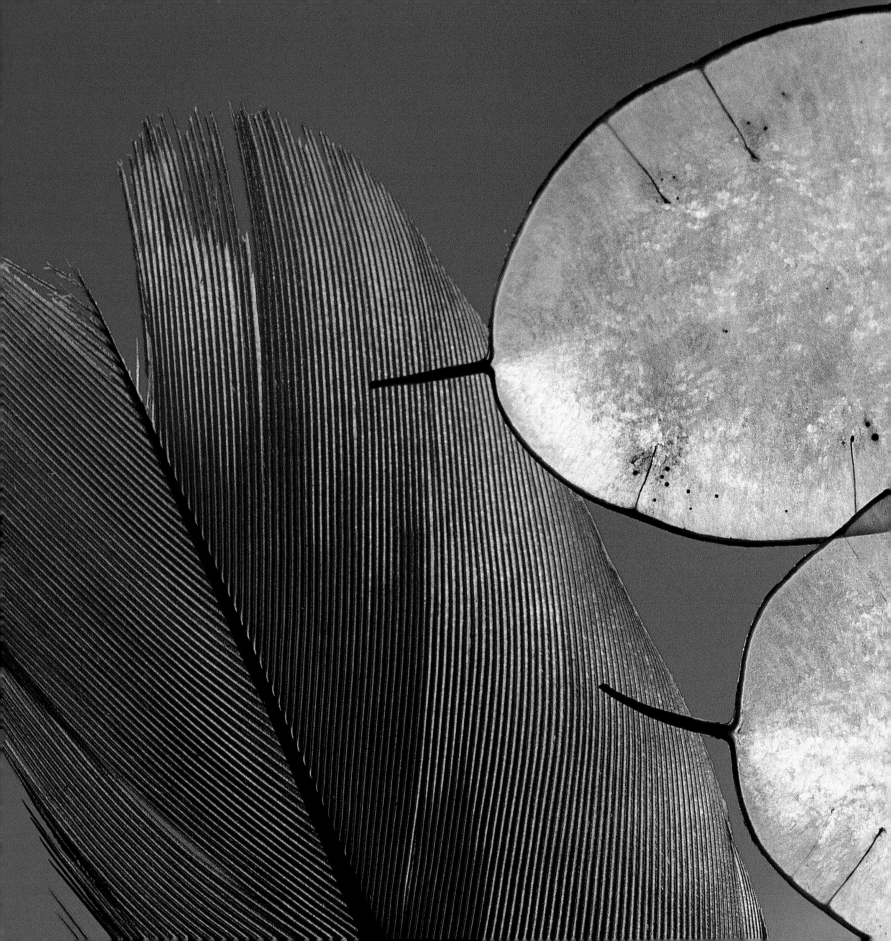

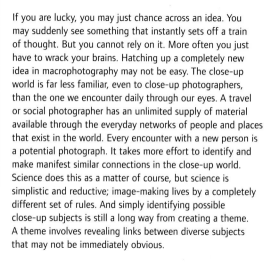

If you are lucky, you may just chance across an idea. You may suddenly see something that instantly sets off a train of thought. But you cannot rely on it. More often you just have to wrack your brains. Hatching up a completely new idea in macrophotography may not be easy. The close-up world is far less familiar, even to close-up photographers, than the one we encounter daily through our eyes. A travel or social photographer has an unlimited supply of material available through the everyday networks of people and places that exist in the world. Every encounter with a new person is a potential photograph. It takes more effort to identify and make manifest similar connections in the close-up world. Science does this as a matter of course, but science is simplistic and reductive; image-making lives by a completely different set of rules. And simply identifying possible close-up subjects is still a long way from creating a theme. A theme involves revealing links between diverse subjects that may not be immediately obvious.

Left Dried honesty seed head with red feather.

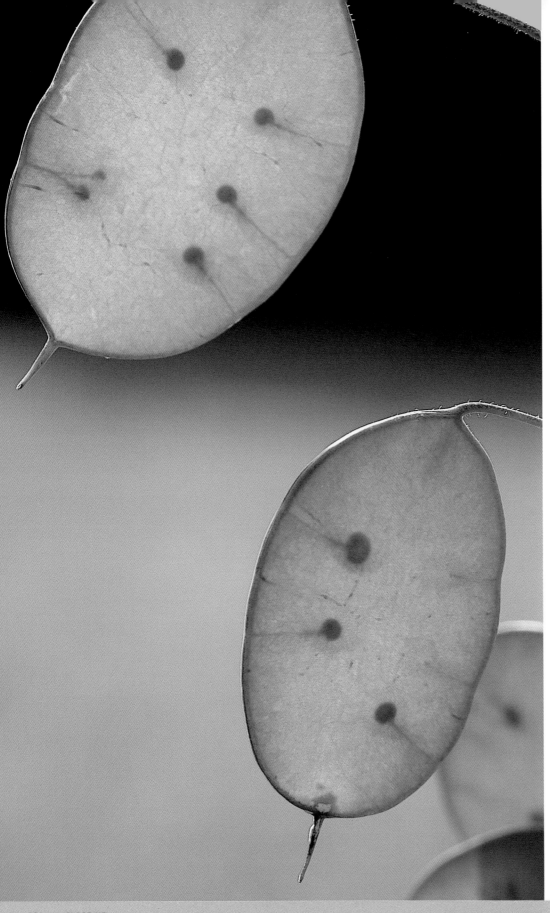

The themes and subjects you pick do not have to relate to the standard macro subjects: flora and fauna. Suppose you have an interest in clocks; how could you use this interest as the starting point for a photographic theme? What material do you have available? Ideas you might consider are images showing the internal workings of clocks through the glass casing of a carriage clock, or perhaps the intricate parts of a silver pocket watch. These tiny mechanisms are beautifully revealed by macrophotography. Use your imagination to challenge the norms, to find new subjects. The only limit to the possibilities is the imagination. Adopting a theme will sharpen your skills, and give your photography momentum. If you persevere, it may also earn you the distinction of becoming a minor specialist in your own area, whatever that may be.

Thematic material can vary from the exotic to the prosaic. Of course, in the right hands the prosaic can be transformed into the exotic. Take sunglasses. Everyone has seen close-up photographs of people wearing sunglasses reflecting their environment, usually in a beach setting. A portfolio could be assembled consisting entirely of sunglasses depicting scenes from diverse locations. Be ironic: make use of unexpected reflections—rather than sunny skies and sandy beaches, reflect a derelict building site or a wintry railway station. Rather than simply an observational exercise, your images could be manipulated to make statements.

Left Green honesty seed heads
(*Lunaria annua*).

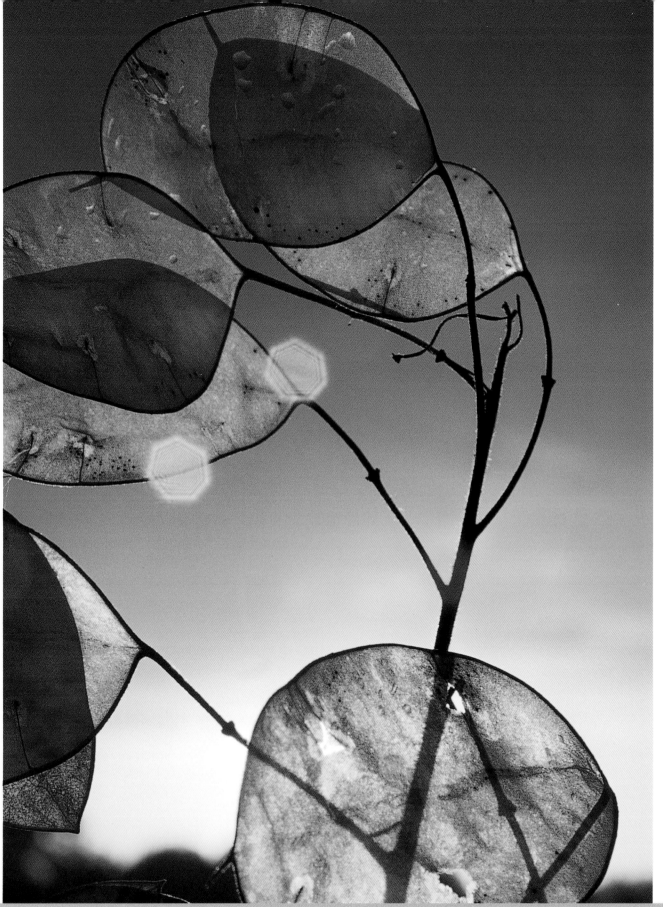

Left Dried honesty seed heads, sunset.

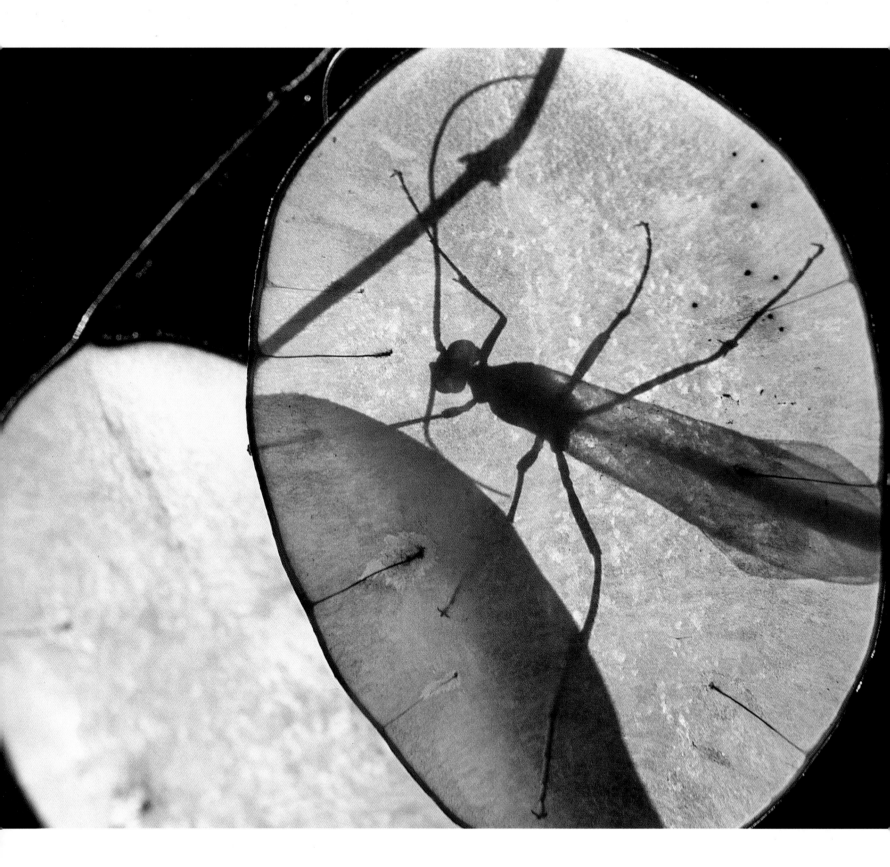

Challenge yourself

Of course, with each theme that you develop, you rely on the materials to hand, and each has its own technical challenges. With glasses, the image of the sun, the sky, and the reflected scene actually exists behind the glass, and is not spread over its surface. It's the same for ordinary mirrors. If you focus a macro lens onto the surface of a mirror expecting to see the reflected image, you won't. You have to focus deep into the mirror surface to obtain this image. In the case of the sunglasses, you can either focus on the frame and the glass itself, or on the deeper reflected image. To get both simultaneously into focus you might have to try another approach; using a wide-angle lens set to its closest focusing distance, or fit the same lens with an extension tube. But these demands can be surmounted. With macro, perhaps more than other areas of photography, practice and experimentation are pre-requisites.

Left Dried honesty seed head with shadow of ichneumon wasp. This shot was an example of pure serendipity. I was photographing the seed head when a wasp unexpectedly flew out of the vegetation and landed, giving me less than a minute to take three shots before it flew away. The only evidence of the wasp clinging to the other side of the seed head is the end of its antenna poking out from behind.

Right Goatsbeard seed head encapsulated to form a paperweight. Composition with pumpkins. This was shot in fall in my home village.

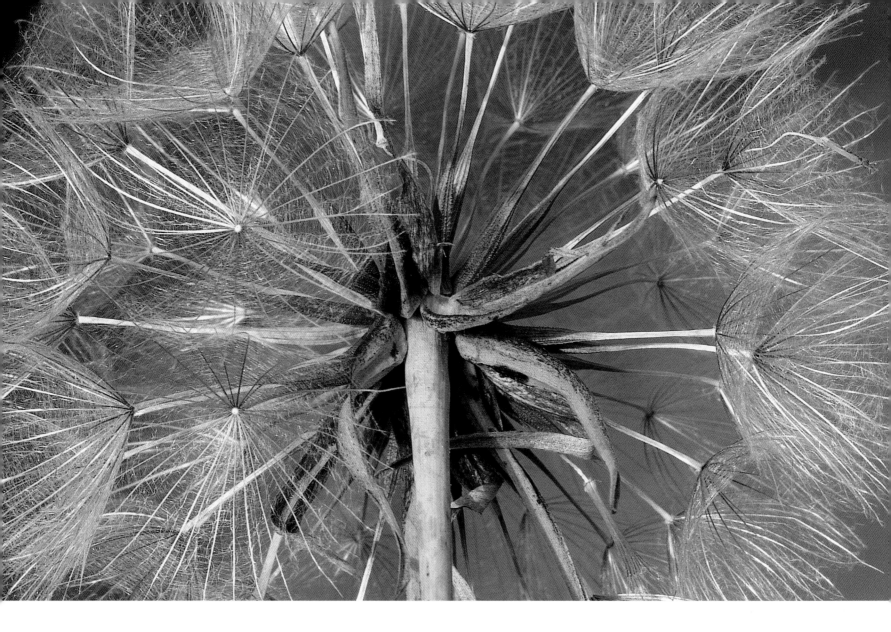

Above left Goatsbeard seed head
(*Tragopogon* sp.).

Above right Parachute seed of
goatsbeard, with water droplet.
The background was provided by
an out-of-focus silk garment.

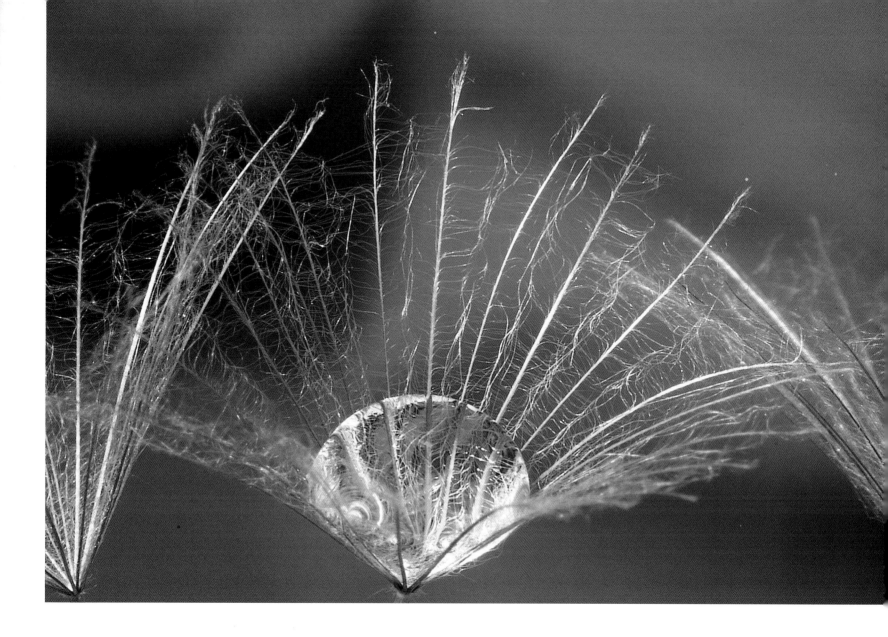

Making use of the everyday

Sometimes an idea for a theme can be sparked by an unusual feature in an otherwise undistinguished subject. I feature a number of photographs in this book of the seed heads of "Honesty", a favored plant of dried-flower arrangers. What particularly struck me about this subject was not its shape but its silky, translucent texture, which made it ideal for shooting against the light using the "contre-jour" technique. I experimented with fresh, green heads as well as dried ones, using morning, afternoon, and evening light. Predicting correct exposures for contre-jour subjects is almost impossible, and the only solution is to bracket widely— by as much as plus or minus three or four stops.

Seeds offer all kinds of graphic possibilities, such is the diversity of shape and texture. Here I shot a series of images of the dried seed from a "Goatsbeard" plant, *Tragopogon*. The first picture (see *page 108*) was taken in the wild in the Teide National Park, Tenerife. There had just been a rainstorm and I liked the way the light seed heads made a stark impression against the darkness of the mountainside. I collected some specimens and later, in much brighter conditions, focused in more closely on groups of seeds, (*above left*) or individual seeds placed on a mirror (*page 131*).

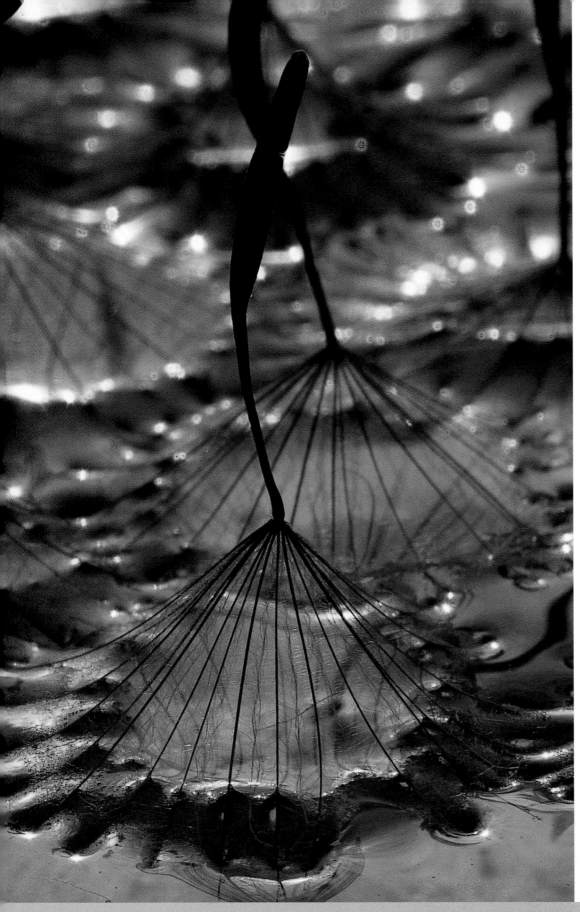

Left Raft of inverted goatsbeard seeds photographed against the setting sun.

Right Goatsbeard seeds on mirror.

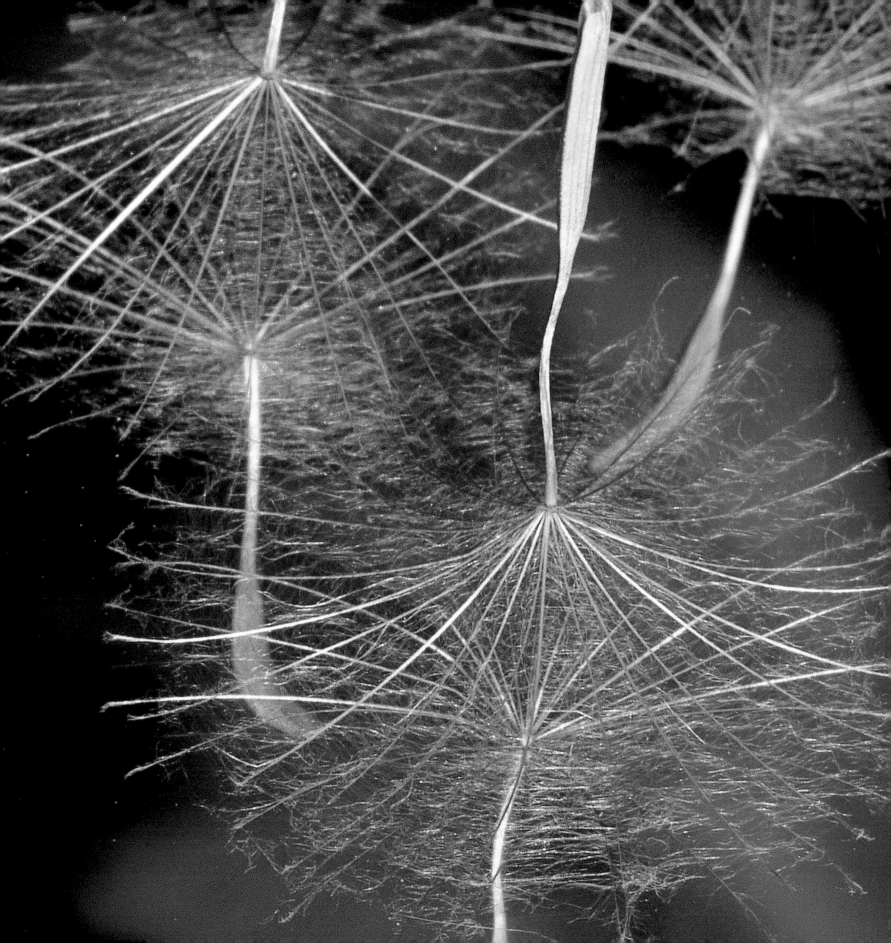

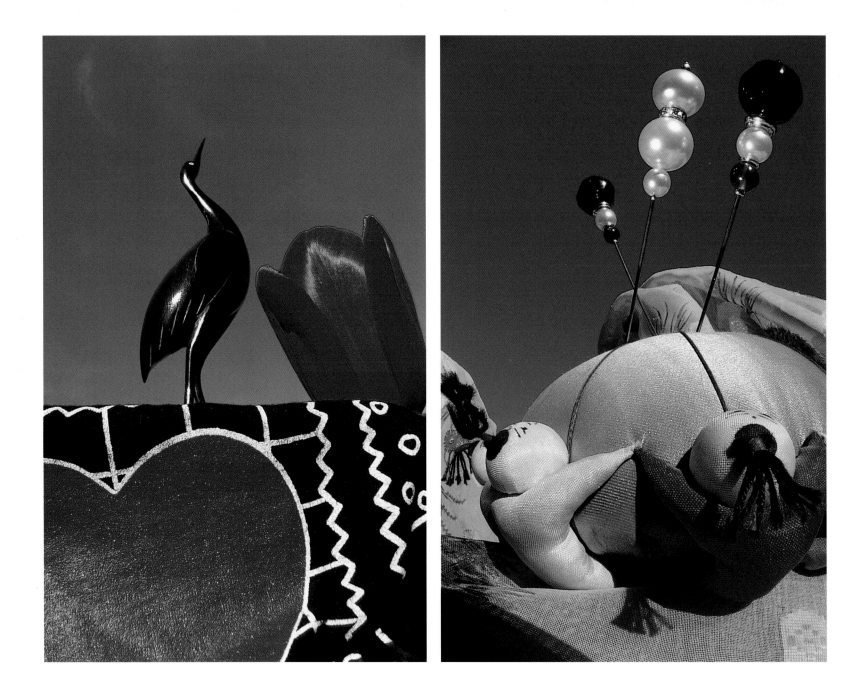

From left to right Small ornamental
stork and tulip, pin-cushion
and hat-pins, African masks and
amber beads. These photographs
were part of a theme on jewelry
and ornaments.

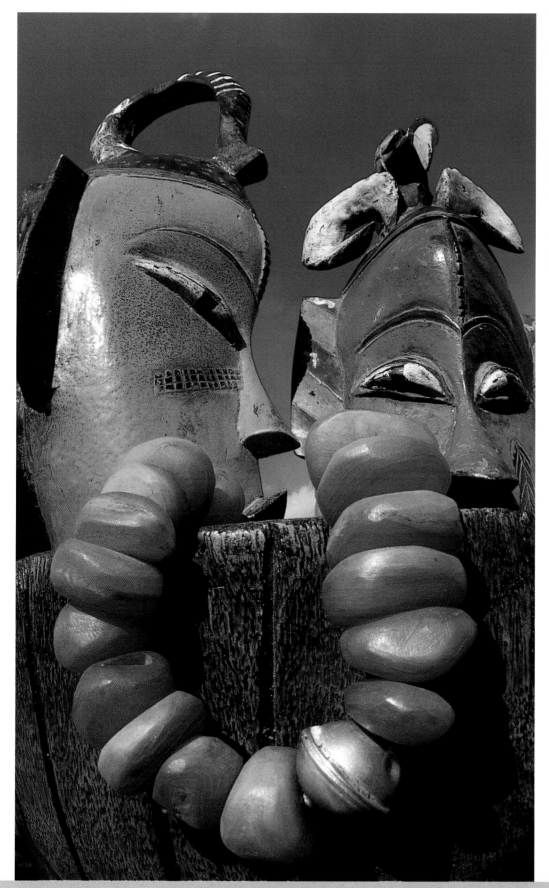

There are all kinds everyday items you might use for your pictures. Close-up photography is dominated by the physical appearance of things: their shape, color, and texture. But each subject possesses many potential identities, depending on the nature of the lighting that is used to elicit them. Once you have discovered the chimeric quality of close-up subject matter you will never be short of ideas. Rather than concentrating exclusively on form, you will begin to experiment with the many different ways in which form and light are related. This in turn may lead to deeper interrogations about the meaning of imagery. What are the qualities of a picture that instinctively draw the eye to it? I remain convinced that even in a digital era, the greatest challenges for a photographer lie in his or her interactions with original subjects in the real world rather than, at one remove, with virtual subjects inside a computer. But nothing is sacred: I am also aware of the doors that have been opened with the advent of digital technology. As in life, there is a balance, and whatever inspires your image-making, that's what counts most.

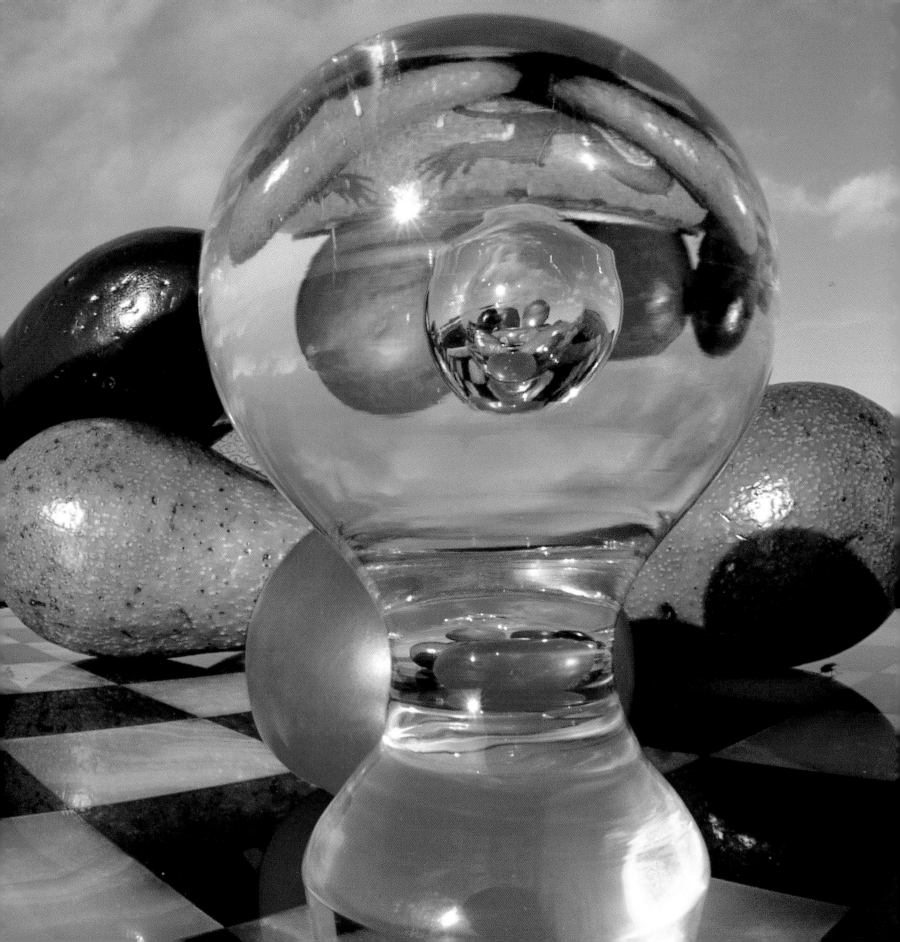

In close-up: being a macrophotographer

Unlike the work of a commercial photographer, who wakes up in the morning and has his day sketched out ahead of him, there is no such thing as an average day's shooting for the macrophotographer—certainly not this one. Nature is not predictable, and that is both the challenge and the frustration of the task. Having said that I nearly always set out with a rough idea of what I want. But one always hopes, too, for new encounters, since these are the life-blood of photography. I would be surprised, and mildly disappointed, if each foray did not uncover at least one new idea or discovery. I feel that if I have made the effort, the day owes me a small favor. One's optimism is rarely misplaced, although it may not be until the final moments of the day that it is fulfilled.

Left Decanter stopper on checkerboard.

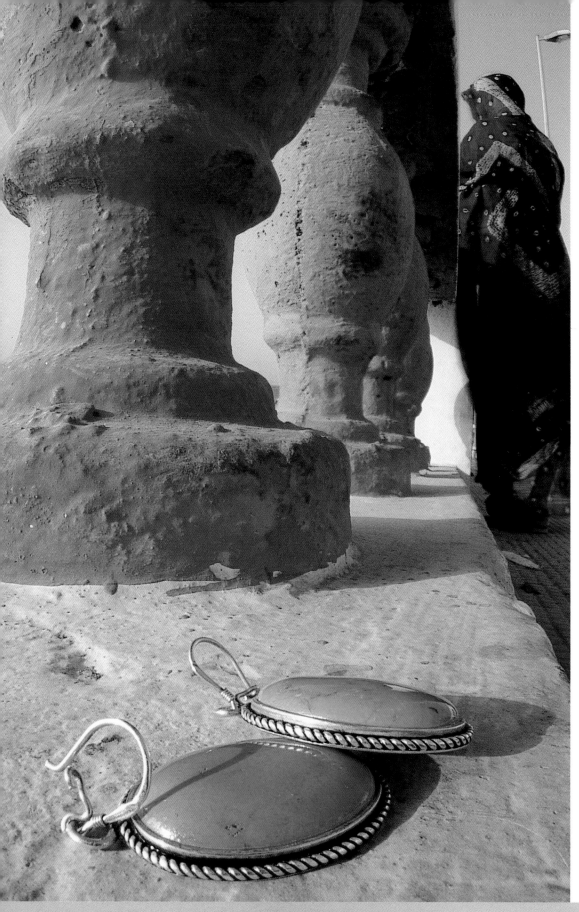

The first task before setting out is selecting what to put in the bag. I am not a slave to lenses, so this is never really a problem. For straightforward macro work I carry two micro Nikkors, the 55mm F2.8 and 105mm F2.8, together with a selection of extension tubes. I carry a single camera body, a seasoned old Nikon FM2, which is fully mechanical and completely reliable, and a few filters which I use very sparingly. Most of my carrying power is located in my left shoulder about which is strung the heavy Benbo-style tripod that accompanies me everywhere, whether at home or abroad. Many are the fellow airline passengers who have narrowly missed impalement as I wrestled this monster into the overhead luggage compartment. Together with its large ball-and-socket head, the tripod is in fact a leaden albatross but I have never regretted the solid base and perfect flexibility that it gives to work at ground level. It is easy to make this statement after a few hours of sortie into the cool, smooth, fenland countryside in which I live, but one's tolerance may be more severely tested after battling through the heat of the Sinai desert.

A great location

The great attraction of the Sinai for me is the transparency of its light and the rosy luminosity of its rocks. A day's photography in this sublime environment might begin with a headlong dash from the port town of Nuweiba on the Red Sea coast, inland through the mountains in the direction of St. Catherine's monastery, a well-known magnet for pilgrims. Our conveyance is normally a hired taxi, a huge, battered Mercedes supervised by an affable Egyptian driver who is prepared to wait patiently in the middle of the desert while my wife and I trek for hours along some acacia-strewn wadi or glowing range of mountains. We return, exhilarated and hungry, to find our driver already cooking up a meal in the back of his taxi. He has the eyes of an eagle and has spotted us long ago making our way back to the taxi.

Left Azure earrings.

Right Extreme close up of a pair
of Moroccan leather sandals.

Left Gold necklace in desert scene, Sinai.

Right Discarded water bottle, Sinai.

A number of my desert pictures feature a mystery figure in the background. This is my wife Zena. She also appears in various disguises in a number of other pictures in this book and I leave to you to puzzle out which. I hasten to add that this is not a case of exploitation; she has her own photographic interests and, in return for the occasional pose, I occasionally shoulder her extra camera bodies and lenses.

Embracing the exotic

Another desert country, Morocco, has also provided a setting for my photography, one of my favorite locations being the fishing port of Essaouira on the Atlantic coast. One particular day's shooting began with a visit to the central piazza. The picture of the green pepper in the center of the piazza contained all the elements that I was looking for in a panoramic close-up: the macro subject itself filling the foreground; a subsidiary figure in the mid-ground in the form of a seated person (you guessed it, my wife again); and an interesting but not too distracting background, the façade of the national bank, Credit du Maroc. Taking this picture instigated an unusual amount of interest from bystanders, not least a Moroccan policeman who fortunately saw the funny side of things once he had assured himself that what I was crouching behind was not a weapon. We then moved on to the fishing port itself where I photographed the bleary-eyed sabre fish shown right. The catch had just been landed and was being gutted for market, but what the viewer does not see is the cloud of screaming gulls eyeing my catch and the entrail-strewn water line lapping at my ankles. I had been fixed to this particular spot for about two hours before the tide finally pushed me landwards. Clambering over the old harbor wall onto the rocks below I was confronted by another battlefield of discarded fish remnants, including the one shown overleaf. By now it was quite late in the evening and the low sun can be seen reflected in the creature's dead but still bright eye.

Left Green pepper, Morocco.

Right Sabre fish, Essaouira, Morocco.

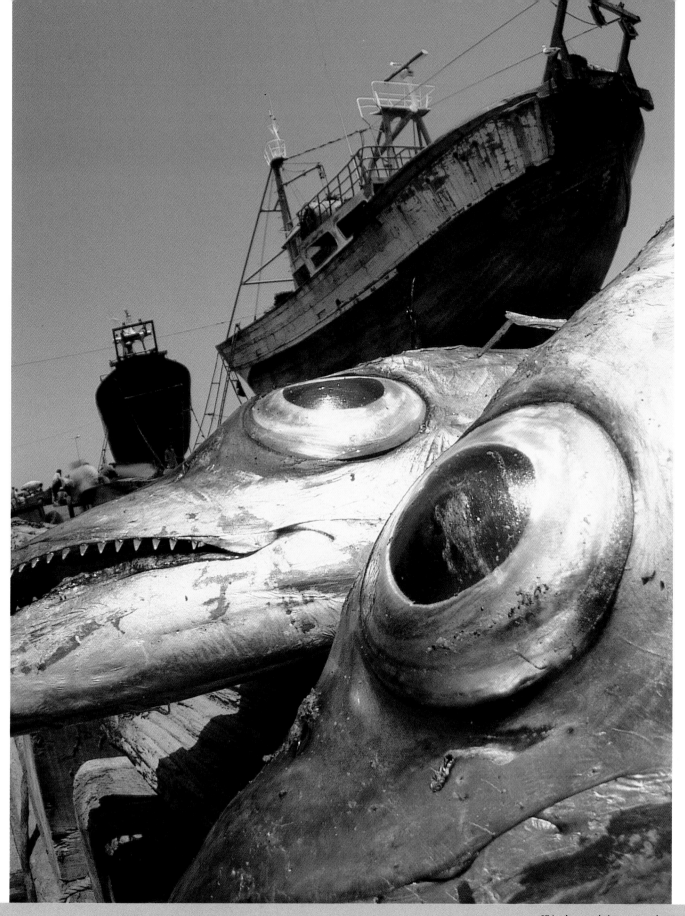

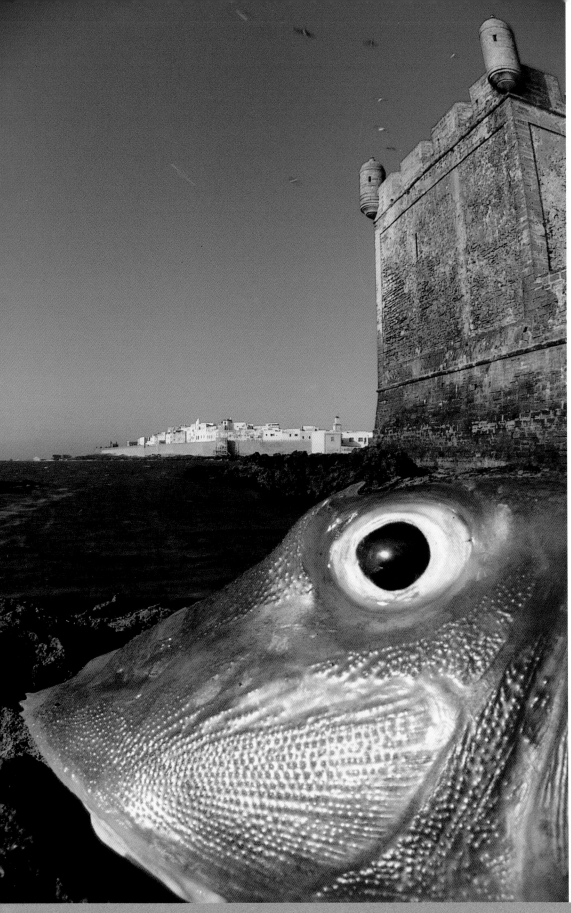

Left Dead fish, port of Essaouira, Morocco.

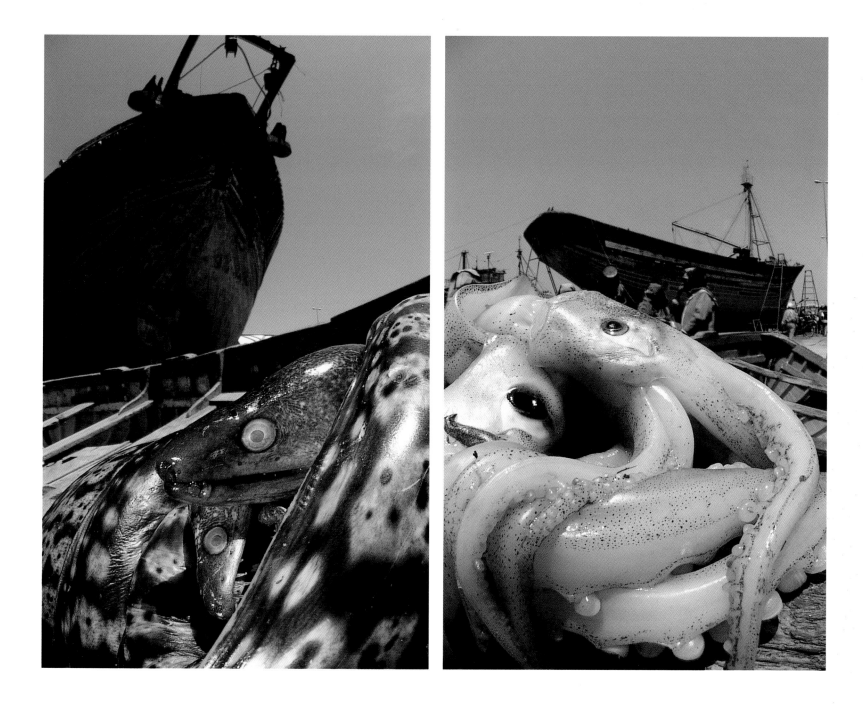

Above Leopard eels, port of
Essaouira, Morocco.

Right Squid, port of Essaouira,
Morocco.

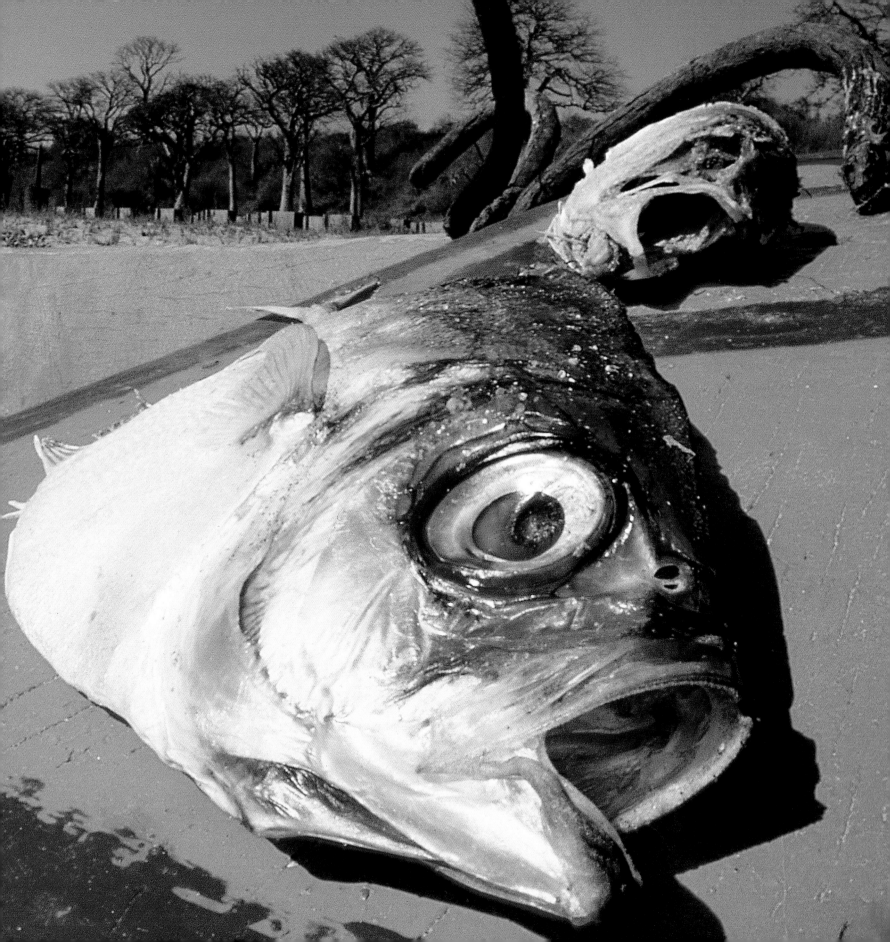

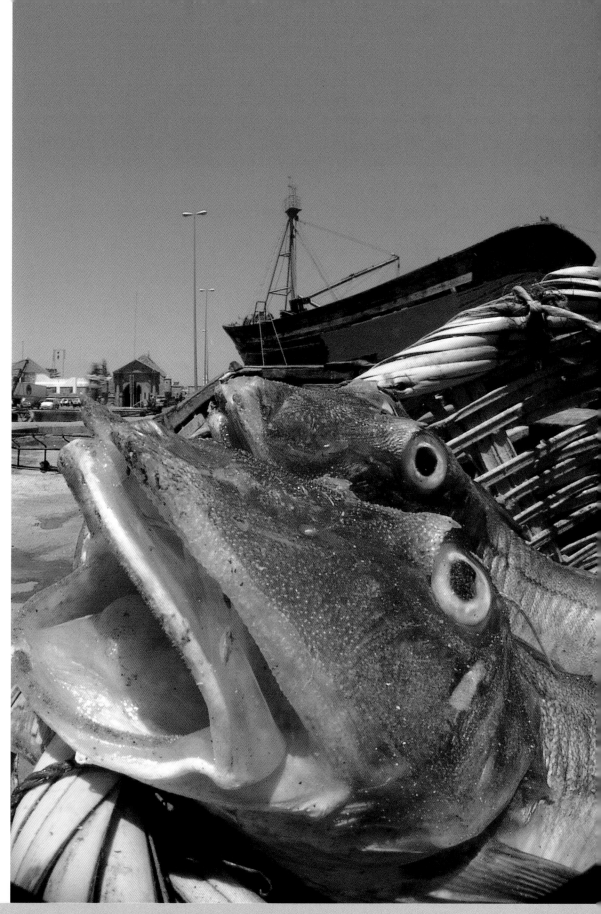

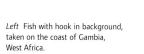

Left Fish with hook in background, taken on the coast of Gambia, West Africa.

Right Fish on the quay at the port of Essaouira, Morocco.

Above Spitting salmon.

Right Flying sprats.

Sparkling ideas

The watery, fishy theme continued with the picture of the spitting salmon. The idea emanated from the example of a real fish which sometimes rises to the surface and shoots down flies with a spout of water. There was no attempt to duplicate biological reality; this was simply meant to be an amusing picture. Concealed inside the dead salmon's head is the nozzle of the re-circulating pump which is generating the spout. The insect is a real, live, jumping locust, and in common with most living things, locusts have a great aversion to water, and to photographic and electrical equipment. What a battle of wills. Just above the summit of the arch lay the horizontal infra-red beam through which, somehow, I had to entice the creature to leap. I had only one factor in my favor: positioned on the other side of the water arch was the kitchen window—the insect's potential escape route. So I placed individuals on the back of my outstretched hand, pointed them in the direction of the window and hoped for the best. Naturally, most of the time they skilfully avoided the beam using some sixth sense as yet unknown to science. But I am not going to complain unduly about a success rate of one or two per roll of Velvia!

I exhausted the fish theme with the picture shown, entitled, perhaps unedifyingly, Flying sprats. Again, this was meant to be an amusing picture but it also reflected a more serious notion that, even in the humdrum surroundings of a kitchen, there lay unexpected moments of photography. Call it manufacturing a challenge where one did not seem to exist. I tried to imagine the sprats falling through the air into the bowl, ready to be cleaned and gutted. This time the set-up was based around a tiny hand-basin in the downstairs restroom which just shows the lengths to which the macrophotographer will go!

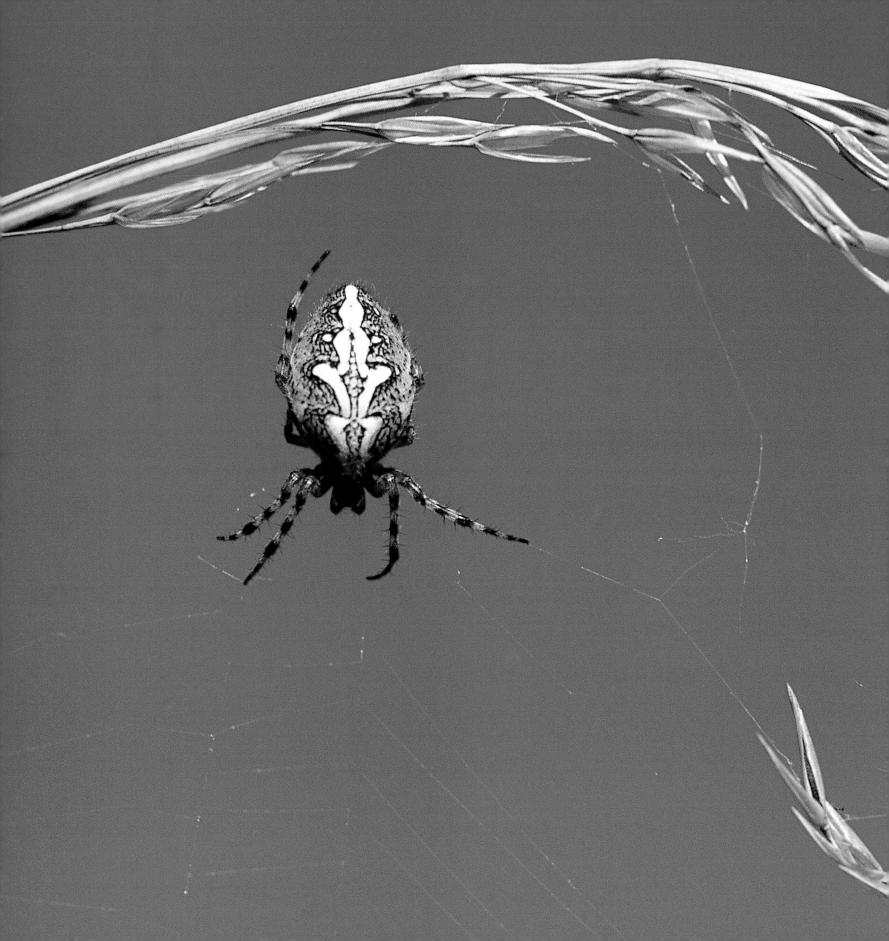

Springing into action

Nothing that I have done in photography places as many demands on stalwartness and persistence, as photographing flying insects. At the start of the project I chose a location in the Cantabrian mountains of Northern Spain, an area rich in species due to its hot, wet, almost subtropical summer climate. The equipment was transported over the long journey to Spain in the back of my old Landrover, consisting of camera gear, electronic black boxes, heavy-duty car batteries, and an assortment of ironmongery.

For the initial trials my studio consisted of a cramped, two-person tent which was necessary to protect the equipment from the elements, but also left me with excruciating backache at the end of each day. I soon progressed to the greater luxury of a full-sized family tent which could easily accommodate both the set-up and me, and still leave flying space for the insects. On arrival at each new location, the tent-erection and installation of the equipment would take an entire day, largely due to the complexity of the numerous electrical connections. A typical working day involved an early rise and a four- or five-hour trek into the upland meadows and beech forests to collect the insects, which were then transferred into cool, dark boxes to keep them healthy and inactive until the afternoon's work began. During the shoots, one end of the tent was left permanently open to the sky as an escape route and, with the set-up located in the middle of the tent, it was my job to release insects from the far end of the tent, hoping upon hope that they would pass through the electronic trip-wire on their exit. By adjusting the size of the tent opening I could narrow down their flight path, thereby optimizing my chances of success.

Over the course of five annual visits, each lasting between a month and six weeks, I accumulated approximately 35,000 exposures which severe editing then reduced to a few hundred that met the photographic criteria I had laid down for myself. On December days back home, when the sun struggled to be seen through the clouds even once in a fortnight, I sometimes reflected on the irony of spending half of one's day inside a tent while outside lay the sunshine and majesty of the Spanish Picos de Europa mountains.

Left Orb-web spider shot against the sky. Hand-held at 1/60th of a second.

I close this chapter, and this book, with a picture of an insect's eye, seen in a way in which you will not have seen it before. You will recall that the insect eye provided me with the original idea for the panoramic close-up image. It will never be known what an insect *actually* sees, but my question at the time was not exactly this, but what we could see through them. How do you photograph an image through an insect's eye? Whatever else it may possess, an insect does not possess a glass eye, as a quick inspection will soon verify. So I cannot simply take a dead insect, remove an eye, hold it in front of a camera and expect to take a picture through it.

But there is a way. An insect is like a snake: with each molt it casts the covering of its eye, which is transparent. This is what is shown here, a freshly molted, multi-faceted eye. It is only 2–3mm (⅛in) long, so we are working close to the limits of macrophotography: five or six times life-size magnification. Early trials showed that it was impossible to simultaneously obtain a focused image of both the eye itself and the background behind it. The solution lay in thinking of things in reverse, as it were; I needed to project an image from behind the insect eye onto the camera, as though the camera were a projector screen and the insect eye were part of a projector lens. I will spare you the technical whys and wherefores.

The image seen through the insect eye is the leg of a living stick insect sitting on a leaf, situated about half a meter (1½ft) behind the faceted eye. Interposed between the leaf and the eye is a second photographic lens that trials showed had to conform to an extremely narrow specification: it had to be a medium-format, wide-angle lens (actually Pentax 645, 45mm F2.8) and its job is to project the image of the leaf through the insect eye and onto the camera lens. Both the photographic taking lens (i.e. the macro lens) and the medium-format projector lens, have to be stopped down hard, and at such high magnifications, the flash intensity required for correct exposure required the combined power of every flash gun that I had in my possession at the time.

Ultimately, despite the sometimes unwieldy efforts required to obtain such a glorious image—one that, for me, is as close to achieving an understanding of the perspective of the close-up world of the insect as it is possible to do—is completely worth it.

Right Insect eye.

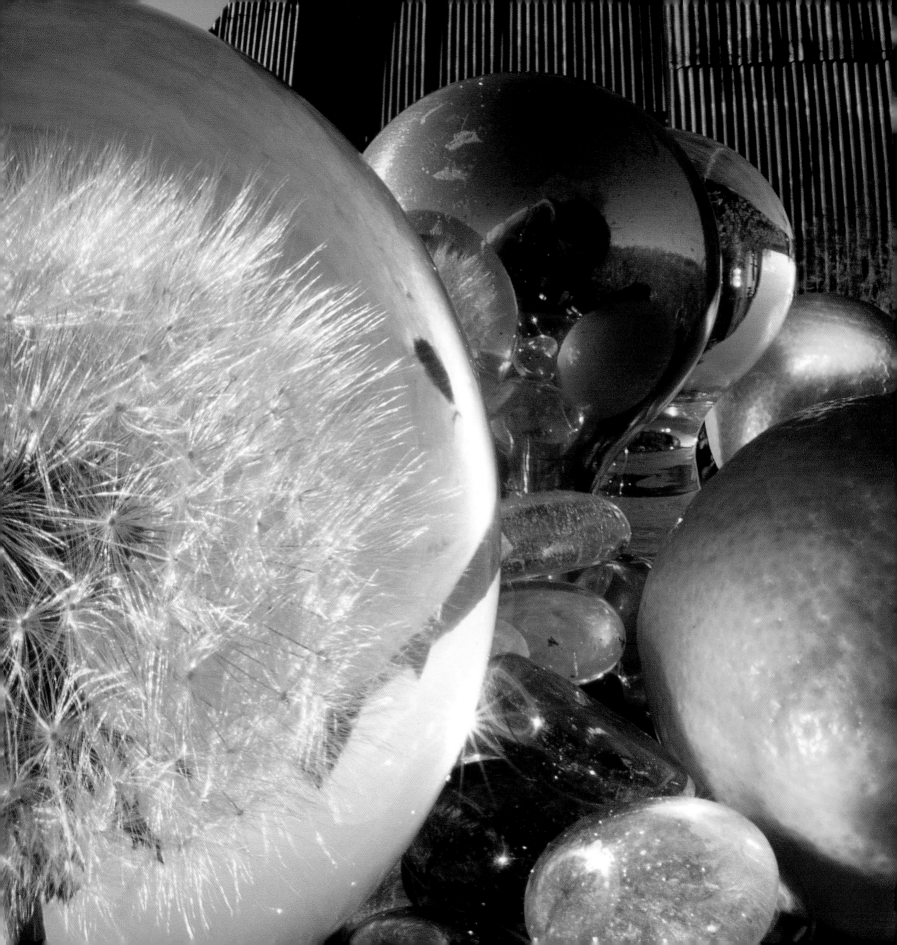

Left A collection of glass and brass objects, including a paperweight containing a seed head, combining to form an impressive display of sparkling reflections, textures, and shapes.

Right Painted ostrich egg and oranges.

Afterword

Thus I have been drawn back, almost magnetically, to the subject of eyes and imagery. By now you will be aware that the insect's own eye, although a real functioning organ in the life of the insect itself, has for me been a proxy human eye through which I have been able to see aspects of the macrophotographic world that I never knew existed. There are many others, too, and, I'm sure, simpler ways of bringing them to life. A final word about technique: remember it is only the handmaiden of the imagination. Cultivate the latter, and the former will follow.

Within these pages I hope I have helped you to realize that there is a world of opportunities, and that it is for you to discover your own ways of translating them onto film. As always, it is the first step that begins the journey: a single image, well taken, may be all the inspiration that is needed.

John Brackenbury

Overleaf Detailed close up of the inside of an imperial lily flower *Fritillaria imperialis* showing the nectaries from which nectar is oozing.

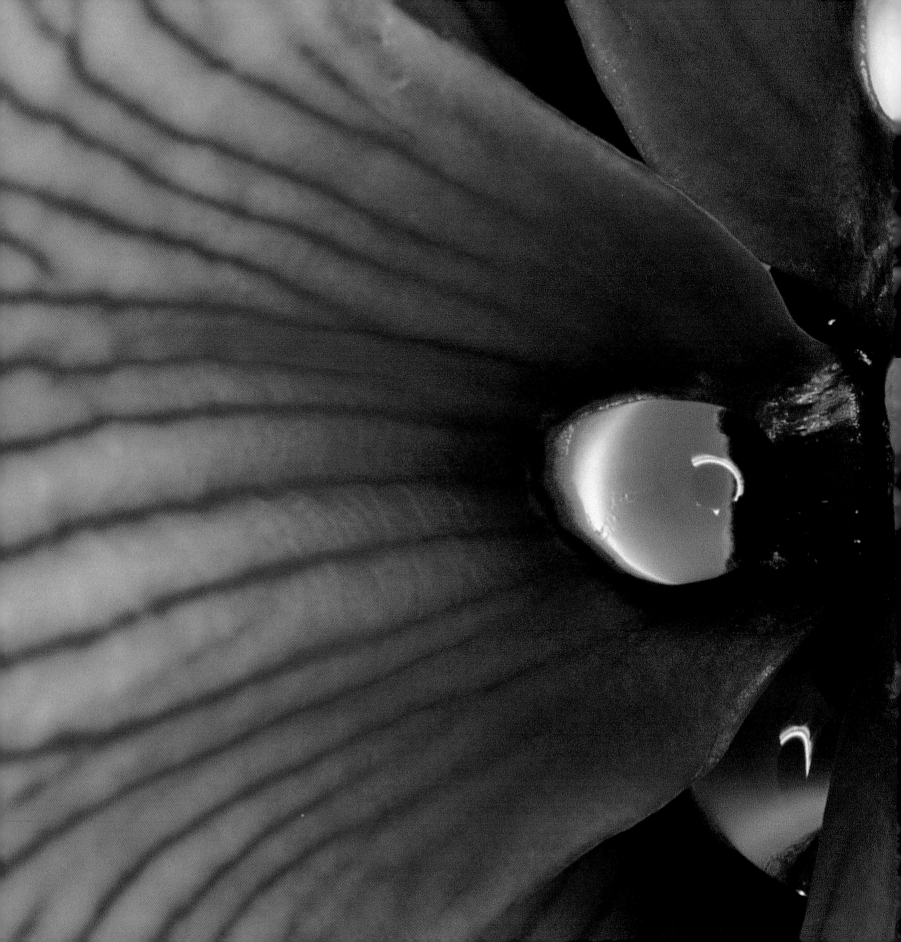

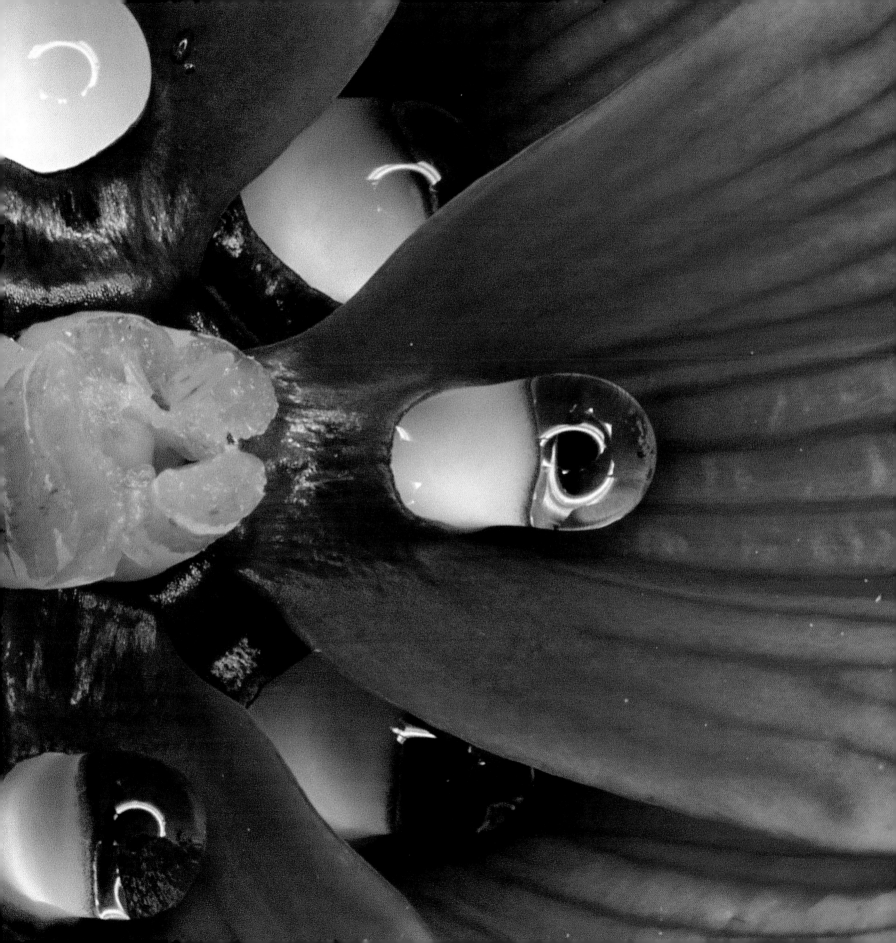

Index

About the author

John Brackenbury is a zoologist,
lecturer in veterinary medicine
at Cambridge University in the
UK, and a fellow of the Royal
Photographic Society. A passionate
photographer of nature and wildlife
subjects, he lectures extensively
on macrophotography on the
university circuit. He also features
in RotoVision's bestselling book
*The World's Top Photographers:
Wildlife* by Terry Hope, and the
forthcoming *Extreme Photography,*
also by Terry Hope.